LIMOR 11 1990

VISUAL QUICKSTART GUIDE

Рното 4

FOR MAC OS X

Adam C. Engst

Visual QuickStart Guide

iPhoto 4 for Mac OS X

Adam C. Engst

Peachpit Press

1249 Eighth Street
Berkeley, CA 94710
510/524-2178
800/283-9444
510/524-2221 (fax)
Find us on the World Wide Web at www.peachpit.com.
To report errors, please send a note to errata@peachpit.com.
Peachpit Press is a division of Pearson Education.

Copyright © 2004 by Adam C. Engst

Editor: Nancy Davis

Production Editors: Lisa Brazieal, Lupe Edgar

Copyeditor: Tonya Engst Compositor: Adam C. Engst Indexer: Rebecca Plunkett Cover Design: The Visual Group

Cover Production: George Mattingly / GMD

Notice of rights

All rights reserved. No part of this book may be reproduced or transmitted in any form by any means, electronic, mechanical, photocopying, recording, or otherwise, without the prior written permission of the publisher. For information on getting permission for reprints and excerpts, contact permissions@peachpit.com.

Notice of liability

The information in this book is distributed on an "As Is" basis, without warranty. While every precaution has been taken in the preparation of the book, neither the author nor Peachpit Press shall have any liability to any person or entity with respect to any loss or damage caused or alleged to be caused directly or indirectly by the instructions contained in this book or by the computer software and hardware products described in it.

Trademarks

Visual QuickStart Guide is a registered trademark of Peachpit Press, a division of Pearson Education.

iPhoto, iTunes, iDVD, and iMovie are registered trademarks and/or registered service marks of Apple Computer, Inc.

ISBN 0-321-24662-4

987654321

Printed and bound in the United States of America

Dedication

To my son, Tristan Mackay Engst, the subject of so many of my photographs.

About the Author

Adam C. Engst is the publisher of *TidBITS*, one of the oldest and largest Internet-based newsletters, distributed weekly to many thousands of readers (find *TidBITS* at www.tidbits.com). He has written numerous computer books, including the best-selling *Internet Starter Kit* series, and many articles for magazines, including *Macworld*, where he is currently a contributing editor. He has appeared on a variety of internationally broadcast television and radio programs.

His indefatigable support of the Macintosh community and commitment to helping people has resulted in numerous awards and recognition at the highest levels. In the annual MDJ Power 25 survey of industry insiders, he consistently ranks as one of the top five most influential people in the Macintosh industry, and he was named one of MacDirectory's top ten visionaries. And how many industry figures can boast of being turned into an action figure?

Please send comments about the book to Adam at iphoto-vqs@tidbits.com or post them on the book's Web site at http://iphoto.tidbits.com/.

Other Books by Adam C. Engst

The Wireless Networking Starter Kit

Eudora 4.2 for Windows & Macintosh: Visual QuickStart Guide

Crossing Platforms: A Macintosh/Windows Phrasebook

Internet Starter Kit for Macintosh

Special Thanks

No book is the work of a single person, and many people helped with this one, including

- Tonya Engst (not only my wonderful wife, but also a great copyeditor)
- Nancy Davis (an excellent editor and an almost geographically suitable friend)
- Lisa Braziel and Lupe Edgar (spotters of wayward pixels)
- Nancy Ruenzel (for giving me the nod on this book)
- Kim Lombardi and Scott Cowlin (for PR and marketing wizardry)
- Chris Engst (for watching Tristan!)
- Glenn Fleishman and Marshall Clow (without whose help I could never have explained color management and resolution)
- Keith Kubarek, Sandro Menzel, Cory Byard, and Laurie Clow (for their photography knowledge and tips)
- Jeff Carlson, Geoff Duncan, Glenn Fleishman, Matt Neuburg, and Mark Anbinder (for helping keep *TidBITS* running)

Technical Colophon

I wrote this book using the following hardware and software:

- A dual-processor 1 GHz Power Mac G4 with a pair of 17-inch Apple Studio Display monitors, Canon PowerShot S100 and S400 digital cameras, and an Addonics Pocket DigiDrive card reader
- Mac OS X 10.3 Panther, iPhoto 4, Adobe InDesign CS for layout, Snapz Pro X 2.0 for screen shots, and the Peachpit VQS template

Featured Photographers

I took most of the photos in this book, but I also included some pictures from friends and the folks at Peachpit Press. A tip of the lens cap to Lisa Brazieal, Doug Davenport, Jennifer Engst, and Tonya Engst.

The traditional art featured in some of the screenshots comes from artists Marjorie Baer, Trish Booth, Gary-Paul Prince, and Mimi Vitetta.

CONTENTS AT A GLANCE

Chapter 1:	Getting Started	,
Chapter 2:	Importing and Managing Photos	1:
Chapter 3:	Organizing Photos	29
Chapter 4:	Editing Photos	57
Chapter 5:	Creating Books	79
Chapter 6:	Sharing Photos	103
Chapter 7:	Troubleshooting	153
Appendix A:	Deep Background	16
Appendix B:	Taking Better Photos	17
	Index	18

TABLE OF CONTENTS

Chapter 1:	Getting Started Hardware and Software Requirements Acquiring iPhoto Installing iPhoto Updating iPhoto via Software Update Updating from 2 to 4 Launching iPhoto iPhoto's Modes Interface Overview	3 4 5 6 7
Chapter 2:	Importing and Managing Photos Entering Import Mode Importing from a Camera Importing from a Card Reader Importing from Files Importing from a Kodak Photo/Picture CD Importing from an iPhoto Disc Importing Only Selected Photos iPhoto Directory Structure Deleting Photos Recovering Photos Creating Multiple iPhoto Library Folders Switching between iPhoto Library Folders Backing Up Your Photos. Other Backup Options. Merging iPhoto Library Folders iPhoto and Image Capture	13 14 15 16 17 18 19 20 21 22 23 24 25 26
Chapter 3:	Organizing Photos Entering Organize Mode Organize Tools Overview Changing the Display Pane's Layout. Other Display Preferences Contextual Menu Shortcuts Moving Around in iPhoto Editing Film Rolls Creating New Film Rolls Moving Photos between Film Rolls. Creating Albums Creating and Editing Smart Albums Smart Album Ideas.	31 32 33 34 35 36 37 38 39

	Duplicating Albums	42
	Renaming and Rearranging Albums	43
	Deleting Albums	
	Selecting Photos	45
	Adding Photos to Albums	
	Removing Photos from Albums	
	Arranging Photos	
	Assigning Titles to Photos	
	Assigning Comments to Photos	
	Editing Photo Dates	
	Managing Keywords	
	Assigning and Removing Keywords	
	Searching via Keyword	
	Assigning Ratings	
	Viewing Photo Information	56
Chapter 4:	Editing Photos	57
	Entering Edit Mode	
	Contextual Menu Shortcuts	59
	Edit Tools Overview (Display Pane)	60
	Edit Tools Overview (Separate Window)	
	Customizing the Toolbar	62
	Using the Toolbar	63
	Zooming Photos	64
	Duplicating Photos	65
	Rotating Photos	66
	Enhancing Photos	67
	Making Photos Black-and-White or Sepia	
	Adjusting Brightness and Contrast	69
	Selecting Portions of Photos	
	Specific Aspect Ratios	
	Cropping Photos	
	Reducing Red-Eye	
	Retouching Photos	
	Undoing Changes	
	Editing in Another Program	
	Recommended Image-Editing Programs	
	Another Useful Image-Editing Program	78
Chapter 5:	Creating Books	79
	Switching Modes while Creating Books	
	Book Tools Overview	81
	Creating Books	82
	Designing Books	
	Designing Pages	84
	Arranging Photos on Pages	85
	Dealing with Warning Icons	
	Entering and Editing Text	87

	Typing Text Correctly	
	Changing Fonts and Styles	89
	Changing Styles	90
	Changing Text Color	91
	Checking Spelling	92
	Checking Spelling As You Type	
	Previewing Books	
	Printing Books on Your Own Printer	
	Catalog Book Example and Ideas	
	Classic Book Example and Ideas	
	Collage Book Example and Ideas	
	Picture Book Example and Ideas	
	Portfolio Book Example and Ideas	
	Story Book Example and Ideas	
	Year Book Example and Ideas	
Character 4		
Chapter 6:	Sharing Photos	103
	Accessing Sharing Tools	
	Sharing Tools Overview	
	Printing Photos	106
	Previewing Prints	107
	Printing Contact Sheets	
	Printing Full-Page Photos	109
	Printing Greeting Cards	110
	Printing N-Up Photos	111
	Printing Sampler Sheets	112
	Printing Standard Prints	113
	Printing Custom Layouts	114
	Printing Tips	
	Setting up Slideshows	116
	Running Slideshows	117
	Slideshow Tips	
	Creating an iMovie Slideshow	
	Emailing Photos	
	Other Ways of Emailing Photos	
	Setting up an Apple ID	
	Using Your Apple ID	
	Preparing to Order Prints	
	Ordering Prints	
	Ordering Books	
	Book Observations	127
	Setting up a .Mac Account	
	Major .Mac Features	
	Publishing Photos Using HomePage	
	Managing HomePage Albums	
	Publishing .Mac Slides.	
	Subscribing to Mac Slides	

	Setting the Desktop Picture	134
	Creating a Screen Saver	
	Creating a DVD Slideshow with iDVD	136
	iDVD Slideshow Tips	137
	Sharing Photos on Disc	138
	Receiving an iPhoto Disc	139
	Exporting Files	
	Exporting Files by Dragging	
	Exporting to Web Pages	
	Web Page Export Tips	
	Exporting to QuickTime Movies	
	Distributing QuickTime Movies	
	Sharing Photos via iPhoto Library Manager	
	Sharing Photos via a Shared Volume	
	Sharing Photos via iPhoto Network Sharing.	
	Accessing Shared Photos	
	Extending iPhoto with AppleScript	
	iPhoto AppleScript Scripts	
Chapter 7		
Chapter 7:	Troubleshooting	153
	General Problems and Solutions	
	Importing Problems and Solutions	
	Other Importing Problems	
	Slideshow Problems and Solutions	
	Printing Problems and Solutions	
	Editing Problems and Solutions	
	Print and Book Problems and Solutions	
	Print/Book Ordering Problems and Solutions	
	Help Resources	
	Dealing with Warning Icons	166
Appendix A:	Deep Background	167
	Understanding Aspect Ratios	168
	Understanding Resolution	
	Understanding Color Management	
Appendix B:		
Appendix b:	Taking Better Photos	175
	What Kind of Photographer Are You?	
	Choosing a Camera	
	Where to Read Camera Reviews	
	Camera Accessories	
	General Photo Tips	
	More General Photo Tips	
	Portrait Photo Tips	
	Child and Pet Photo Tips	
	Landscape Photo Tips	
	Travel Photo Tips	185
	Index	187

1

GETTING STARTED

Get the Electronic Version!

I make an electronic version of this book available for free to anyone who's bought the paper version. Why might you want to read the book in PDF format onscreen?

- It's completely searchable.
- It takes up only a few megabytes of space on your hard disk, and thus doesn't weigh down your bag like the paper book when you're traveling.
- All the photos and screen shots are in full color, which is both more attractive and, in some cases, more useful.

To find out how to get it, send email to get-iphoto4-vqs@tidbits.com.

In late 2001, Apple realized the immense popularity of digital cameras meant that millions of Mac owners now use digital cameras in favor of their traditional analog counterparts. And yet, the camera is only part of the equation, and the other part, the software, is often incomprehensible to the average user.

Enter iPhoto, which helps users perform tasks never before possible in a photo management program, such as ordering prints from an online service and building and printing photo books—essentially customized hardcover photo albums. At the same time, iPhoto is easy to use, thanks in part to a simple interface, but also thanks to the fact that it doesn't attempt to compete with the big boys of the image-cataloging and image-editing worlds.

If iPhoto is so easy, why write this book? Even though iPhoto 4 improves on previous versions, it still doesn't entirely demystify the process of importing a digital photograph, editing it, and presenting it on paper or on the computer screen. And iPhoto comes with no documentation beyond minimal and incomplete online help.

Read on, then, not just for the manual iPhoto lacks, but also the help you need to take digital photos and make the most of them.

Hardware and Software Requirements

Although iPhoto 4 is a simple program, it has fairly significant system requirements thanks to the difficulty of working with large digital images.

To run iPhoto, you need:

- ◆ A Macintosh with built-in USB ports. A sufficiently souped-up older Mac with a PCI card providing USB ports might work, but Apple isn't guaranteeing it. iPhoto should work on any Mac that runs Mac OS X, but Apple recommends one with at least a 400 MHz PowerPC G3 processor and at least 256 MB of RAM. Realistically, the more CPU power and RAM you can throw at iPhoto, the better its performance. You'll also find a large monitor extremely helpful.
- ◆ Mac OS X. Specifically, Mac OS X 10.2.6 or later, with Mac OS X 10.2.8 and QuickTime 6.4 both recommended, and Apple says that you must have at least Mac OS X 10.2.8 to be able to burn CDs and DVDs from within iPhoto.
- ◆ A source of digital images, which could be an iPhoto-compatible digital camera, scanned images, Photo CDs, or a service that provides digital images along with traditional film developing. Apple maintains a list of cameras and card readers that are supposedly compatible with iPhoto at www.apple.com/iphoto/compatibility/. Take that list with a grain of salt; some devices on it may not work entirely properly, and some devices missing from the list do work fine with iPhoto.

Acquiring iPhoto

Apple offers several methods of getting iPhoto, although it's worth noting up front that iPhoto is no longer a free download, as it was before iPhoto 4.

Ways to get iPhoto:

- Look in your Applications folder. If you purchased your Macintosh since January 2004, iPhoto 4 may already be installed.
- ♦ Buy a \$49 copy of Apple's iLife '04, which is a CD/DVD package containing all five of Apple's digital hub applications: iPhoto 4, iMovie 4, iTunes 4, iDVD 4, and GarageBand 1.0. Although these applications come with new Macs for free, the iLife package is the only way for current owners of iPhoto 2, iMovie 3, and iDVD 3 to get updates for those products. Visit www.apple.com/ilife/ for details.
- Buy a new Macintosh, which will come with iPhoto pre-installed. Steve Jobs thanks you.

✓ Tip

Rather than buy multiple copies of iLife '04, you can buy a \$79 family pack that's licensed for up to 5 users.

What Happened to iPhoto 3?

If you're reading carefully, you'll have noticed that Apple bumped the version numbering of iPhoto from iPhoto 2 to iPhoto 4. The reason likely had to do with matching the version numbers of iMovie, iTunes, and iDVD.

However, iPhoto 4 isn't exactly what Apple intended iPhoto 3 to be, at least according to a "What's New in iPhoto 3?" document that Apple accidentally left in iPhoto 4's help pages (it's now gone). Some things supposedly in iPhoto 3 that are missing from iPhoto 4 include:

- Selective import of photos in import mode
- Built-in capabilities to create and switch between multiple libraries
- ◆ Tools to adjust color balance and lighting effects in edit mode
- More book themes (iPhoto 4 has only one new theme)
- Searching for photos based on multiple criteria (you can simulate this with a smart album in iPhoto 4)

Installing iPhoto

Installing iPhoto from the iLife '04 package requires almost no effort at all.

To install iPhoto:

- 1. Insert the iLife CD or DVD (you must use the DVD if you have a DVD drive in your Mac).
- 2. In the Install window that appears after mounting the CD or DVD, double-click the Install icon (Figure 1.1).
 The installer launches and asks if it may run a program to determine if the soft-

ware can be installed. Click Continue.

3. Click through the Introduction (Figure 1.2), Read Me, License, Select Destination (select your hard disk here), Installation Type, Installing, and Finish Up steps.

When you're done, you end up with iPhoto (and the rest of the iLife applications) in your Applications folder.

- If you don't want to install some of the iLife applications (only iDVD and GarageBand take up much disk space), click Customize in the Installation Type step and select only the applications you want (Figure 1.3).
- The installer calculates whether or not you have enough disk space; if you're on the edge, install only iPhoto.
- If you have current versions of the iLife applications installed, you can force the installer to overwrite them by deleting the copies from your hard disk first (you may also wish to delete related support files in your user's Library folder).

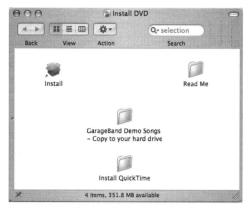

Figure 1.1 Double-click the Install icon to start the installation process.

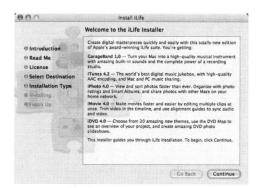

Figure 1.2 The iLife Installer Introduction screen describes the applications briefly.

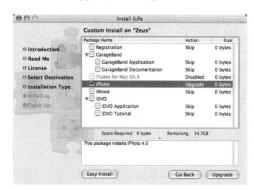

Figure 1.3 If you don't want to install all the iLife applications, click Customize in the Installation Type screen and select only those you do want.

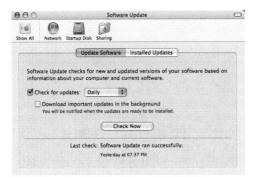

Figure 1.4 Click Check Now to make Software Update look for iPhoto updates.

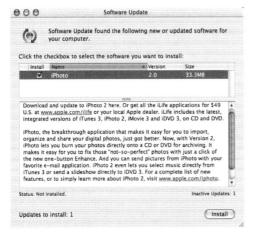

Figure 1.5 To install an update, click the checkbox next to its name, and then click the Install button.

Watching for Updates

I recommend setting Software Update to check for updates automatically. You can also visit Apple's iPhoto Web pages at www.apple.com/iphoto/ every so often for news about iPhoto or updates that might not have been released via Software Update. And of course, I will post any major news at this book's Web site at http://iphoto.tidbits.com/.

Updating iPhoto via Software Update

Although you can't get iPhoto 4 for free via Software Update, Apple will release minor revisions, such as to the current iPhoto 4.0.1, via Software Update.

To update iPhoto via Software Update:

- **1.** From the Apple menu, choose System Preferences.
- **2.** In the System collection of preference panes, click Software Update to display the Software Update pane (**Figure 1.4**).
- 3. To make Software Update find any iPhoto updates for downloading, make sure you're connected to the Internet, and then click the Check Now button. If Software Update finds any updates, it launches another application that displays updates that make sense for your Mac, including iPhoto if any exist (none do as of this writing).
- **4.** Click the checkbox next to the update you want to install (**Figure 1.5**).
- 5. Click the Install button, and when the installer prompts you for it, enter your administrator password.
 Software Update will proceed to download and install the update with no more input from you.

- To set Software Update to kick in on its own, select the Check for Updates checkbox, and from the pop-up menu choose how often you wish it to check.
- When Software Update fails to find updated software appropriate for your computer, it tells you none are available.

Updating from 2 to 4

In theory, updating from iPhoto 2 should be merely a matter of installing iPhoto 4 and letting it upgrade your iPhoto Library. However, a few simple actions can prevent future problems.

Tips when updating to iPhoto 4:

- ◆ Make sure to back up your iPhoto Library folder (located in your Pictures folder) before installing iPhoto 4. Then, if something bad happens or if you need to revert to iPhoto 2 for some reason I can't imagine, you won't lose all your photos. I'm sure you have a backup anyway, but another one can't hurt. If you were to need it, you can still download iPhoto 2.0 from http://docs.info.apple.com/ article.html?artnum=120188.
- ◆ If you have installed third-party export plug-ins (see the "Export Plug-Ins" sidebar on "Exporting to Web Pages" in Chapter 6, "Sharing Photos"), you may wish to remove them before updating. To find them, Control -click iPhoto's icon in the Finder, choose Show Package Contents, and navigate to the PlugIns folder. Drag any third-party plug-ins you previously installed to the Trash.
- If you want to be sure you get a clean installation, choose Find from the File menu and search for files whose name contains "iphoto". Move the com.apple. iPhoto.plist file, the iPhoto Cache folder, and of course, the iPhoto application to the Trash, but leave your iPhoto Library folder alone. Then install iPhoto 4.
- If you have trouble immediately after updating, delete the files in the previous tip, then reinstall iPhoto 4.

Changes from iPhoto 2 to iPhoto 4

iPhoto 4 came out at the very beginning of 2004; a year after iPhoto 2. iPhoto 4 offers a number of welcome enhancements that are covered throughout this book. Here are my favorite changes:

- Date-based and smart albums automatically organize your photos.
- You can assign ratings to your photos to identify your favorites easily.
- You can now display controls for deleting, rotating, and rating photos during slideshows.
- Slideshows now offer more transition effects, and you can assign an entire iTunes playlist to play during a slideshow, rather than just one song.
- Rendezvous-based photo sharing makes it possible for others on your network to see and copy your photos.
- Batch editing lets you give multiple photos the same name, comments, or date all at once.
- There's a new book theme, and several additional HomePage themes.
- You can now replace HomePage albums from within iPhoto.
- A Sepia button in edit mode lets you give your photos that old-time look.
- Books and prints ordered from Apple can now be sent to Japan and several European countries.

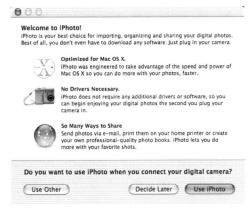

Figure 1.6 Select whether or not you want iPhoto to launch automatically when you connect your digital camera or insert a memory card into a card reader.

If iPhoto 4 Won't Launch

Some people who have upgraded to iPhoto 4 find that it won't launch after the upgrade. For some of these people, the problem seems to be corruption in three files in the iPhoto Library folder: Thumb32.data, Thumb64.data, and ThumbJPG.data. Move those three files to your Desktop from your iPhoto Library folder and launch iPhoto again. If it launches, rebuilds those files, and all is well, you can throw the copies on your Desktop away. If not, refer to Chapter 7, "Troubleshooting" for additional tips.

Launching iPhoto

Once you have installed iPhoto, the next step is to launch it. The first time you launch iPhoto differs from subsequent launches.

Ways to launch iPhoto:

- Double-click the iPhoto icon in your Applications folder.
- If iPhoto's icon already appears in your Dock, click the iPhoto icon.
- Drag the iPhoto icon to your Dock to add it to the Dock permanently, and then click the Dock's iPhoto icon.
- After you've launched iPhoto at least once, from the hierarchical Recent Items menu in the Apple menu, choose iPhoto.

iPhoto's initial launch

The first time iPhoto ever launches, it displays a dialog that welcomes you to iPhoto and gives you a choice of what should happen when you connect your digital camera to your Mac (**Figure 1.6**). The choice you make here sets your "Hot Plug Action."

Hot Plug choices:

- Click Use iPhoto to set iPhoto to launch automatically when you connect your camera.
- Click Use Other to leave your Hot Plug Action setting the way it is right now (probably set to launch Apple's Image Capture utility).
- Click Decide Later to have iPhoto ask you this question again on the next launch.

✓ Tip

 You can reset the Hot Plug Action setting in Apple's Image Capture application.

iPhoto's Modes

When you use iPhoto, you'll find yourself in one of four modes at all times. The rest of the book looks at these modes, focusing on the tasks you perform in each mode. Here's a quick summary of the modes.

Import mode

To add photos to your photo library, you import them, either from files or directly from a digital camera.

Organize mode

Once you have images in iPhoto, you'll want to organize them into albums, assign them keywords, and delete the lousy ones. All that and more happens in organize mode, where you'll probably spend the bulk of your time.

iPhoto's organize mode also provides tools for exporting photos, printing them, ordering high-quality prints online, printing books, running slideshows, creating Web pages, setting your screen saver and Desktop picture, emailing photos, and much more.

Edit mode

Even the best photographers edit their images. iPhoto provides a few simple image-editing tools so you can crop pictures, adjust brightness and contrast, enhance colors, remove red-eye, retouch unsightly blemishes, and make pictures black-and-white or sepia. If you need more advanced tools, iPhoto can work with another image editor.

Book mode

One of iPhoto's great strengths is the way it helps you design and print professional-looking hardcover photo albums. Book mode provides the tools you need to lay out these books and order copies from Apple for your friends and relatives.

Interface Overview

Before we dive into the specifics of using iPhoto in the upcoming chapters, let's take a bird's-eye view of the main window so you can orient yourself and get a feel for the program's primary functions (**Figure 1.7**).

I assume here that you already know about standard Mac OS X window widgets like the close, minimize, and zoom buttons, the scroll bars and scroll arrows, and the resize handle in the lower right. If not, let me recommend that you check out a copy of the *Robin Williams Mac OS X Book, Panther Edition*, also from Peachpit Press. It will help you with the basics of Mac OS X.

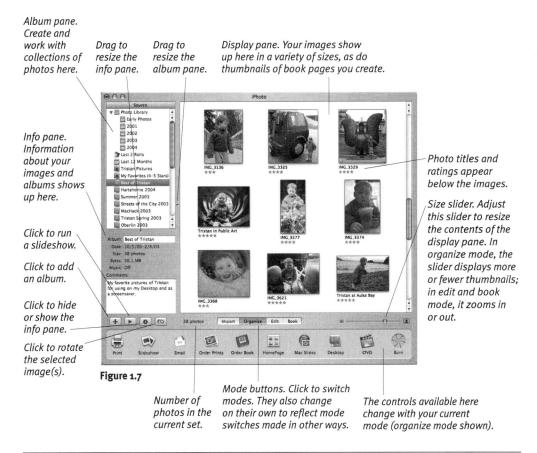

IMPORTING AND MANAGING PHOTOS

The first thing to do in iPhoto is import some photos. iPhoto provides a number of ways you can import photos, including the most obvious: from a digital camera. You can also import files that you downloaded from your camera previously, acquired on a CD, scanned in from prints, or received from a photo processing company that provides digital images along with traditional prints. It's also possible to use a card reader—a USB device into which you put the memory card from your camera and which presents the contents of your memory card as files on a disk—with the twist that iPhoto recognizes some card readers and can import from them just as though they were cameras. And lastly, you can copy photos that other iPhoto users make available to you on disc or over a network.

In this chapter, we'll look at all the ways you can import pictures into iPhoto and manage them afterward, including such tasks as trashing and recovering photos, making and switching between different iPhoto Library folders, backing up your images to CD or DVD, and learning exactly how iPhoto stores images on your hard disk.

Multitasking While Importing

Although it may not seem like it, you can work in other parts of iPhoto while it is importing images. Although this fact is worth keeping in mind, it's not always as much of a help as you might think, since you usually want to work with the images that are being imported.

Entering Import Mode

It's easy to bring your photos into iPhoto no matter where they may originate because iPhoto offers four different importing approaches, all of which switch you into import mode automatically. The only time you need to switch into import mode manually is if you switch modes after connecting a camera but before clicking the Import button to start the actual import.

Ways to enter import mode:

- Connect your digital camera to your Mac's USB port and turn the camera on. iPhoto need not be running; it launches automatically if necessary.
- Insert your camera's memory card into the card reader. iPhoto need not be running; it launches if necessary.
- From iPhoto's File menu, choose Import. iPhoto displays an Import Photos dialog from which you can select a file, a folder, or multiple items before clicking Open.
- From the Finder, drag and drop one or more files or an entire folder of images into the iPhoto window or onto the iPhoto icon in the Dock
- Click the Import button that's always present under the display pane (Figure 2.1).

✓ Tips

- iPhoto remembers the last set (or sets, if you wish) of images you imported in the Last Roll album in the album pane. Click it to see just those images (Figure 2.2).
- iPhoto tracks every import as a separate film roll. Film rolls are a useful automatic organization tool, but appear only in the Photo Library album (Figure 2.3).

Figure 2.1 To switch into import mode manually, click the Import button under the display pane.

Figure 2.2 To see the last set of images you imported, click the Last Roll album.

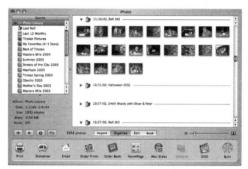

Figure 2.3 For best use of iPhoto's film rolls as an organizational device, shrink the thumbnail size using the size slider, then click the triangle next to film rolls you don't want to see to hide all the images inside.

Launching Automatically

iPhoto launches automatically only if you allow it to do so. The first time iPhoto runs, it asks if you want it to launch automatically from then on. If you say yes, iPhoto takes over for Image Capture as the application that launches when you connect a camera; see "iPhoto and Image Capture" in this chapter for more details.

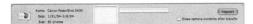

Figure 2.4 iPhoto launches and switches into import mode automatically when you connect your camera. It also identifies your camera and tells you how many images it contains and the dates they encompass. To start the import, click the Import button on the right side of the import pane.

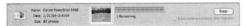

Figure 2.5 While iPhoto imports photos, it displays a thumbnail of the image being downloaded and displays a progress bar. To stop the process before it completes, click the Stop button.

Supporting More Cameras

Although iPhoto (via Mac OS X) supports a large number of cameras, some extremely inexpensive cameras still lack support from Apple. Luckily, a small firm of driver gurus has stepped up to the plate. To add support for many cameras with similar guts, download a copy of the Mac OS X Driver for USB Still Cameras from IOXperts at www.ioxperts.com/usbstillcamera.html. That page links to a full list of supported cameras.

Importing from a Camera

If you use a digital camera, it's easiest to import photos directly from the camera.

To import from a digital camera:

- **1.** Connect your camera to your Mac using the USB cable included with the camera.
- 2. Turn on the camera. Make sure the camera is set to view pictures.

 iPhoto automatically launches and switches into import mode (Figure 2.4).
- **3.** To have iPhoto erase the contents of your camera after importing the photos, click Erase Camera Contents After Transfer."
- 4. Click the Import button.

 iPhoto starts importing the photos, showing thumbnails and a progress bar. If you've made a mistake, click Stop to stop the import (Figure 2.5). When the import finishes, the photos appear in the display pane.

- To be safe, **never** select the Erase Camera Contents After Transfer checkbox.

 Instead, erase the card in your camera after verifying the import.
- If you want to import only selected photos into iPhoto, see "Importing Only Selected Photos" in this chapter.
- iPhoto warns you if you're about to import duplicate images and asks if you want duplicates or only new images.
- Some digital cameras can record movies or take photos in RAW (uncompressed) format, but iPhoto can't download them. (It won't delete them either.)
- Some cameras mount on your Desktop like a hard disk. Make sure to eject the camera volume before disconnecting it!

Importing from a Card Reader

Importing images via a memory card reader works almost exactly like importing from a digital camera.

To import from a card reader:

- **1.** Connect your card reader to your Mac using the card reader's USB cable.
- Insert your memory card.
 iPhoto automatically launches and
 switches into import mode (Figure 2.6).
- To have iPhoto erase your card after importing, click the Erase Camera Contents After Transfer checkbox.
- **4.** Click the Import button. iPhoto starts importing the photos, showing thumbnails and a progress bar. Click Stop to halt a mistaken import.
- 5. To remove the memory card from the card reader, click the Eject button in the Finder's sidebar (in Panther) or drag the card's disk icon to the Eject icon in the Dock (it replaces the Trash icon when you have a memory card or disk selected), and then eject the card from the card reader (Figure 2.7).

✓ Tips

- When using a card reader, you may be able to preview your pictures in the Finder's column view (**Figure 2.8**). You can also drag files from the card into iPhoto to import them manually.
- If you delete pictures from the memory card before importing into iPhoto, eject and reinsert the card before importing to avoid confusing iPhoto about the number of images to import.
- Never eject the card while importing!

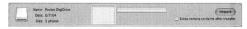

Figure 2.6 When you insert a memory card, iPhoto launches and switches into import mode. It also identifies your card reader and tells you how many images it currently contains. To start the import process, click the Import button.

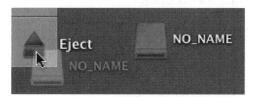

Figure 2.7 To remove a memory card from your card reader after importing, first drag the memory card's icon on the desktop to the Eject icon in the Dock, and only then eject the memory card from the card reader.

Figure 2.8 For a quick look at a photo on a memory card, make sure you're in column view (the rightmost of the View buttons), navigate to where the images are stored, and select one to see a preview.

PC Card Adapters

If you use a PowerBook with a PC Card slot, you can also buy an inexpensive PC Card adapter for your memory cards. Then, instead of mucking about with a bulky USB card reader, you can insert your memory card into the credit card-sized PC Card adapter, and then insert the PC Card adapter into the PowerBook to import the photos on the memory card.

Figure 2.9 The easiest way to import files into iPhoto is to drag the desired files or folders into the display pane or the album pane, as I've done here.

Figure 2.10 iPhoto proceeds to import the images, showing a thumbnail of the current photo and a progress bar of how many have been processed. If you need to stop the import, click the Stop button.

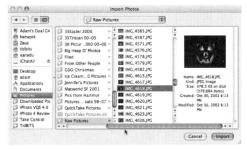

Figure 2.11 To import existing image files into iPhoto, choose Import from the File menu, navigate to your images, select the desired files, and click Import.

Supported File Formats

iPhoto can import images in any file format supported by Apple's QuickTime technology, including BMP, GIF, FlashPix, JPEG, MacPaint, PICT, PNG, Photoshop, SGI, Targa, and TIFF.

If you edit or rotate a GIF, iPhoto saves it as a JPEG, but Apple claims that all other file formats, as well as unedited GIFs, retain their file types when edited.

Importing from Files

If you used a digital camera before iPhoto came out, you probably have a collection of photos already on your hard disk. iPhoto can import these files in several ways.

Ways to import files into iPhoto:

- ◆ From the Finder, drag the desired files or folders into iPhoto's display pane or album pane (Figure 2.9). iPhoto starts importing the images. If you want to halt the import, click Stop (Figure 2.10). When the import finishes, the photos appear in the display pane.
- ◆ From the File menu, choose Import (Cmd(Shift(I)). In the Import Photos dialog, navigate to your images, select the desired file(s) or folder(s), and click Import (Figure 2.11).

- Hold down Shift or Cmd to select multiple files in the Import Photos dialog.
- iPhoto copies the files you import, so make sure you have enough hard disk space if you're importing a lot of images.
- If you drag a file or folder into the album pane, iPhoto imports the photos *and* creates an album. You can also drag photos directly into a specific album.
- iPhoto retains the EXIF camera information stored with images along with filenames you've given the images.
- If you import folders, iPhoto creates and names a new film roll for each folder.
- You can also drag photos in from some other image-cataloging programs.

Importing from a Kodak Photo CD or Picture CD

One way to get digital images from a film camera is to order a Kodak Photo CD or Picture CD (Photo CDs have higher resolution scanned images than Picture CDs) when you have your film developed. If you do that, you can import pictures from those CDs directly into iPhoto.

To import from a Photo/Picture CD:

- Insert the Photo or Picture CD into your Mac's optical drive.
 iPhoto should launch and switch into import mode automatically.
- **2.** Click the Import button (**Figure 2.12**). iPhoto starts importing the photos, showing thumbnails and a progress bar. Click Stop to halt a mistaken import.

- iPhoto imports images from Photo CDs at the highest resolution available on the disc (usually 3072 x 2048).
- You can't erase the contents of the CD after importing because Photo CDs and Picture CDs are read-only.
- You can also import files from Picture CDs manually by importing files from the Pictures folder on the disc. Don't try to import the entire disc or you'll end up with many unwanted files to delete.
- It's possible to copy files from Photo CDs for manual importing, but you can't see the necessary Photos folder on the disc in Mac OS X. You may be able to reboot into Mac OS 9, and then locate the folder inside the Photos folder corresponding to the resolution you want to import. Certain Mac OS X utilities may also be able to see the folder.

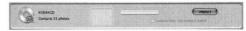

Figure 2.12 To import photos from a Kodak Photo CD or Picture CD, insert the disc and click the Import button.

Figure 2.13 iPhoto discs appear in your album pane with any albums on the disc showing up under the disc name.

Figure 2.14 The easiest way to import pictures from an iPhoto disc into iPhoto is to drag the desired photos into an album, as I've done here.

Keyword Wackiness

When you import from an iPhoto disc, iPhoto retains keywords attached to the photos on that disc. That's good (and it doesn't happen with iPhoto's network photo sharing). But what if the keyword from the disc doesn't exist in the iPhoto Library into which the import takes place? The unknown keyword still comes over, but you can't search for it or attach it to other photos until you create a new keyword with the same name.

Importing from an iPhoto Disc

iPhoto helps you protect your photo collection by making backup copies to CD or DVD (see "Backing Up Your Photos" later in this chapter). Should something go wrong with your main iPhoto Library, you can restore your photos from these backup discs.

Also, friends or relatives who use iPhoto might send you discs of their photos; although you can view their photos from the disc, if you want to edit a photo or create a book, you must first import the desired images. (See Chapter 6, "Sharing Photos.")

To import from an iPhoto disc:

- Insert the iPhoto disc into your Mac's optical drive and switch to iPhoto. iPhoto displays the disc in your album pane (Figure 2.13).
- 2. Select one or more photos, or entire albums, and drag them to your Photo Library album to import them just into the Photo Library, into an album to import them and add them to that album, or to the bottom of the album pane to import them and create a new album (Figure 2.14).

iPhoto starts importing the photos, showing thumbnails and a progress bar. Click Stop to halt a mistaken import.

- Importing from an iPhoto disc works almost exactly the same as copying photos from a shared photo album.
- iPhoto performs duplicate checking, just as with the other import methods.
- Dragging a disc's album to the bottom of the album pane copies the album to your iPhoto Library.

Importing Only Selected Photos

When you import photos from a camera, USB card reader, or Kodak Photo/Picture CD, iPhoto tries to import every photo. But since importing can be slow, at times you may want to import only a few photos.

Ways to import only selected photos:

- If you have imported from a camera or memory card once, and added photos, it's easy to import just the new ones. Import as you would normally but when iPhoto asks about importing duplicates, select the Applies to All Duplicates checkbox and click the No button (Figure 2.15).
- Use Image Capture to download selected images from your camera to your hard disk (Figure 2.16 and Figure 2.17), and then import those files by dragging them into iPhoto.
- If you're importing from a memory card reader, view the contents of the card in the Finder and drag just the desired images into iPhoto.

- Relying on iPhoto's duplicate checking capability to import only new images on a camera or memory card is slow because iPhoto looks at each photo in turn. If you want to import just a few selected photos quickly, choose one of the other methods.
- If you import a photo, delete it in iPhoto (but don't empty iPhoto's Trash), and then import again, iPhoto still sees the deleted image as a duplicate.
- If you want to see selective import in a future version of iPhoto, tell Apple via the Provide iPhoto Feedback command in the iPhoto menu.

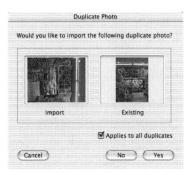

Figure 2.15 When iPhoto prompts about duplicates, tell it not to import duplicates. iPhoto will import only new images on the camera or card.

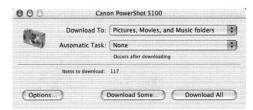

Figure 2.16 To download selected images in Image Capture, connect your camera or insert your memory card, open Image Capture, and click Download Some to see a thumbnail list of available images.

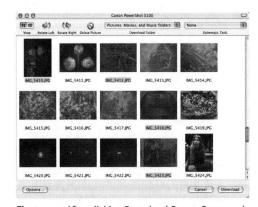

Figure 2.17 After clicking Download Some, Commandor Shift-click to select the desired images in Image Capture's thumbnail listing, and then click the Download button.

Figure 2.18 iPhoto uses a date-based directory structure that starts in your Pictures folder.

iPhoto Directory Structure

iPhoto creates its entire directory structure in the Pictures folder inside your user folder, starting with a folder called iPhoto Library. Inside it, iPhoto creates folders for each year (along with support files and folders—see below), inside each year folder are folders for months, inside those are folders for days, and only then do you get to the actual files (**Figure 2.18**).

Important support folders:

- The top-level Albums folder contains folders and data files for each of your albums. The specific album folders contain aliases to the original photos.
- The top-level Desktop, iDVD, and Screen Effects folders (when present) hold aliases to photos used for your Desktop picture, with iDVD slideshows, and for the screensaver.
- The Data folders contain files iPhoto uses to track images; they're unreadable.
- The Thumbs folders contain the tiny thumbnail images iPhoto displays in the display pane.
- The Originals folders contain the original image files as soon as you edit their corresponding photos (any edited photos you see in iPhoto are actually copies of the originals).

- Do **not** move, rename, or delete anything inside the iPhoto Library folder in the Finder because you'll risk confusing iPhoto and corrupting your library!
- If you need to locate a particular image in the Finder, use Apple's Show Image File AppleScript script, available from www.apple.com/applescript/iphoto/.

Deleting Photos

Many of the pictures any photographer takes are lousy, and you need to cull the ones of your spouse wearing a stupid expression. Believe me, you really do.

Ways to trash photos:

- ◆ In the Photo Library, Last Roll, or Last 12 Months album, select one or more photos (see "Selecting Photos" in Chapter 3, "Organizing Photos"), and press Delete.
- In the Photo Library, Last Roll, or Last 12 Months album, Control-click one or more photos and choose Move to Trash from the contextual menu that appears.
- While viewing a photo from the Photo Library, Last Roll, or Last 12 Months album in a slideshow or in edit mode in iPhoto's display pane, press Delete.
- From only the Photo Library album, drag one or more images to the Trash album.

To delete photos for good:

- **1.** Choose Empty Trash from the File menu. iPhoto asks if you really want to remove the pictures (**Figure 2.19**).
- **2.** Click OK to delete the photos.

✓ Tips

- Deleting a photo from a normal album you created does not delete the original image but removes it from that album.
- The only way to remove a photo from a smart album is to change the photo's criteria so the smart album doesn't see it.
- Dragging a photo to the Trash icon on the Dock puts the photo in iPhoto's Trash, not the Finder's Trash.
- Remember, backups are your friends!

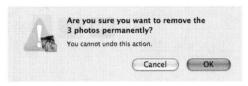

Figure 2.19 iPhoto checks to make sure you really want to delete photos from your hard disk before doing so.

The Best Way to Cull Photos

So you've just imported a bunch of photos and you want to get rid of the ones that are seriously fuzzy or are otherwise worthless. Here's my favorite method, which can be done entirely from the keyboard and shows each photo at full size, which is necessary when deciding which should bite the bit bucket. Follow these steps.

- 1. Select the first photo in the film roll you want to clean up, and then click the Slideshow button under the album pane to start a slideshow.
- **2.** Press the Spacebar to gain manual control over the slideshow.
- **3.** If necessary, rotate the image to the correct orientation with (CmdR) or (CmdQOption(R)).
- **4.** If you like it, press → (the right arrow key) to move on to the next photo.
- **5.** If you don't like it, press Delete to move it to the Trash and move on to the next photo automatically.
- **6.** Repeat steps 3 through 5 as necessary.

If you like to do quick edits during this first pass, you can use these same keys in edit mode.

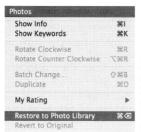

Figure 2.20 To
remove photos from
the Trash, select them
and choose Restore
to Photo Library from
the Photos menu.

Use Your Trash!

I strongly recommend that you make full use of iPhoto's Trash and don't feel the need to empty it frequently. The whole point of having a Trash is to save you from mistakes, and you never know if you'll realize a mistake right away. Instead, let photos sit in the Trash for a while before deleting them for good. Or wait until you feel like you need the disk space they take up before deleting them.

Recovering Photos

iPhoto sports a special Trash album that holds all your deleted photos, just like the Finder's Trash. And like the Finder's Trash, you can pull mistakenly deleted photos out.

Ways to recover photos:

- Select one or more photos in the Trash album and choose Restore to Photo Library (Cmd Delete) from the Photos menu (Figure 2.20).
- Select one or more photos in the Trash album, Control-click the selection, and choose Restore to Photo Library from the contextual menu that appears.
- Drag one or more photos from the Trash album into the Photo Library album or to the bottom of the album pane.

- You can't edit photos stored in the Trash, nor can you create a book using the Trash album. Well, duh!
- You can't drag a photo from the Trash album into another album without first restoring it to the Photo Library.
- iPhoto doesn't move the actual image files when you put them in the Trash; it merely tracks which ones are in the Trash album. Only when you empty the Trash are the actual files deleted.

Creating Multiple iPhoto Library Folders

Although there's no outward indication of this, iPhoto lets you create and maintain multiple iPhoto Library folders.

Reasons to create multiple iPhoto Library folders:

- You might want to keep two different types of photos completely separate, such as personal snapshots and location shots for your real estate business.
- You might want different iPhoto Library folders for different purposes. For instance, I have a special iPhoto Library folder that holds just a few images that I use when giving presentations.
- You might want an iPhoto Library for miscellaneous photos sent to you by other people that you don't want cluttering your main collection.

To create iPhoto Library folders:

- 1. Quit iPhoto.
- **2.** In the Finder, rename your iPhoto Library folder (just add a word to the end of the name) or move it to another folder.
- **3.** Launch iPhoto, and when prompted, click Create Library to create a new iPhoto Library folder (**Figure 2.21**).

✓ Tips

- If you want a second iPhoto Library folder to contain all your photos to start with, select the original iPhoto Library folder in the Finder and choose Duplicate ((Cmd(D)) from the Finder's File menu.
- You can also create new libraries using the free iPhoto Library Manager (see sidebar) from http://homepage.mac.com/bwebster/iphotolibrarymanager.html.

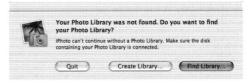

Figure 2.21 Let iPhoto create a new iPhoto Library folder for you by renaming or moving your existing one, and then clicking Create Library when next launching iPhoto.

Using iPhoto Library Manager

You can do a number of things in Brian Webster's free iPhoto Library Manager (**Figure 2.23**, opposite). Read its online help for more details.

- To create a new iPhoto Library folder, click New Library and name the new iPhoto Library folder.
- To add an existing iPhoto Library folder, either drag it into iPhoto Library Manager or click Add Library and locate it in the Open dialog.
- To remove an iPhoto Library folder from the list, click Remove Library. This does not delete the iPhoto Library folder.
- Select the checkbox next to an iPhoto Library folder and click the Launch iPhoto (or Relaunch iPhoto, if it's already running) button to make iPhoto use that folder.
- Use the permissions pop-up menus to allow another user access to a shared iPhoto Library folder that's stored in a location both users can see, like the Shared folder in the Users folder. The checkboxes for applying permissions at launch and quit are also essential.
- To quit iPhoto from within iPhoto Library Manager, click Quit iPhoto.

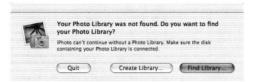

Figure 2.22 After renaming or moving your current iPhoto Library folder, you can switch between iPhoto Library folders by clicking Find Library and locating your desired iPhoto Library folder.

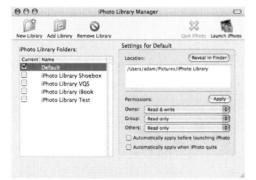

Figure 2.23 Use iPhoto Library Manager to switch among multiple iPhoto Library folders.

Late, Lamented Shortcut

iPhoto 2 supported a truly cool shortcut that was the easiest way to switch among multiple iPhoto Library folders. All you had to do was hold down <code>Cmd(Option)</code> and drag an iPhoto Library folder to iPhoto's Dock icon to switch to using that folder. It's actually a system-wide shortcut that makes an application attempt to open any item dragged to it, which makes the fact that this shortcut no longer works in iPhoto 4 all the more inscrutable. Perhaps this is a short-lived bug that Apple will fix in a minor revision; if so, you've been alerted to the potential existence of the shortcut.

Switching between iPhoto Library Folders

So you now have two (or more) iPhoto Library folders. How do you switch between them?

Ways to switch between iPhoto Library folders:

- With iPhoto not running, manually rename or move your main iPhoto Library folder, then rename or move the desired iPhoto Library folder so it's called just "iPhoto Library" and is located in your Pictures folder.
- When iPhoto is not running, rename or move the iPhoto Library folder, launch iPhoto again, and when iPhoto asks you, click Find Library and locate the desired iPhoto Library folder (Figure 2.22).
- Use the free iPhoto Library Manager from http://homepage.mac.com/ bwebster/iphotolibrarymanager.html (Figure 2.23). See the "Using iPhoto Library Manager" sidebar, opposite.
- ◆ Use one of the other free iPhoto Library management programs, such as iPhoto Librarian (http://www.scruffyware.com/products/iPhotoLibrarian.html), iPhoto Override (http://homepage.mac.com/dr_turgeon/Developing/Personal31.html), or iPhoto Buddy (www.nofences.net/iphotoBuddy/). I prefer iPhoto Library Manager.

✓ Tip

■ I've seen iPhoto become confused if you use iPhoto Library Manager in conjunction with one of the manual approaches. If iPhoto becomes confused, use the second method above, and once you've cleared the problem, try iPhoto Library Manager again.

Backing Up Your Photos

The most important thing you can do when managing your photos is to make a backup.

To back up photos:

- Select the photos you want to back up, best done by selecting entire film rolls or entire albums.
- 2. Click the Burn button, insert a blank disc if prompted, and click OK (Figure 2.24). In the info pane, iPhoto shows the name of the disc and information about how much data will be burned to the disc (Figure 2.25). The disc icon will be red if it can't hold the selected photos.
- **3.** Select fewer or more photos to use the space on your destination disc as desired.
- 4. Change the name of the disc if you want.
- 5. When everything looks right, click the Burn button again to start the burn, and when iPhoto asks you to confirm one last time and lets you set additional burning options, click Burn (Figure 2.26). iPhoto creates a disk image, copies the selected photos to it, and burns the disc.

- Until you click the Burn button the first time, the statistics in the info pane aren't accurate, since the disc must contain more than just the actual photos.
- If you select albums to burn, the backup disc will retain those album references. Film roll information is lost, however.
- Titles and keywords are maintained.
- On the disc, your photos are stored in an iPhoto Library folder like the main one.
- iPhoto 4.0.1 properly burns Originals folders to disc, unlike iPhoto 4.

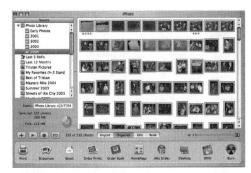

Figure 2.24 Select an album or a set of photos and click the Burn button.

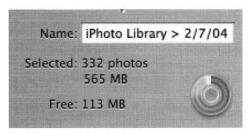

Figure 2.25 Once you've clicked the Burn button, the info pane lets you name your disc and gives you information about how much data will be burned to it.

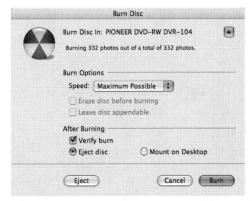

Figure 2.26 iPhoto verifies that you really want to burn a disc with one last dialog that also provides additional burn options if you click the button in the upper-right corner (see the "Burn Options" sidebar, opposite, for more information).

Other Backup Options

What if you don't have a writable optical drive or don't want to end up with your photos existing only in an iPhoto Library? You have a few other options.

Other backup options:

- Copy your iPhoto Library (remember that it's in your Pictures folder) to an external hard disk.
- ◆ Use a dedicated backup program, such as Dantz Development's Retrospect (www.dantz.com), to back up your iPhoto Library folder (and while you're at it, I recommend backing up your Home folder, or even your entire Mac).
- Export photos to folders in the Finder, then manually burn them to CD or DVD to back them up with your desired organizational approach. It's more work, but you get exactly what you want at the end.

✓ Tips

- No matter which backup method you choose, I recommend having more than one backup copy and storing one of them off-site. That way, should your house or office burn down or be burglarized, your backup would remain safe.
- To reduce media usage (though CD-R discs are awfully cheap), buy the more expensive CD-RW discs and erase them in the Finder between uses.
- Don't use CD-RW for true archiving, since anything that can be easily erased is a lousy permanent medium.
- Don't assume that any backup media will last forever. Every so often, check to make sure your backups are readable, and it wouldn't hurt to recopy them every few years, just to be safe.

Burn Options

I always recommend that you select Verify Burn for safety; if you have trouble burning, try reducing the burn speed.

The options for erasing media and leaving a disc appendable apply only to rewritable media like CD-RW discs.

The choice of ejecting the disc after burning or mounting it on the Desktop is minor, though I recommend a quick visual inspection of the contents of the disc in iPhoto after burning, just to be safe.

True Archiving

If you want to archive photos, that is, burn them to disc and then remove them from your hard disk, I recommend the following.

- Make at least two copies and store one off-site, like at a friend's house.
- Work methodically by making albums from film rolls to retain organization and by selecting everything in order.

Merging iPhoto Library Folders

If you have two Macs, you may want to merge the contents of two iPhoto Library folders, one from each computer.

To merge iPhoto Library folders (I):

- 1. Network your Macs via AirPort, Ethernet, or even FireWire (using IP over FireWire in Mac OS X 10.3; enable it in the Network preference pane).
- 2. On both Macs, turn on photo sharing in iPhoto's Preferences window (Figure 2.27). For more information, see "Network Photo Sharing" in Chapter 6, "Sharing Photos."
- **3.** Drag the desired photos or albums from the source Mac's shared album to the Photo Library of the destination Mac.

To merge iPhoto Library folders (II):

◆ If one of your Macs has a writable optical drive (CD-R, CD-RW, or DVD-R), burn a disc containing all the photos you want to transfer from the source iPhoto Library folder. Then import them into the destination iPhoto Library folder as explained in "Importing from an iPhoto Disc" earlier in this chapter.

To merge iPhoto Library folders (III):

- From the source iPhoto Library, export the desired images by album or film roll into folders (see "Exporting Files" in Chapter 6, "Sharing Photos").
- **2.** Copy those folders to the Mac with the destination iPhoto Library folder via a network or FireWire Target Disk Mode.
- **3.** Drag the folders into iPhoto to import their photos (see "Importing from Files" earlier in this chapter).

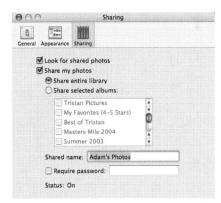

Figure 2.27 To turn on photo sharing, select Look for Shared Photos and Share My Photos in the Sharing tab of iPhoto's Preferences window.

- Keywords are retained only on iPhoto discs, so if you have spent a lot of time keywording your photos, choose that method.
- If you're burning to disc, use CD-RW media if you want to reuse that disc; use CD-R media if you want a backup.
- When exporting via the third method, I recommend using the photo title as the filename or else you'll lose any work you put in titling your photos.

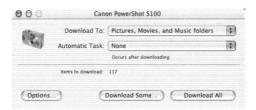

Figure 2.28 Use Image Capture if you want to download photos to a folder in the Finder, rather than straight into iPhoto.

Figure 2.29 To download only some images, click Download Some in the main Image Capture window, select the images to download, and then click the Download button.

Figure 2.30 Image Capture has some options that may be useful; access them by clicking the Options button.

iPhoto and Image Capture

Before Apple released iPhoto, the way you transferred images from a digital camera to a Mac running Mac OS X was with an included utility called Image Capture (found in your Applications folder). Image Capture is still useful for downloading selected images from your camera, and it can also download movies from your camera.

Image Capture functions:

- Using Image Capture, you can download photos to any folder. Select one in the Download To menu, and then click the Download All button (Figure 2.28).
- You can also download only selected images in Image Capture. Click the Download Some button in Image Capture's main window, select the images to download, and click the Download button (Figure 2.29).
- Although Image Capture offers some options for making a Web page from the images you download and formatting them to different sizes, it's easier and more reliable to do this in iPhoto.
- ◆ If you want to download images using Image Capture, and then import them into iPhoto, it might be easiest to set the "When a Camera Is Connected, Open" pop-up menu in Image Capture's Preferences window to launch Image Capture, rather than iPhoto.
- ◆ To adjust Image Capture's options, click the Options button in Image Capture's main window. In particular, make sure it doesn't delete after downloading so iPhoto can download the images as well. It might also be useful to have Image Capture set your camera's date and time (Figure 2.30).

3

ORGANIZING PHOTOS

There are two types of people when it comes to photos. First are the Martha Stewart types who manage to organize every picture into precious handmade albums constructed of used tissues and old grocery bags. Then there are the rest of us, who dump our pictures in a box, and that's if we remember to develop the film in the first place. We in the second group hate those in the first group (though we're sure you're actually very nice people).

For me, the promise of digital photography was a way not just to join that first group, but to beat them at their own game. I'm constitutionally incapable of cutting a print to crop it, and my miserable handwriting makes captions painful. I figured I could do it all on the computer with no trouble and make prints to boot. Unfortunately, it was just too hard—until iPhoto.

iPhoto's editing tools are covered in a future chapter, so here we're going to focus on iPhoto's organizational features. Some require a little effort, but even with no work, your digital photo collection will be far better organized than the box in the attic.

And if you're one of those people who put together handmade photo albums before digital photography, well, you're still going to love what iPhoto can do for you.

Entering Organize Mode

For the most part, iPhoto makes sure you're in organize mode whenever necessary, but unlike with import mode, it can't do so automatically quite all the time.

Realistically, I don't expect you to do much more than click the Organize button when you want to switch into organize mode, but knowing the other methods may either prove useful as you become familiar with iPhoto or will at least explain why certain actions don't switch you into organize mode.

Ways to enter organize mode:

- Click the Organize button under the display pane (Figure 3.1). iPhoto switches to organize mode and displays thumbnails of your photos in the display pane.
- When you're in edit mode, but are not using the Retouch tool, double-click the picture to switch back to organize mode.
- When you're in any other mode, click the Photo Library, Last Roll, or Last Months albums in the album pane. One caveat—if the album you click is already selected, clicking it again won't switch you to organize mode.
- When you're in import or edit mode (but not book mode), click any album other than the one you're using to switch to organize mode.

Figure 3.1 To switch into organize mode at any time, click the Organize button.

Organize Tools Overview

iPhoto's interface changes depending on what mode you're in, and some tools even offer different functions depending on mode. Here's a quick reference to the tools available in organize mode (**Figure 3.2**). For details about all the buttons in the organize mode's tools pane, see Chapter 6, "Sharing Photos."

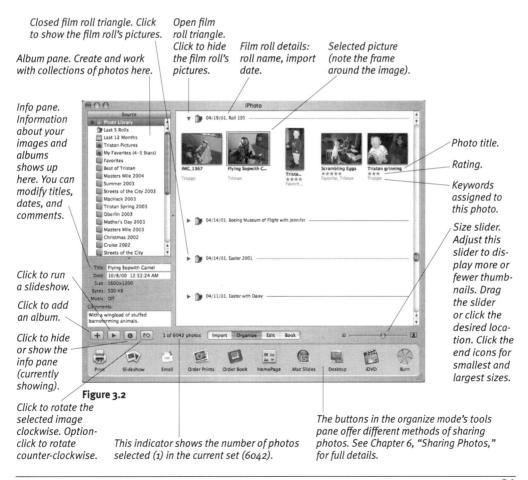

Changing the Display Pane's Layout

One of iPhoto's slickest features is the slider that enables you to change the size of the thumbnails in the display pane, but you can do other things to change the way the display pane looks.

To change the display pane layout:

- Move the size slider (or click in the desired location) under the right side of the display pane to adjust the size of the thumbnails from a single image (which automatically hides titles and keywords) at the largest (Figure 3.3) all the way down to as many photos as fit in the window at postage stamp size (Figure 3.4).
- To show or hide titles, ratings, keywords, and film rolls (Figure 3.5) (film rolls only when in the Photo Library album), select the desired item from the View menu.

- To increase the size of the display pane, you can shrink or even close the album pane by dragging its handle to the left. Open it by dragging back to the right.
- Viewing titles in the display pane isn't useful when you use smaller thumbnail sizes, but remember that you can see the selected photo's title in the info pane.
- Film roll separators help show where you are in the Photo Library, so I recommend leaving them showing and giving them names. Option-click a film roll expansion triangle to hide or show all film rolls.
- Play with different settings for the size slider to find a setting that fits your monitor size and working style.

Figure 3.3 Move the size slider all the way to the right to view a single image at a time in organize mode.

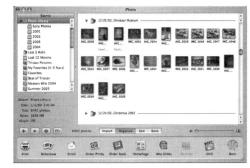

Figure 3.4 Move the size slider all the way to the left to view as many thumbnails as possible.

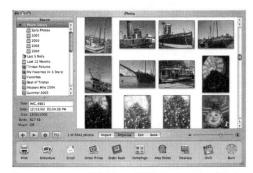

Figure 3.5 Turn off display of titles, ratings, keywords, and film rolls in the View menu for an uncluttered look.

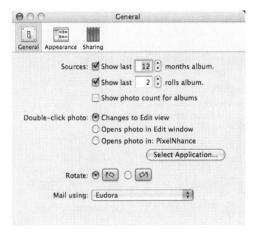

Figure 3.6 Use the Sources settings in iPhoto's General preferences tab to control the Last Months and Last Rolls albums, and the display of the photo count next to album names.

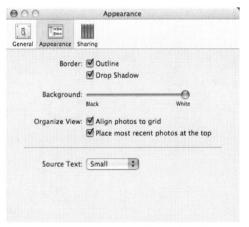

Figure 3.7 The Appearance tab of iPhoto's Preferences window provides settings that control how iPhoto draws and sorts photos, and the size of album name text.

Other Display Preferences

You can also set options in iPhoto's Preferences window that affect how the display pane looks.

From the iPhoto application menu, choose Preferences (Cmd,) to open the Preferences window; you can find display preferences in both the General and Appearance tabs (Figure 3.6 and Figure 3.7).

Display preferences you can change:

- In the General tab, use the Sources controls to manage which of the Last... albums appear, and how many months or rolls they contain.
- Select Show Photo Count for Albums to append the number of photos in each album after its name in the album pane.
- In the Appearance tab, select Outline and/or Drop Shadow border styles, and use the Background slider to change the darkness of the background.
- To align all your photos to a regular grid in which the width of the widest picture sets the width for all photos, check the Align Photos to Grid checkbox.
- Use the "Place Most Recent Photos at the Top" checkbox to control how your photos sort by date.
- If you have many albums, set Source Text to Small so you can see more at once.

- I've seen iPhoto 4 (but not 4.0.1 yet) become confused and display the oldest photos at the top incorrectly. Fix it by toggling that setting off and on again.
- I work with the most recent photos at the top, except when I do slideshows, since then the photos display in reverse order.

Contextual Menu Shortcuts

As you'll find out in this chapter, iPhoto isn't great about letting you edit information about a photo—title, date, and keywords—directly "on" the photo. Instead, you must select the photo and then make your changes in the info pane or the Keywords window. However, you can Control-click (or, if you have a two-button mouse, right-click) a photo to bring up a contextual menu that lets you perform a number of actions directly on the photo you clicked (Figure 3.8).

Contextual menu shortcuts:

- You can cut, copy, or paste photos, but only within iPhoto. Cutting a photo removes it from the current album and pasting a photo adds it to the current album (other than the Photo Library in both cases).
- ◆ The Edit commands are useful for opening multiple selected photos in separate windows simultaneously, and for opening the occasional photo in an external editor without switching iPhoto's preferences.
- All the rest of the commands—Rotate, Show Info, Batch Change, Duplicate, My Rating, Remove from Album, and Revert to Original—are the same as those in iPhoto's Photos menu, but using the contextual menu to apply them may feel more intuitive.

✓ Tip

Although you can't copy a photo from iPhoto and paste it into another application, you can often drag photos from iPhoto to other applications.

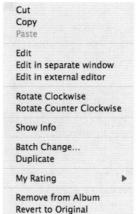

Figure 3.8 Controlclick one or more selected photos to display iPhoto's contextual menu shortcuts.

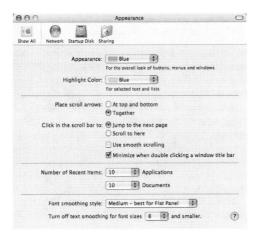

Figure 3.9 You can change Mac OS X's scrolling behavior in the Appearance preference pane.

Wacky Scrolling

If you have a photo selected (which is likely much of the time), scroll to locate another photo, and then adjust the size slider, iPhoto immediately scrolls you back to the selected image. Annoying, eh? (Actually, I consider it a bug, and I hope Apple fixes it in a future version of iPhoto.)

Here's the workaround. Before you adjust the size slider to change the size of thumbnails, first click a photo to select it. Then, when you change the thumbnail size, the display pane won't jump around seemingly randomly.

Moving Around in iPhoto

Obviously, you can move around in iPhoto using the scroll bars, but knowing a few tricks and techniques can make navigating through your photos easier.

Ways to move around:

- Click or drag the scroll bar, just as you would in any other Mac application.
- Option-click the scroll bar to jump to the particular spot you clicked.
- Click a photo to make sure the display pane is active, then use the arrow keys to move around.
- ◆ With the display pane active, use Page Up and Page Down to scroll through your photos, one screen at a time.
- With the display pane active, use Home and End to move to the top and bottom of the current album.

- The Option-clicking behavior actually applies to Mac OS X in general, and you can make it the default behavior by selecting the Scroll to Here radio button in Mac OS X's Appearance preference pane (Figure 3.9). I find the Scroll to Here setting disconcerting, since it's counter to the way I've used scroll bars on the Mac forever.
- If you're having trouble scrolling to a desired location, it might help to reduce the thumbnail size so you can see many more thumbnails on the screen at once.
- Hold down Option when scrolling to scroll smoothly. This feature may not help many people, but it made arranging the iPhoto window to take nicely aligned screen shots a lot easier for me while I was writing this book.

Editing Film Rolls

You can change the titles and dates of film rolls in the Photo Library. This capability proves to be extremely useful, since film rolls with a title are much easier to identify, and by changing the film roll's date, you control where it appears in the Photo Library when it's sorted by Film Roll.

To change the title of a film roll:

- 1. Make sure you're in the Photo Library with film rolls and the info pane showing, and then click a film roll in the display pane to select it.
- In the info pane, enter a new title for the film roll in the Title field (Figure 3.10). iPhoto changes the title of the film roll in the display pane to match.

To change the date of a film roll:

- 1. Make sure you're in the Photo Library with film rolls and the info pane showing, and then click a film roll in the display pane to select it.
- 2. In the info pane, enter a new date for the film roll in the Date field (**Figure 3.10**). iPhoto changes the date of the film roll in the display pane and re-sorts the film rolls to put the one you edited in the proper order.

- Although iPhoto recognizes a large number of date formats, it ignores improperly formatted dates when you're typing them manually, so to avoid confusion, it's easiest to edit the date using the same date format iPhoto uses.
- After you change the date of a film roll, iPhoto sorts it according to the new date, so it will probably move to a new location in the display pane.

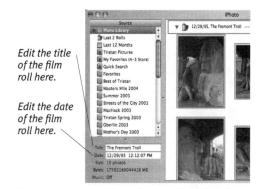

Figure 3.10 Use the Title and Date fields in the info pane to change the title and date of the selected film roll in the Photo Library.

Figure 3.11 Select some photos, then choose New Film Roll from Selection from the File menu.

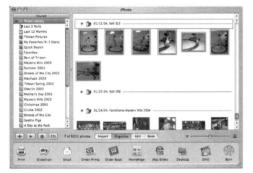

Figure 3.12 iPhoto creates a new film roll using the selected photos and organizes it according to the dates of the photos.

Creating New Film Rolls

Whenever you import photos into iPhoto, it creates a film roll to hold them, and in previous versions of iPhoto, that was that. In iPhoto 4, though, you can create new film rolls.

To create a film roll:

- **1.** In the Photo Library, select one or more photos (**Figure 3.11**).
- **2.** From the File menu, choose New Film Roll from Selection. iPhoto creates a new film roll using the selected photos (**Figure 3.12**).

- Creating new film rolls is a great way to break up a too-large import into groups of related photos.
- By default, the new film roll picks up the dates of the photos you've added to it, which may mean that it sorts higher or lower in your Photo Library than you expect.
- If you have iPhoto set to display the most recent photos at the top, creating a new film roll in this way has the effect of reversing that setting. Apple fixed this bug in iPhoto 4.0.1, so be sure to upgrade.

Moving Photos between Film Rolls

Not only does iPhoto 4 enable you to create new film rolls, you can move photos between film rolls as well.

To move photos between film rolls:

 Select one or more photos and drag them on top of another film roll.
 iPhoto moves the photos to the destination film roll (Figure 3.13).

- You must drop the selected photos on the film roll's name, which highlights as your pointer moves over it. Dropping the photos inside the film roll's contents won't work.
- Although you might think otherwise, you can't use the Edit menu's Cut or Copy command with the Paste command to move photos between film rolls.
- If you have iPhoto set to display the most recent photos at the top, moving photos between film rolls has the effect of reversing that setting. Apple fixed this bug in iPhoto 4.0.1, so be sure to upgrade.

Figure 3.13 Drag photos from one film roll to the name of another to move them.

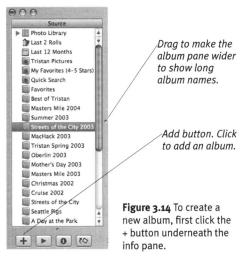

Figure 3.15 Next, name the album in the dialog iPhoto presents, and click OK.

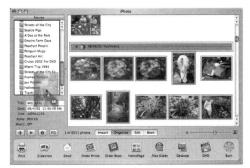

Figure 3.16 When you drag photos into the album pane to create a new album containing them, notice how the album pane gets a thick black border and your pointer changes from a plain arrow to one with a + badge. iPhoto also tells you, via a number in a red circle, how many images you're dragging. If the album pane is full (so you see its scroll bar), you must drag to a point just above or just below the Trash album, as I've done here. Look for the thick black border around the entire album pane; dragging to any other spot will put the photos in an existing album.

Creating Albums

Most of us categorize our photos in our heads—these were from the trip to Hawaii, those were from Grandma's 80th birthday party, and iPhoto provides "albums" to help organize images and for working with books, as we'll see in Chapter 5, "Creating Books."

To create an album (I):

- Click the Add button (+) below the info pane (Figure 3.14) or choose New Album (CmdN) from the File menu. iPhoto displays a dialog for you to name your album (Figure 3.15).
- **2.** Enter a name for the new album and click OK to add it to the list in the album pane.

Other ways to create an album:

- Drag one or more photos, or an entire film roll, into the album pane, but *not* onto any existing album (Figure 3.16).
- Drag one or more photos, or a folder of photos from the Finder into the album pane, but *not* onto any existing album.
- ◆ Select some photos and choose New Album from Selection (Cmd(Shiff(N)) from the File menu.

- When the album pane is full, the only way to drag to an "empty" spot is to drag just above or below the Trash album.
- Use albums for categories of pictures that appear once in your photo collection. In contrast, use keywords for categories that recur throughout your collection. Albums work well for a specific trip's photos; keywords work better for identifying pictures of your family members, landscapes, or recurring events.

Creating and Editing Smart Albums

New in iPhoto 4 is a major organizational feature: smart albums. Unlike normal albums, which you must maintain manually, smart albums use a set of rules that you create to maintain their contents automatically.

To create a smart album:

- 1. Either Option-click the Add button (+) below the info pane or choose New Smart Album (Cmd Option N) from the File menu.
 - iPhoto displays a dialog for you to name and configure your album (**Figure 3.17**).
- **2.** Enter a name for the new album.
- **3.** From the first pop-up menu, choose a criterion that photos must match to be included (**Figure 3.18**).
- **4.** From the second pop-up menu, choose how that criterion should be evaluated (**Figure 3.19**).
- **5.** Enter a condition against which the criterion is to be evaluated (**Figure 3.20**).
- **6.** If you want your smart album to have multiple criteria, click the + button and repeat steps 3 through 5.
- 7. When you're done, click OK. iPhoto looks at all your photos and adds those that match to the smart album.

To edit a smart album:

- **1.** Control-click an album and choose Edit from the contextual menu that appears.
- **2.** Follow steps 2 through 7 above to make changes to the smart album's name or configuration.

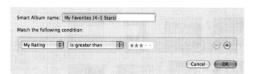

Figure 3.17 Name and configure your smart album in the dialog that appears after choosing New Smart Album from the File menu.

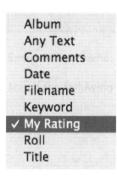

Figure 3.18 Smart albums can match photos based on numerous criteria, shown here. In this case, I'm looking for photos with a specific rating.

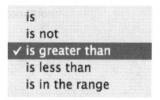

Figure 3.19 Once you've chosen a criterion, you must determine how it should be evaluated. The second pop-up menu changes dynamically to match the selected criterion. Here, since I'm matching on rating, and I'd like the smart album to find only photos with 4 or 5 stars, I've selected "is greater than".

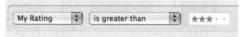

Figure 3.20 Lastly, enter the condition against which your criterion will be evaluated. To finish the smart album that matches my 4- or 5-star photos, I've clicked the field to select 3 stars. Read as a whole, my rule says, "Select all photos whose rating is greater than 3 stars."

Use Smart

Albums to Search for Text

In iPhoto 2, the Keywords window also provided a field that enabled you to search for any bit of text in a photo's metadata—titles, comments, and keywords. Apple removed that feature in iPhoto 4, perhaps because it was extremely clumsy to use. So how do you search for text in iPhoto 4? Smart albums.

Whenever you want to perform a search, create a new smart album with the Any Text criterion matching the text you want to find. All the photos that match your search appear in the smart album, and you can work with them as you would photos in any other album.

Since there's a keyboard shortcut for New Smart Album (Cmd Option N) but not for Edit Smart Album, it's probably easier to create and delete the smart album (rather than edit an existing one) each time you want to search for text.

Perhaps Apple will add an iTunes-like search field to a future version of iPhoto.

Smart Album Ideas

It may be hard to think about the types of smart albums you can create, so use these ideas to get started.

Smart album ideas:

- By matching on ratings, you can easily create a Favorites smart album that contains just your top-rated photos.
- Clever use of multiple date range matches will help you make a smart album that contains the photos from all your vacations.
- My camera always names photos IMG_0000.JPG, so by creating a smart album that looks for photos whose filenames don't include "IMG", I can separate many photos sent to me by other people with different cameras.
- If you're consistent about how you assign keywords, you can use smart albums to select sets of keywords more easily than working through the Keywords window, whose selections are fleeting.
- To create an album that contains all the photos of a certain person, use the Any Text criterion matching that person's name. It won't be perfect, but if you give your photos descriptive titles or comments, it's a good start.

- You can't remove photos from a smart album manually; the only way to take them out is to change either the photo or the criteria so they no longer match.
- You can create books using smart albums, but be careful, since adding new photos could change your books in unexpected ways.

Duplicating Albums

Another way to create a new album—either normal or smart—is to duplicate an existing one. Duplicating is useful for creating different versions of the same album quickly and easily.

Ways to duplicate an album:

- Control-click an album and choose Duplicate from the contextual menu that appears (Figure 3.21).
- Select an album, and then choose Duplicate from the Photos menu (Cmd(D)).

iPhoto duplicates the album, appending "-1" to its name (**Figure 3.22**).

Reasons to duplicate an album:

- ◆ If you're making picture books for two sets of grandparents or portfolio books for different clients, for instance, you might want to use the same (or a very similar set of) photos with different text. Rather than create one book, order it, and change the text for the second one, it's easier to make two albums. I recommend duplicating the book's album after you've laid out one book to minimize the effort of arranging photos in the second one.
- If you want two different slideshows to contain the same images, but to show them in a different order, duplicating an album is easier than creating another album from scratch.
- If you've constructed a complex smart album and want to make another that's only slightly different, duplicating the first one and modifying the duplicate is efficient.

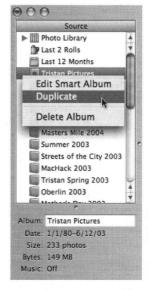

Figure 3.21 To duplicate an album Control-click it and choose Duplicate from the contextual menu.

Figure 3.22 iPhoto appends a number to the name of the duplicate album.

Figure 3.23 To rename an album (such as one you just duplicated), double-click the album name and edit it, or select it and edit the name in the Album field in the info pane.

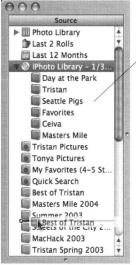

Albums in an iPhoto disc show up hierarchically.

Figure 3.24 To move an album in the list, drag its name to the desired location.

Renaming and Rearranging Albums

You'll undoubtedly want to rename albums to give them descriptive names. Plus, since iPhoto initially lists albums in the order you created them, you'll probably want to move them around in the list.

Ways to rename an album:

- Double-click the album's name, and then edit the name (Figure 3.23).
- Select an album, and then edit its name in the Album field in the info pane (Figure 3.23).

To rearrange the album list:

 Drag an album to the desired location in the album list. Note the black bar that indicates where the album will appear when you drop it (Figure 3.24).

- Smart albums always sort to the top of the album pane; you can rearrange smart albums within their group, but you can't interleave them with normal albums.
- Although albums stored on an iPhoto disc show up hierarchically under that disc's name (as in Figure 3.24), there's no way to have hierarchical albums normally. Complain to Apple.
- You can enter comments about the album in the Comments field of the info pane (showing in **Figure 3.23**), but any comments are purely for your own use; they aren't used elsewhere in iPhoto.
- You can use iPhoto's spelling tools while editing album names. See "Checking Spelling" in Chapter 5, "Creating Books."
- You can Cmd-click or Shift-click to select and move multiple albums at once.

Deleting Albums

Albums are easy to create, and luckily, if you decide you don't want one cluttering your list of albums, they're even easier to delete.

Ways to delete an album:

- Control-click an album and choose Delete Album from the contextual menu that appears (Figure 3.25).

iPhoto prompts you to make sure you know what you're doing; click Remove to delete the album (**Figure 3.26**).

- Remember that deleting an album doesn't affect the original photos in the Photo Library since the album merely contains pointers to the originals.
- Don't feel that albums must be created carefully and then kept forever. It's totally reasonable to group a bunch of photos in an album, work on them for a little while, and then delete the album. I do that often to avoid scrolling around my entire Photo Library.

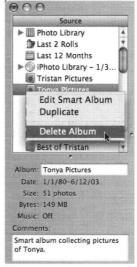

Figure 3.25 You can Control-click an album and choose Delete Album to delete it, though that's harder than just pressing Delete.

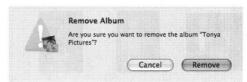

Figure 3.26 iPhoto prompts to make sure you really want to delete the album. Click Remove if you do.

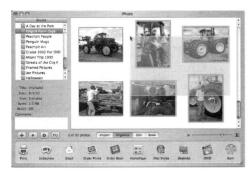

Figure 3.27 To select multiple pictures by dragging, click in an empty area of the display pane, and then drag a selection rectangle over the desired photos.

Select Multiple Albums

Don't assume you must work with only the photos in a single album at a time. You can select multiple albums at once by Cmd- or Shift-clicking album names, and when you do that, the photos from all the selected albums show in the display pane.

Selecting Photos

Throughout the rest of this chapter, I tell you to select photos before performing some task. I'm sure you have figured out the basic ways of selecting and deselecting images, but some others aren't so obvious.

Ways to select photos:

- Click a photo to select it.
- Click one photo to select it, hold down Shift), and then click another photo to select it and all the intervening pictures.
- Click one photo to select it, hold down Cmd, and then click additional photos to select them individually.
- Click in an empty area of the display pane, then drag a selection rectangle over the photos you want to select (Figure 3.27). If you drag to the top or bottom of the display pane, iPhoto scrolls the window and keeps selecting additional images.
- With the display pane active, choose Select All (CmdA) from the Edit menu to select all the images in the current album.
- In the Photo Library, use the View menu to make sure film rolls are showing, and then click the film roll separator to select all the images in that film roll. This works only in the Photo Library because film rolls don't show in other albums.

Ways to deselect photos:

- To deselect one of several selected images, Cmd)-click it.
- To deselect all photos, click in the empty area surrounding the photos or choose Deselect All from the Edit menu (Cmd Shift A).

Adding Photos to Albums

Once you've made a normal album, the next task is to add photos to it (smart albums populate themselves, of course).

Ways to add photos to albums:

- Select one or more photos in the display pane and drag them onto an album. Note the thick black border that appears when you drag over an album (Figure 3.28).
- Drag photos from the display pane into the album pane, but not onto a specific album. This technique creates a new album and adds the images to it (Figure 3.29).
- From the Finder, drag one or more photos, or an entire folder of photos, to an album. iPhoto imports the photos and then adds them to the album. Note that the photos will appear in the Photo Library also, not just in the album.
- Select photos, choose Copy (CmdC)
 from the Edit menu, click the desired
 destination album, and choose Paste
 (Cmd(V)) from the Edit menu.
- ◆ Control-click one or more selected photos, choose Copy from the contextual menu that appears, switch to the desired album, Control-click a blank spot in the display pane, and choose Paste from the contextual menu. It's the same idea as the previous method.

- When the album pane is full, the only way to drag to an "empty" spot is to drag just above or below the Trash album.
- You can add a photo to an album only once. To put a photo in an album twice, you must duplicate it—see "Duplicating Photos" in Chapter 4, "Editing Photos."

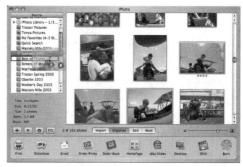

Figure 3.28 To add photos to an album, select them and drag them onto the desired album in the album pane. Note how the destination album gets a thick black border and how the pointer changes from a plain arrow to one with a + badge. iPhoto also tells you, via a number in a red circle, how many images you're dragging.

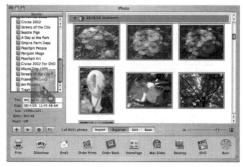

Figure 3.29 To create an album and add photos to it in one fell swoop, select the images and drag them to the album pane, but not onto any specific album.

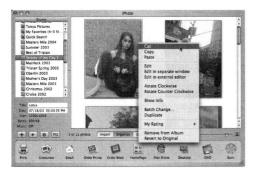

Figure 3.30 Control-click a photo and choose Cut to remove the picture from that album.

Removing Photos from Albums

As you work with an album, you may decide that you don't want some of the images in the album. Luckily, they're easy to remove.

Ways to remove photos from albums:

- Making sure you're in the desired album, select the photos you want to remove and press Delete.
- ◆ Select the photos you want to remove, and then choose Remove from Album from the Photos menu (Cmd Delete) or Cut (Cmd X) from the Edit menu.
- Drag the photos you want to remove to the Trash album.
- ◆ Control-click one or more selected photos, and then choose Cut or Remove from Album from the contextual menu (Figure 3.30).
- To remove a photo from a smart album you must either redefine the smart album or change the photo's information such that the photo no longer matches the smart album's criteria.

- Removing a photo from an album doesn't delete it from your Photo Library.
- iPhoto doesn't ask for confirmation when you remove photos from an album; if you make a mistake, you can either choose "Undo Remove Photo From Album" from the Edit menu (Cmd(Z)) or add them again from the Photo Library.
- Dragging a photo to the Trash album from another album merely removes the photo from that album; it does not delete it from your Photo Library, nor does it copy the photo to the Trash album.

Arranging Photos

iPhoto can perform four simple sorts, or you can move images around manually, which is useful for books and slideshows.

To arrange photos by film roll:

 While in the Photo Library, choose by Film Roll from the View menu's Arrange Photos hierarchical menu (Figure 3.31).

To arrange photos by date:

 When in any album, choose by Date from the View menu's Arrange Photos hierarchical menu.

To arrange photos by title:

 From the View menu's Arrange Photos hierarchical menu, choose by Title.

To arrange photos by rating:

 From the View menu's Arrange Photos hierarchical menu, choose by Rating.

To arrange photos manually:

 Drag one or more photos to the desired location in the album, as marked by a black line (Figure 3.32).

✓ Tips

- To reverse sort order, set the "Place Most Recent Photos at the Top" checkbox appropriately in the Appearance tab of iPhoto's Preferences (**Figure 3.33**).
- Albums have individual sort settings.
- iPhoto remembers manual changes even if you switch to another sort order and back by choosing Manually.
- You can't arrange photos manually in the Photo Library, Last Roll, Last 12 Months, or smart albums.

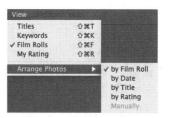

Figure 3.31 To arrange photos in the current album, choose the desired style from the Arrange Photos menu.

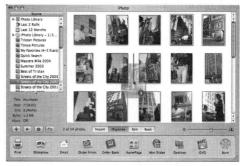

Figure 3.32 To arrange photos manually, drag one or more photos to the desired location, as indicated by a thick black line.

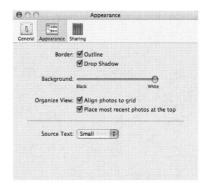

Figure 3.33 Set the chronological sort order for your photos in the Appearance tab of iPhoto's Preferences window.

Newest at Top Is Best

I recommend checking the "Place Most Recent Photos at the Top" checkbox because otherwise, you must scroll down after importing to see the just-imported film roll.

Figure 3.34 To assign a title to a photo, select it and enter the name in the Title field in the info pane.

Figure 3.35 Batch Change enables you to set the titles of multiple selected photos all at once, appending numbers if you so desire.

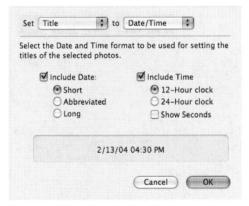

Figure 3.36 When changing the title of a photo to Date/Time, set the format in the dialog before clicking the OK button.

Assigning Titles to Photos

Digital cameras assign sequential numeric names to photos, but iPhoto lets you add your own descriptive titles. Smart albums can look for text in titles, and iPhoto can use the titles when you design books or publish to Apple's .Mac HomePage service.

To assign a custom title to a photo:

 Make sure the info pane is showing, and then select a photo and enter a title for it in the Title field (Figure 3.34).

To assign titles to multiple photos:

- 1. Select a number of photos, and choose Batch Change (Cmd Shift B) from either the Photos menu or by Control-clicking the photos.
- 2. In the dialog that appears, choose Title from the Set pop-up menu, and then choose Empty, Text, Roll Info, Filename, or Date/Time from the To pop-up menu (Figure 3.35).
- If you chose Text or Date/Time, select the desired options in the dialog (Figures 3.35 and 3.36).
 iPhoto changes the titles appropriately.

- Titles stick to their photos no matter what mode you're in. So, if you assign a title to a photo in an album, that same title shows up in the Photo Library, and when you're designing a book.
- Keep titles short so they're easy to read in the display and info panes and so they fit when used with HomePage.
- Wouldn't it be nice if you could edit titles directly in the display pane? Choose Provide iPhoto Feedback from the iPhoto menu and enter your suggestion in Apple's feedback Web page.

Assigning Comments to Photos

It's often helpful to describe a photo briefly so you remember the original scene better. That's one good use for iPhoto's comments, and iPhoto also uses comments as descriptive text in some of the book designs.

To assign comments to photos:

• Make sure the Comments field of the info pane is showing by clicking the Information button (once or twice, depending on what part of the info pane is already showing), and then select a photo and type your comment in the Comments field (Figure 3.37).

To assign comments to multiple photos at once:

- 1. Select a number of photos, and choose Batch Change (Cmd Shift) from either the Photos menu or by Control-clicking the photos.
- 2. In the dialog that appears, choose Comments from the Set pop-up menu, and then enter the comment to attach to each photo (**Figure 3.38**).
- **3.** If you want to append your text to each, instead of replacing what's there, select Append to Existing Comments. iPhoto changes the comments.

✓ Tips

- Expanding the info pane is the only way to see more of the Comments field. iPhoto doesn't provide a scroll bar, but you can drag or use the arrow keys to scroll through too-long comments.
- Resize the Comments field by dragging the size handles at the top of the info pane and the side of the album pane.

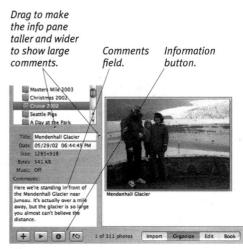

Figure 3.37 To assign a comment to a photo, select the photo and enter the comment in the Comments field in the info pane.

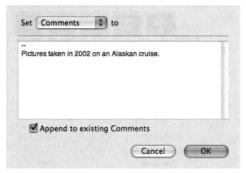

Figure 3.38 Use the Batch Change command to change or append comments for a number of photos at once.

✓ More Tips

- Like titles, comments stick to their photos no matter which mode you're in.
- You can use iPhoto's spelling tools in the Comments field. For more details, see "Checking Spelling" in Chapter 5, "Creating Books."
- The Comments field can display only about 14 kilobytes of text. If you need long comments, create them in another application and paste them into iPhoto.

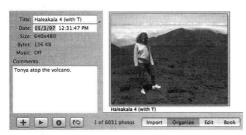

Figure 3.39 Edit the Date field in the info pane to change a photo's date.

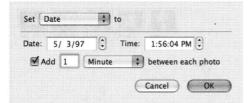

Figure 3.40 Use the Batch Change command to modify the dates of multiple photos at once, adding a set amount of time between each photo if you wish.

✓ More Tips

- If iPhoto is set to arrange photos by date, changing a photo's date causes it to resort according to the new date. Keep that in mind if a photo isn't where you expect it to be after changing its date.
- You can type numbers into the date and time fields, use the arrow keys to change the values up and down, and click the little up/down arrow controls to increase or decrease the selected number.
- When using Batch Change to modify a number of photos with a time increment, note that iPhoto changes them in the order (left to right, top to bottom) that they're currently arranged.
- It's a good idea to use the time increment to ensure that you know how photos will sort by date later; if they're all set to exactly the same date and time, you may not be able to predict how iPhoto will sort them.

Editing Photo Dates

It's not uncommon for digital cameras to forget the date, which can result in a set of photos being imported as though they had been taken in 1980, for instance. Plus, some older digital cameras didn't store the date with the photo, so if you import photos taken with such a camera, the date will be set to when you imported, not when the picture was taken. You can edit photo dates in iPhoto to correct this annoyance.

To edit a photo's date:

• Make sure the Date field of the info pane is showing by clicking the Information button below the album pane, and then select a photo and edit its date in the Date field (Figure 3.39).

To edit multiple photo dates at once:

- 1. Select a number of photos, and choose Batch Change (Cmd Shift) from either the Photos menu or by Control-clicking the photos.
- **2.** In the dialog that appears, choose Date from the Set pop-up menu, and then use the controls to set the date to attach to each photo (**Figure 3.40**).
- **3.** If you want to add a set amount of time by which to increment each photo's date, select the checkbox, enter a number, and choose Seconds, Minutes, Hours, or Days from the pop-up menu. iPhoto changes the dates appropriately.

✓ Tip

Although iPhoto recognizes a large number of date formats, it ignores improperly formatted dates when you're typing them manually, so to avoid confusion, it's easiest to edit the date using the same date format iPhoto uses.

Managing Keywords

Along with titles and comments, you can assign keywords to your photos. First, you must learn how to create, rename, and delete keywords. For all these tasks, open the Keywords window by choosing Show Keywords (Cmd K) from the Photos menu.

To create a keyword:

- From the Keywords pop-up menu, choose New (Figure 3.41).
 iPhoto creates a new untitled keyword.
- 2. Name the new keyword.

To rename a keyword:

- Select a keyword and from the Keywords pop-up menu, choose Rename. iPhoto lets you edit the keyword (Figure 3.42).
- **2.** Enter the new name.

To delete a keyword:

 Select a keyword and from the Keywords pop-up menu, choose Delete.
 iPhoto deletes the keyword immediately.

✓ Tips

- You can create an unlimited (or at least very large) number of keywords.
- A new keyword is created right below the currently selected keyword. This is important to be aware of because there's no way to rearrange or sort the keywords list other than by deleting and recreating keywords.
- Photos inherit keyword changes, so if a photo has the "Nature" keyword and you rename the keyword to "Landscape," the photo updates to match.
- If you delete a keyword, iPhoto removes it from all photos to which it was assigned.

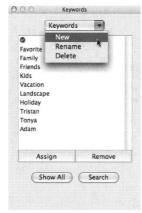

Figure 3.41 To make a new keyword, choose New from the Keywords pop-up menu.

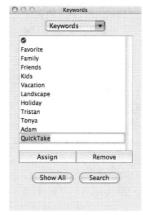

Figure 3.42 To rename a keyword, select it, choose Rename from the Keywords pop-up menu, and enter the new name.

Keywords versus Albums

Use keywords for categories of pictures that recur throughout your photo collection. In contrast, use albums for unique categories that appear only once in your collection. Keywords work well for identifying pictures of your family, landscapes, or recurring events; an album would be better for a specific trip's photos.

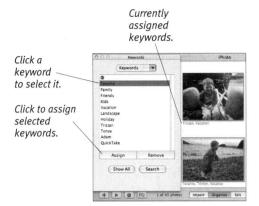

Figure 3.43 Assign keywords by selecting photos, selecting the desired keywords, and clicking the Assign button.

Working with the Checkmark Keyword

iPhoto provides a special checkmark keyword at the top of the keyword list. When you apply it to an image, iPhoto shows the checkmark on top of the image itself, rather than under it, like all other keywords. Plus, the checkmark shows whether or not other keywords are showing. What's it good for?

Use the checkmark keyword as a temporary marker. For instance, when my grandparents ask for prints of certain photos that I'm showing them, I mark those photos with the checkmark keyword so I can easily find them when I get around to ordering the appropriate prints.

Assigning and Removing Keywords

Once you've customized your list of keywords, you can assign keywords to individual images. For this task, you must open the Keywords window by choosing Show Keywords (Cmd(K)) from the Photos menu.

To assign keywords to photos:

- 1. Select one or more photos.
- **2.** Select one or more keywords that you want to apply ([Cmd]-click, [Shift]-click, or drag over multiple keywords to select more than one).
- **3.** Click the Assign button. iPhoto highlights the keywords with gray and, if keywords are showing in the display pane, displays them underneath the photos (**Figure 3.43**).

To remove keywords from photos:

- **1.** Select one or more photos that have keywords associated with them.
- **2.** Select one or more keywords that you want to remove.
- **3.** Click the Remove button. iPhoto removes the gray highlight from the selected keywords and removes the keywords from the selected photos.

- The gray-highlighted keywords match all the keywords that are assigned to the set of selected photos; not all of those keywords are assigned to each photo.
- Be careful when selecting photos and keywords to avoid assigning the wrong keywords to the wrong photos. You can always use Undo (Cmd Z) from the Edit menu if you make a mistake.

Searching via Keyword

Keywords make it easy to find just those photos associated with certain keywords. When you search for photos, iPhoto doesn't merely select matching photos—it displays only those you want to see. These tasks take place in the Keywords window; open it by choosing Keywords (Cmd K) from the Photos menu.

To search for photos via keyword:

- 1. Select one or more keywords.
- Click the Search button. iPhoto displays just those photos that match the set of selected keywords (Figure 3.44).

Ways to show all photos:

- ◆ Click the Show All button.
- ◆ Close the Keywords window.
- Switch to any other album.

Tips

- To search quickly for a single keyword, double-click it.
- To narrow a search, select additional keywords and then click Search again (Figure 3.45). To widen a search, deselect one or more keywords and click Search again.
- Searches take place in the current album.
- In iPhoto 2 and later, unlike earlier versions, you can assign keywords to the results of a search.

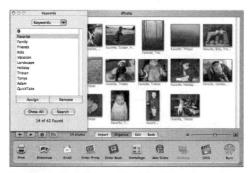

Figure 3.44 Here I've searched for all the photos in my "Best of Tristan" album that have the "Favorite" keyword, and iPhoto is displaying 14 of 42 photos.

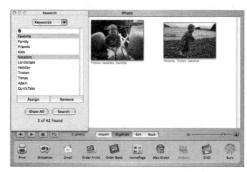

Figure 3.45 Now I've narrowed the search by looking for only those photos that have both the "Favorite" and "Vacation" keywords; iPhoto found only two photos to display.

Figure 3.46 To assign a rating to a photo, select the photo and choose the desired rating from the My Rating menu (or use the keyboard shortcuts, which are a lot faster in this situation). Here you can see my star ratings underneath the photos.

Consider Using Only High Ratings

Don't assume you must rate all your photos. My experience is that there's relatively little point in rating anything with 1 or 2 stars, since those ratings basically mean, "I like this photo only enough to keep it." I consider 3 stars an average rating, so I usually don't use that either, reserving my rating effort for the 4 and 5 star photos that are my favorites.

Remember too that you can create smart albums that match photos whose ratings are lower than a set number, so you could easily find all the photos that didn't have 4 or 5 stars.

Of course, everyone has different ideas about how to arrange, categorize, and rate photos, so take this advice merely as a suggestion.

Assigning Ratings

New in iPhoto 4 is a highly welcome feature—photo ratings. Just as with iTunes, where you can rate your favorite songs on a scale of 1 to 5 stars, you can now rate your photos, which is a great way to identify your favorites easily.

Ways to assign ratings:

- ◆ Select one or more photos, and from the hierarchical My Rating menu in the Photos menu, choose the desired rating. Note the Cmd 0 through Cmd 5 keyboard shortcuts—if you're ever going to use keyboard shortcuts, now is the time.
- Select one or more photos, [Control]-click one of the selected photos, and choose the desired rating from the hierarchical My Rating menu.
- With the slideshow controls turned on, click the star buttons to assign ratings while the slideshow runs.

After you choose a rating, iPhoto applies it to the selected photos, displaying it below the photo if you have My Rating (Cmd Shift) turned on in the View menu (Figure 3.46).

- The keyboard shortcuts in the Photo menu's hierarchical My Rating menu are available at all times, even when you're playing a slideshow!
- You can change the rating for a photo at any time; it's by no means set in stone.
- iPhoto considers 5 stars better than 1 star, although there's nothing stopping you from assuming the reverse.

Viewing Photo Information

iPhoto presents information about photos in two places: the info pane and the Photo Info window.

To view information in the info pane:

With the info pane hidden, click the Information button underneath the album pane once to display the info pane, twice to display the info pane with the Comments field, and three times to hide the info pane again (Figure 3.47).

To view information in the Photo Info window:

- Select a photo and choose Show Info from the Photos menu (Cmd I).
 iPhoto displays the Photo Info window's Photo Tab (Figure 3.48).
- **2.** Click the Exposure tab to see exposure information (**Figure 3.49**).

✓ Tips

- When the Photo Info window is showing, you can click another photo to see its information immediately.
- You can change photo titles, dates, and comments in the info pane, but you can't make changes in the Photo Info window.
- The Photo Info window picks up its information from the EXIF data stored by most digital cameras. EXIF, short for Exchangeable Image File, is an industry standard that's designed to help interoperability between cameras, printers, and other imaging devices. In theory, EXIF support could help a printer produce a better rendition of an original image, although the theory appears to fall short of reality.

Info pane, with Title, Date, Size, Bytes, Music, and Comments fields.

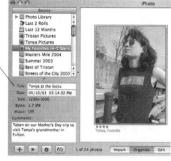

Figure 3.47 iPhoto's info pane displays some basic information about selected photos.

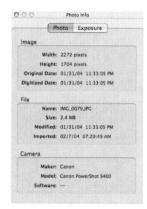

Figure 3.48 The Photo Info window's Photo tab provides detailed information that was recorded by the camera about the image.

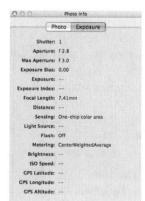

Figure 3.49 The Exposure tab of the Photo Info window displays information about the camera's settings at the time it took the image.

EDITING PHOTOS

If you're anything like me, not all your photos come out perfect. In fact, lots of them are probably pretty bad, and those you can delete after import. No harm, no foul, and you didn't pay for developing.

What about those pictures that are okay, but not great? Most of the time they merely require a little work. Perhaps you need to crop out extraneous background that distracts the eye from the subject of the photo, or maybe you want to remove the red glow from your cute baby's eyes (it's the fault of the camera flash, not a sign of a demon child). iPhoto can help with those tasks.

I'm not suggesting that you whip out an image-editing application, clip your cousin's ex-husband out of the family reunion photo, and use filters that sound like alien death rays (Gaussian blur?) to make it appear as though he was never there. If you can do that, great, and iPhoto will even let you use any other image-editing application. But I can't do that, and I doubt most people can. For us, iPhoto provides most of the simple tools we need.

The main thing to remember is that there's no shame in editing photos to improve them. All the best photographers do it, and now you can do it too, thanks to iPhoto.

Entering Edit Mode

Since you can edit a photo in the display pane, in a separate window, or even in another application, it's not surprising that you can enter edit mode in several ways.

To choose how to edit photos:

- From the iPhoto application menu, choose Preferences ([Cmd],).
 iPhoto opens the Preferences window. If it's not selected, click the General icon (Figure 4.1).
- 2. Under Double-click Photo, select whether you want iPhoto to open photos for editing in the display pane (Changes to Edit View), in a separate window, or in another editing program.
- **3.** To use another program, click Select Application, and choose a program in the Open dialog (**Figure 4.2**).
- 4. Close the Preferences window.

Ways to enter edit mode:

- Select a photo in any mode, and click the Edit button under the display pane (Figure 4.3).
 - iPhoto switches to edit mode with the selected image in the display pane.
- Double-click a photo in any mode. iPhoto switches to edit mode and displays the photo according to the setting in the Preferences window.
- Option-double-click a photo in any mode to open the photo in either the display pane or a separate window, whichever is not the default in iPhoto's preferences.
- ◆ Control-click a photo in organize mode, and choose one of the editing commands from the contextual menu that appears. (Figure 4.4).

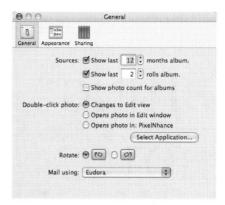

Figure 4.1 In the Preferences window, select how you want iPhoto to react when you double-click a photo.

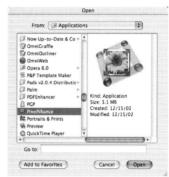

Figure 4.2 To use another program, select Opens Photo In in the iPhoto Preferences window, click Select Application, and find your desired program.

Figure 4.3 To switch into edit mode, click the Edit button underneath the display pane.

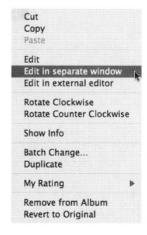

Figure 4.4 Controlclick a photo in organize mode and choose one of the editing commands from the contextual menu. This is a particularly good way to edit in an external application on an occasional basis.

Next
Previous

Edit in separate window
Edit in external editor

Enhance
Red-Eye
Retouch
B & W
Sepia

Crop
Rotate Clockwise
Rotate Counter Clockwise
Show Info

Duplicate
Revert to Original

Figure 4.5 Control-click a photo in the display pane in edit mode to display iPhoto's contextual menu shortcuts.

Enhance Red-Eye Retouch B & W Sepia Crop Rotate Clockwise Rotate Counter Clockwise Revert to Original

Figure 4.6 Control-click a photo when editing in a separate window to display a slightly different set of contextual menu shortcuts.

Contextual Menu Shortcuts

You can Control-click (or, if you have a two-button mouse, right-click) a photo in edit mode to bring up a contextual menu that lets you perform a number of actions without going to the display pane's editing tools or the separate window's toolbar (Figure 4.5 and Figure 4.6).

Contextual menu shortcuts:

- Use Next and Previous to move to the next and previous photos in the album.
- The Edit commands are useful for opening the current photo in a separate window and for opening the photo in an external editor without toggling iPhoto's preferences.
- The Enhance, Red-Eye, Retouch, B & W, Sepia, and Crop commands work just like their equivalent buttons.
- The Rotate, Show Info, Duplicate, and Revert to Original commands are exactly the same as those in iPhoto's Photos menu, so you can use whatever feels most comfortable.

Edit Tools Overview (Display Pane)

Here's a quick look at the tools available when you edit an image in the display pane (**Figure 4.7**).

✓ Tip

■ The dimmed buttons in the screen shot below are disabled because they don't work when there's a selection.

The image you're editing appears in the display pane.

Selection rectangle. Click and drag in the image area to select. Parts of the image outside the selected area appear fogged out.

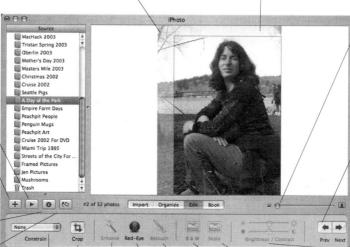

Figure 4.7

Click to run a slideshow.

Click to add an album.

Click to hide or show the info pane (currently hidden).

Click to rotate the selected image(s) clockwise. Option-click to rotate counter-clockwise.

To constrain a selection to a specific aspect ratio, choose the desired ratio in the Constrain pop-up menu, and then select a portion of the image.

Click the Enhance button to fix photos automatically.

To crop a photo, select a portion of the image, and then click the Crop button.

To eliminate redeye in a picture of a person or pet, select the subject's eyes and click the

Red-Eye button.

Use the Retouch tool to scrub out unwanted blemishes. Size slider.
Adjust this
slider to
zoom in and
out of the
picture in the
display pane.

Use the Previous and Next buttons to navigate to the previous or next photo in the current album without going back to organize mode.

To adjust the brightness and contrast of the image, move the sliders.

Click the Sepia button to convert the image to sepia.

Click the B & W button to convert the image to blackand-white.

✓ Tips

- The image-editing window doesn't remember its size, so you may need to resize or zoom the window each time.
- Editing in windows is a good way to compare multiple images.
- Editing in a window lets you see a photo at larger sizes than in the display pane.
- Use the Window menu to switch to windows you can't see.
- You lose the ability to undo changes you've made when you close the window.

Edit Tools Overview (Separate Window)

The tools available when you edit a photo in a separate window are slightly different from those available when editing in the display pane (Figure 4.8).

> To adjust the brightness and contrast of the image, move the sliders. (Disabled because these controls work only on the entire image.)

resize the image to match the window size. Clicking the Zoom buttons after clicking Fit starts size the picture was before you

clicked Fit.

Click the Fit button to

To constrain a selection to a specific aspect ratio, choose the desired ratio in the Constrain zooming at the pop-up menu, and then select a portion of the image.

The title bar of the To constrain window the selection shows you to a custom the title of aspect ratio the photo (like 2×8). and the enter the zoom perdesired numcentage. bers here.

Click to hide or show the toolbar.

Click the Customize button to show a dialog that lets you pick different tools for the toolbar.

To eliminate red-eye in a subject's eyes, select the subject's eves and click the Red-Eye button.

To crop a photo, select a portion of the image and click the Crop button.

Selection rectangle. Drag a rectangle over the image to create a selection. Parts of the image outside the selected area appear fogged out.

> Resize handle. Drag to resize both the window and the photo proportionally.

Click the close button to close the window when you're done editing.

Click the zoom button to zoom the window, and the photo with it, to the largest possible size.

000 Zoom buttons. Click these to zoom in and out of the image without resizing the window. Be careful when clicking mul-

Click to rotate the current image clockwise. Optionclick to rotate counter-clockwise.

tiple times or you

than you intend.

could zoom farther

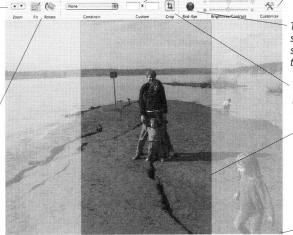

Figure 4.8

Customizing the Toolbar

You can customize the set and arrangement of tools in the image-editing toolbar.

To customize the toolbar:

- **1.** With the image-editing window open, if the toolbar is closed, click the Toolbar button in the extreme upper right of the window to display the toolbar.
- **2.** Either click the Customize button or, from the Window menu, choose Customize Toolbar to reveal the toolbar customization dialog (**Figure 4.9**).
- **3.** Drag items to or from the toolbar to customize to your liking.
- 4. Click Done to save your changes.

Toolbar customization options:

- ◆ To add an item to the toolbar, drag it from the dialog to the desired location.
- To remove an item from the toolbar, drag it off the toolbar (where it disappears with a satisfying poof).
- To move an item on the toolbar, drag it to the new location (other items move out of the way as you drag).
- To revert to the default set of tools, drag the default set to the toolbar, where it replaces whatever is up there.
- To change whether the tools display as icons, text, or icons and text, choose the desired option from the Show pop-up menu at the lower left. However, they display, select Use Small Size to shrink the icons and/or text.

✓ Tip

 Cmd-drag an item off the toolbar to remove it even when the toolbar customization dialog isn't showing.

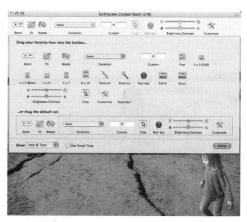

Figure 4.9 To customize the image-editing window's toolbar, click the Customize button, and then drag items on to or off of the toolbar.

What Are All Those Tools?

Not all the tools you can add are either familiar or explained on the previous page, but in fact these seemingly unfamiliar tools don't offer any new functionality. Those with aspect ratios for names are shortcuts for choices available in the Constrain pop-up menu. Free is as well; it corresponds with None in the Constrain menu. Separators are purely cosmetic; they help you group similar items on your custom toolbar.

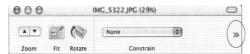

Figure 4.10 When the window is too small to display all the tools, a chevron appears on the right side.

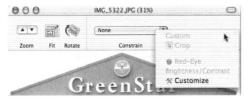

Figure 4.11 Click the chevron to display a pop-up menu containing choices corresponding to the tools that didn't fit on the toolbar.

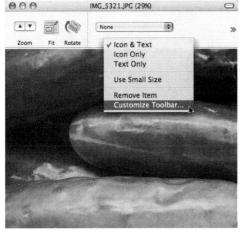

Figure 4.12 Control-click an item on the toolbar to access a contextual menu that lets you remove the item and modify the toolbar in various ways.

Using the Toolbar

Although most aspects of using the toolbar are obvious (click the buttons!), you might need a little help figuring out a few of the best ways of working.

Ways to use the toolbar:

- To activate a toolbar button, click it. Be careful with the Zoom buttons, since they zoom several steps for each click and on slower Macs, it's easy to click too many times.
- To enter a custom aspect ratio in the Custom fields, it's easiest to type the desired numbers before selecting part of the photo.
- When tools are cut off due to the window being too narrow, click the chevron that appears to access them via a menu (Figure 4.10 and Figure 4.11).
- ◆ Control-click a toolbar button to display a contextual menu that lets you remove the tool from the toolbar, change how toolbar buttons display, and customize the toolbar (Figure 4.12).

- Add the tools you want to use the most to the left side of the toolbar, since the ones on the right will be cut off in small windows.
- You can use the space occupied by the Customize button for something more useful. Then, to customize the toolbar, choose Customize Toolbar from the Window menu or from the contextual menu that appears when you Controlclick the toolbar.

Zooming Photos

It can be helpful to zoom in and out while editing, particularly when selecting eyes for red-eye reduction or using the Retouch tool.

To zoom in the display pane:

 With an image showing in the display pane in edit mode, drag the size slider to the right to zoom in (Figure 4.13).
 To zoom out, drag the slider to the left (Figure 4.14).

To zoom in the image-editing window:

- When the photo fills the image-editing window exactly, drag the resize handle to resize the window and the photo. The window resizes proportionally. This approach limits zooming to the maximum and minimum window sizes.
- Click the left Zoom button in the imageediting window's toolbar to zoom in.
 Click the right Zoom button to zoom out (Figure 4.15).

- Make a selection *before* zooming to zoom to that part of the image.
- If the image doesn't fill the image-editing window after zooming, click the Fit button to make it fit. If there's still white space along the edges of the photo, resize the window to eliminate the borders.
- To scroll more quickly than with the vertical and horizontal scroll bars, hold down Cmd and drag the image.
- iPhoto can zoom in to 400 percent, and out to 5 percent.
- Each click of a Zoom button makes the image roughly a third larger or smaller than the previous size.

Figure 4.13 To zoom in on a photo, drag the size slider to the right. Here I've zoomed all the way in, which is why the image looks so pixelated.

Figure 4.14 To zoom back out, drag the slider to the left. Here I've zoomed back out to the size that matches the display pane's size.

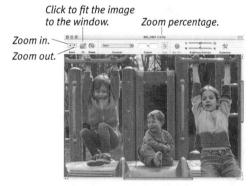

Figure 4.15 Click the Zoom buttons in the toolbar to zoom in and out in the image-editing window. Click Fit to make the image fit in the window if there's extra white space after zooming out.

Figure 4.16 Notice how the duplicated photos show up next to their originals and how some of them have "copy" appended to their titles.

Finding Copies

iPhoto has a confusing bug related to duplicating photos. If you duplicate photos that have been edited in any way (other than rotating, which can apply just to the thumbnail), iPhoto 4 fails to add "copy" to the title of the duplicated photos. That makes identifying copies difficult. So, I recommend duplicating photos before you make any changes.

Luckily, iPhoto 4 is at least consistent about where it places the duplicates; they are always "newer" than the original, so they sort to the left of the originals if "Place Most Recent Photos at the Top" is selected in iPhoto's Appearance preferences, and to the right otherwise.

If you're thinking that you could assign a keyword to the originals to differentiate them from the copies, think again, since iPhoto duplicates everything about the original, including keywords and ratings.

For the record, iPhoto duplicates the actual file in the same Finder folder as its original, though with a slightly modified name. See "iPhoto Directory Structure" in Chapter 1, "Importing and Managing Photos."

Duplicating Photos

iPhoto lets you duplicate photos, which can be useful in a variety of situations.

Reasons to duplicate a photo:

- If you want a photo to appear twice in a book (as you might if you want it to be the cover image and to show up inside as well), you must duplicate that photo.
- If you want to crop a photo in different ways, or if you want to print the same photo in color and black-and-white, you must duplicate the photo first.
- If you duplicate a photo, you can open the original and the copy in separate windows and then compare your edits to the original. (However, it's easier to press Control after making an edit to display the original temporarily.)

Ways to duplicate photos:

- In any mode, select photos and from the Photos menu, choose Duplicate (CmdD).
- Control-click a photo and choose
 Duplicate from the contextual menu.
 iPhoto switches to import mode, duplicates the photo, and switches back to organize mode (Figure 4.16).

- The duplicate image shows up next to the original in the Photo Library, and iPhoto does not create a new film roll.
- The Last Roll album does not show the duplicated photo.
- If an album is selected when you duplicate the photo, the duplicate is added to that album too. However the photo won't be duplicated in any other albums that have that photo.

Rotating Photos

If you've turned your camera to switch from landscape view (horizontal) to portrait view (vertical), you must rotate the image in iPhoto to view it right side up. Rotating is such a common function that iPhoto provides an always-available Rotate button.

Ways to rotate photos:

- In any mode, to rotate one or more photos clockwise, select them and click the Rotate button under the album pane (Figure 4.17 and Figure 4.18). To rotate them counter-clockwise, hold down Option and click the Rotate button.
- In organize or edit mode, select one or more photos, Control-click one, and choose the desired rotation direction from the contextual menu that appears.
- In any mode, select one or more photos and choose either Rotate Clockwise (Cmd(R)) or Rotate Counter Clockwise (Cmd(Option(R))) from the Photos menu.
- In the image-editing window's toolbar, click the Rotate button (Figure 4.17). To rotate the photo in the other direction, Option-click the Rotate button.

✓ Tips

- You can change the direction used by the Rotate buttons in iPhoto's Preferences window; Option-clicking always reverses the default direction (**Figure 4.19**).
- It may be easiest to rotate photos in batches in organize mode. Shrink the thumbnail size so you can see a number of photos at once, Cmd-click the ones that need rotating clockwise, and click Rotate. Repeat with any images that need counter-clockwise rotation, holding down Option when you click Rotate.

Rotate

Figure 4.17 Here I'm showing a "before" photo in the display pane and in its own window just so you can see both Rotate buttons.

Figure 4.18 Here's the "after" picture that resulted from clicking the Rotate button.

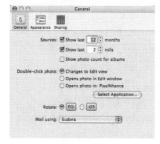

Figure 4.19 In the Preferences window, select which direction you want iPhoto to rotate photos by default.

GIF to JPEG

If you rotate a GIF image, iPhoto renames the actual file with a .jpg extension, and on any other edit, converts the image to a JPEG, which may be undesirable.

Figure 4.20 The original photo. Notice how it's too dark.

Figure 4.21 The photo after clicking Enhance. Though you can't tell as well in the paper version, iPhoto increased the red tones and the brightness. Maybe better, maybe not.

Enhancing Photos

Traditional photo processors learned long ago that fiddling with brightness and contrast and messing with the colors could turn a plebeian picture into a luminescent photo. iPhoto aims to help you do the same for your photos with its one-click Enhance tool.

To enhance a photo:

- **1.** In edit mode, click the Enhance button. iPhoto adjusts several aspects of your photo, including color levels, color saturation, and brightness and contrast.
- **2.** Press and release Control to toggle between the "before" (**Figure 4.20**) and "after" (**Figure 4.21**) views of your photo.
- **3.** If you like what Enhance has done to your photo, continue working. If not, choose Undo Enhance Photo (Cmd Z) from the Edit menu.

- Don't assume Enhance will always improve your photo. It's worth trying, but only you can decide if its results are better or worse than the original.
- If the photo is way too dark or way too bright, Enhance isn't likely to work as well as manual fiddling with the Brightness and Contrast sliders.
- Enhance seems to key off the main color in the image when tweaking color saturation, which can lead to unwanted effects.
- The order in which you perform edits can make a difference. For instance, if you plan to crop a photo, try Enhance before you crop, and if you don't like the results, undo the enhance, crop, and try Enhance again to see if you get different results.

Making Photos Black-and-White or Sepia

Although all cameras take photos in color by default, some photos are improved by conversion to black-and-white. That's often true of portraits of people, since switching to black-and-white smooths out skin coloration and blemishes. Some landscapes also benefit tremendously from conversion to black-and-white, since eliminating color helps the viewer focus on the composition and lighting. Think Ansel Adams.

New in iPhoto 4 is a Sepia button that turns a photo sepia-toned for an old-time look.

To make a photo black-and-white or sepia:

Click the B & W or Sepia button in the edit pane or the image-editing window's toolbar, or Control-click and choose B & W or Sepia from the contextual menu (a bug disables Sepia in the imageediting window's contextual menu). iPhoto displays a progress dialog while it converts the image, and then displays it in black-and-white or sepia.

✓ Tips

- To decide whether you like the color or black-and-white/sepia version of a photo better, press and release Control a few times to toggle instantly between the "before" (Figure 4.22) and "after" (Figure 4.23) views of your photo. If you don't like the change, choose Undo Convert to B &W/Sepia (Cmd)(Z)) from the Edit menu.
- Another way to compare color and blackand-white/sepia versions of the same photo is to duplicate the photo, convert one copy, and then look at them side-byside in separate editing windows.

Figure 4.22 To convert a photo to black-and-white, switch to edit mode and click the B & W button. Here I'm converting a picture of an old barn to make the bleached wood look more like bones and to emphasize the starkness of the leafless trees.

Figure 4.23 I like it better in black-and-white (and it was also improved by Enhance before I converted it).

Get the Electronic Edition!

Note that it's impossible to see the difference between these two screen shots in a black-and-white book. To find out how to get the full-color PDF version, send email to get-iphoto4-vqs@tidbits.com. The PDF version is easier to take with you when you travel with your camera and laptop, but don't want to carry the book.

Figure 4.24 This picture is too dark, because of the bright snow outside the door. You can barely see Tristan's face at all.

Figure 4.25 Increasing the brightness all the way washes out the background entirely, but restores details to Tristan and to the door at his back. It's still a lousy photo, and if I wasn't using it to show off the brightness control, I'd delete it.

Figure 4.26 Again, the brightness of the sky overwhelmed Tristan's face (I should have forced the flash).

Figure 4.27 Increasing the contrast all the way turns Tristan into a silhouette and makes the sky far more dramatic. It wasn't what I expected, but it turned out well.

Adjusting Brightness and Contrast

Digital cameras often make mistakes with brightness and contrast, so iPhoto provides basic controls for adjusting these settings after the fact. Adjusting the brightness of the photo makes the entire image lighter or darker, whereas adjusting the contrast changes the degree of difference between light and dark areas of the image.

To adjust the brightness:

 In edit mode, drag the top slider left to decrease or right to increase the brightness of the image (Figure 4.24 and Figure 4.25).

To adjust the contrast:

 In edit mode, drag the bottom slider left to decrease or right to increase the contrast of the image (Figure 4.26 and Figure 4.27).

- Press and release Control a few times to toggle instantly between the "before" and "after" views of your photo.
- In most cases you will want to tweak brightness and contrast only slightly.
- Other image-editing applications may offer better brightness and contrast controls.
- If you change the image's brightness or contrast, switch modes, and switch back to edit mode, you'll notice that the brightness and contrast sliders are in the middle position again. This means that in the unlikely event that you want to increase or decrease brightness or contrast more than the sliders allow, a second pass offers more leeway.

Selecting Portions of Photos

iPhoto's next two editing tools—cropping and reducing red-eye—require that you select a portion of the picture first.

To select part of a photo:

- In edit mode, drag to create a selection rectangle in the image (you see a crosshair pointer while doing this). iPhoto fogs the photo outside your selection rectangle to help you focus on the selection (Figure 4.28).
- ◆ To move your selection rectangle around, drag it (your pointer should be a hand). You may need to move a selection rectangle to move it up against the edges of a picture, since it's hard to start selecting right at the edge.
- To resize a selection rectangle, drag the rectangle's edge to resize (you'll have an arrow pointer at this point).
- ◆ To constrain the selection rectangle to specific proportions, choose an aspect ratio from the Constrain pop-up menu, or click a Constrain button in the image-editing window's toolbar. If you haven't created a selection rectangle, it will be constrained when you do; if you have one already, iPhoto resizes it (Figure 4.29). To remove a constraint, choose None from the Constrain menu or use the image-editing toolbar's Free button.
- To constrain the selection rectangle to custom proportions, edit the image in its own window, and enter the desired aspect ratio in the Custom fields in the toolbar before you start selecting.
- To deselect everything and start over, click in the fogged area or switch to another photo.

Figure 4.28 To select a portion of a photo, drag to create a selection rectangle. Move it by dragging it; resize it by dragging an edge. Here I've created a selection rectangle with no specific proportion to focus on the seaplane and the odd truck.

Figure 4.29 To constrain an image to specific proportions, choose an aspect ratio from the Constrain menu (here I've chosen 4 x 6, which will make a good print while not detracting from the subject of the picture). You can move and resize the selection rectangle while maintaining the selected aspect ratio.

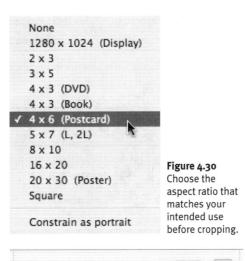

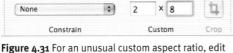

the image in its own window and enter the desired

aspect ratio in the Custom fields before selecting.

Switching between Portrait and Landscape Orientation

You may often find yourself wanting to switch between the portrait (vertical) and landscape (horizontal) aspect ratios as you crop different photos, and you may also find yourself cursing a specific aspect ratio as you try to select a person's eyes to reduce red-eye. iPhoto has two hidden features to assuage your annoyance.

- Press Option while dragging to switch between portrait and landscape. This trick has the same effect as toggling the Constrain as... setting but is much more fluid to use.
- Press Cmd while dragging to switch temporarily to None so you can more easily select eyes for red-eye reduction.

Specific Aspect Ratios

If you wish to use a photo in a book, or for ordering prints, you should crop it to the aspect ratio that matches your intended use first (**Figure 4.30**).

See the next page to learn about cropping photos and see "Understanding Aspect Ratios" in Appendix A, "Deep Background," for more details about aspect ratios.

Uses for specific aspect ratios:

- ◆ Use 1280 x 1024 (Display) before you crop the image for use as a Desktop picture. These numbers are specific to your monitor's resolution.
- Use 4 x 3 (Book) to crop a portrait image for use in an iPhoto book; 4 x 3 (DVD) gives you a landscape image for a DVD slideshow created with iDVD or for use in an iPhoto book.
- Use Square when you want a square selection; I've found it useful for making images for use on the Web.
- Use a custom ratio if some external use, such as a Web page, calls for a specific aspect ratio (Figure 4.31).

- iPhoto 4 assumes you want to crop in the same orientation as the photo, but you can change that. For instance, to create a portrait orientation selection in a land-scape image, choose Constrain as Portrait or press Option while dragging.
- iPhoto 4 added some duplicate aspect ratios, presumably for people who don't realize that aspect ratios are ratios between numbers and multiplying those numbers by some value doesn't change the ratio. 2 x 3 and 20 x 30, for instance, give you identical results.

Cropping Photos

If you are planning to print a photo or display it on your Desktop, you should crop it using an appropriate aspect ratio. (See "Understanding Aspect Ratios," in Appendix A, "Deep Background," for details.) Even if you don't plan to print a photo, cropping extraneous detail can improve an image a great deal.

To crop a photo:

- Select the desired portion of the image, using a constrain setting if you plan to use the image for display or printing.
- 2. Click the Crop button in the edit pane or the image-editing window's toolbar, or Control-click and choose Crop from the contextual menu.
 - iPhoto deletes the fogged area of the picture, leaving just what you had selected (**Figure 4.32** and **Figure 4.33**).

✓ Tips

- Press and release Control to toggle between the "before" and "after" views.
- If your selection rectangle is very close to one of the standard aspect ratios, it's best to use the standard aspect ratio in case you want to print the image later.
- When you crop a photo, you remove pixels from it. So if you crop a 1600 x 1200 pixel photo (1,920,000 pixels) down to 1200 x 900 (1,080,000 pixels), you've removed almost half the image. Thus, if you print the original and the cropped version at the same size, the original will be of a much higher quality. Heavy cropping is one reason why iPhoto shows a low-resolution warning icon when you're creating books or prints. For details, see "Understanding Resolution" in Appendix A, "Deep Background."

Figure 4.32 To crop an image, select the desired portion and then click the Crop button. Here I've cropped out all the irrelevant background around my editor Nancy and her sons.

Figure 4.33 As you can see, cropping this image improves it immensely.

Adjust Shooting Style

When taking pictures, you usually want to fill the frame with the scene, but if you plan to order prints of all your photos, you might want to include a little extra space on the edges to allow for cropping to a print aspect ratio. See Appendix B, "Taking Better Photos," for more tips!

Figure 4.34 To reduce the effect of red-eye in a photo, drag a selection rectangle around the subject's eyes, and then click the Red-Eye button.

What Is Red-Eye?

Red-eye is a phenomenon that occurs in photographs when light from the camera's flash reflects off the blood vessels in the retina of the subject's eyes. It's worse when the flash is close to the lens, with young children, with blue or gray eyes (which reflect more light than darker eyes), and in dim settings.

You can reduce the likelihood of red-eye occurring in the first place:

- ◆ Try to cause the subject's pupils to contract by increasing the room light, asking the person to look at a bright light right before taking the picture, or using a red-eye reduction feature in your camera (which pulses the flash before taking the picture).
- Have the subject look slightly away from the camera lens rather than directly toward it.
- If your camera supports an external flash unit, use it to increase the distance between the flash and the camera lens.

Reducing Red-Eye

Perhaps the most annoying thing that can go wrong in a photograph is red-eye, a demonic red glow to subjects' eyes that plagues flash photography. Luckily, iPhoto makes reducing the effect of red-eye easy, although its approach isn't always ideal.

To reduce red-eye in a photo:

- **1.** Drag a selection rectangle that includes the subject's eyes (**Figure 4.34**).
- 2. Click the Red-Eye button in the edit pane or the image-editing window's toolbar, or Control-click and choose Red-Eye from the contextual menu.
 - iPhoto converts the red shades in the selected areas to dark gray.

- Press and release Control to toggle between the "before" and "after" views.
- It can be easier to select the subject's eyes accurately if you zoom in first, as I've done in **Figure 4.34**. Remember that you can press [Cmd] while dragging to switch away from a constrain setting briefly.
- If you're unhappy with the results, try working with one eye at a time.
- Unfortunately, iPhoto's approach to reducing red-eye tends to make people look as though they have black eyes, which isn't ideal. You can achieve better results in other image-editing programs.
- The Red-Eye tool looks only for specific shades of red, as you can see if you select an entire image and click Red-Eye.
- Sometimes the Red-Eye tool fails, and it won't work on green-eye in dogs. If you can't edit the image in another program, try using the Retouch tool or convert the photo to black-and-white.

Retouching Photos

Cindy Crawford's famous mole notwithstanding, many otherwise great photos are marred by small blemishes. Perhaps it's a smear of jelly on your toddler's face, or someone's chapped lips. Either way, iPhoto's Retouch tool can help.

To retouch a photo:

- 1. Click the Retouch button, or Control-click the image and choose Retouch from the contextual menu.
 - iPhoto puts a white halo around the Retouch wand to indicate that it's active (**Figure 4.35**).
- 2. Click and scrub over the blemish you want to remove, using short strokes. iPhoto blurs the area under the Retouch tool's pointer, blending it with the surrounding colors and textures.
- **3.** Press and release Control to toggle between the "before" (**Figure 4.36**) and "after" (**Figure 4.37**) views of your photo.

- For additional accuracy, zoom in first.
- Retouch is not a panacea. It can fix small blemishes but will make large ones look like dust bunnies. It works best on skin.
- Avoid sharp color edges with the Retouch tool, such as between Tristan's hands and his blue shirt. When the Retouch tool hits edges, it smears the sharp lines. Luckily, you can always undo mistakes.
- Retouch can be good for taking the flash shine off eyes or other reflective surfaces, and is worth a try if the Red-Eye tool fails.

Figure 4.35 The Retouch wand has a white halo when it's active. That's useful to know, because you must click the Retouch button again to turn it off and be able to make selection rectangles again.

Figure 4.36 The original photo. Note the smudge on the left side of Tristan's lips.

Figure 4.37 Much better!

Figure 4.38 To revert to the original version of an image after making a number of edits, select it and choose Revert to Original from the File menu. iPhoto warns you that you'll lose all your changes.

Recover Original

It turns out that Revert to Original isn't doing anything particularly hard. When you edit a photo, iPhoto makes a copy of the original in a folder called Originals that lives in the same directory as the image. As long as this happens, you can recover the original image no matter what might go wrong.

You can find an original image by sorting through the iPhoto Library's sub-folders manually, or you can select the desired image in iPhoto and use the Show Image File AppleScript script to display it in the Finder, after which you can find the original in the related Originals folder. (The script is available at www.apple.com/applescript/iphoto/.)

Undoing Changes

We all make mistakes, and that's certain to happen on occasion when you're working with your photos too. With digital photos, though, your changes aren't irrevocable.

Ways to undo changes to a photo:

- ◆ After you've performed an action, to undo just that action, choose Undo from the Edit menu (Cmd(Z)). Keep choosing Undo to continue undoing earlier actions.
- ◆ To remove all changes from a photo, select it and choose Revert to Original from the Photos menu, or Control-click the image and choose Revert to Original from the contextual menu. iPhoto warns that you'll lose all changes to the photo (Figure 4.38).

- To see what the photo would look like if you were to undo a change, press Control.

 You must still choose Undo if desired.
- iPhoto modifies the Undo command in the Edit menu to reflect your last action, so it may say Undo Crop Photo, for instance.
- If you edit in the image-editing window, you can undo changes you make in that window only as long as it remains open.
- Anything you can undo via the Undo command, you can Redo via the Redo command in the Edit menu.
- Revert to Original works even if you edit a photo in another program—iPhoto starts tracking the original as soon as you double-click the photo. However, don't drag a photo from iPhoto to the Dock icon of another program to edit it; if you do so, iPhoto can't track the changes.

Editing in Another Program

iPhoto's minimal editing tools are sufficient for most tasks, but for more involved changes to photos, iPhoto lets you turn to another image-editing program.

To select an external editor:

- 1. From the iPhoto application menu, choose Preferences (Cmd), to open the Preferences window. If necessary, click the General icon.
- **2.** Under Double-click Photo, select Opens Photo In (**Figure 4.39**).
- **3.** Click the Select Application button, and choose a program in the Open dialog.
- 4. Close the Preferences window.

To edit photos in an external editor:

- Double-click one or more selected photos. iPhoto launches your selected editing program and opens the photos in it.
- **2.** Make your desired changes, and when you're done, save and close the photos.

To open photos in an external editor:

- **1.** Select an external editor, but don't set iPhoto to open photos in it by default.
- **2.** Control-click one or more photos and choose Edit in External Editor from the contextual menu (**Figure 4.40**).

- Revert to Original works on photos edited in another program as long as you open them from within iPhoto (don't drag to the other application to open).
- Click the Edit button or Option-doubleclick to avoid opening a photo in an external editor when that's the default.

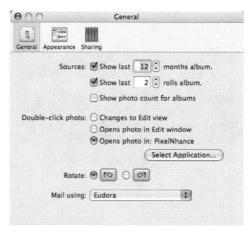

Figure 4.39 To configure iPhoto to use another program for editing photos, choose Preferences from the iPhoto application menu, select Opens Photo In from the Double-click Photo section, click the Select Application button, select the desired application, and close the Preferences window.

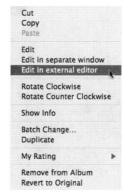

Figure 4.40 To edit a photo in an external editor without switching iPhoto's preferences, Control-click the image and choose Edit In External Editor from the contextual menu.

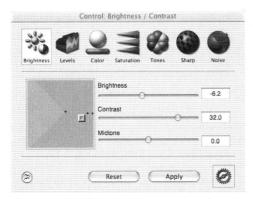

Figure 4.41 PixelNhance provides a number of tools for editing your photos—click a tool at the top of the window, and then use the controls to modify the image in its own window (see the next screen shot).

Figure 4.42
PixelNhance's image window displays the photo, with a movable bar separating how the image looked originally from how the changes you make will affect it. Here I've increased the contrast of a wintry scene to make it darker and more vibrant.

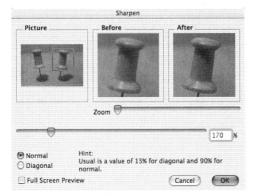

Figure 4.43 Via a relatively technical interface, GraphicConverter offers a vast number of features, such as the Sharpen tool shown above. Here I've used it to increase the sharpness of a photo of hand-turned thumbtacks to bring out the wood grain.

Recommended Image-Editing Programs

You can use any image-editing program with iPhoto. However, a few applications are particularly appropriate for use with iPhoto.

PixelNhance

For the next step up in editing tools, I like Caffeine Software's free PixelNhance, even though the company has closed its doors. PixelNhance helps you modify the brightness and contrast of your photos, adjust the levels of different colors, increase or decrease the sharpness, reduce the amount of visual noise in the image, and more (**Figure 4.41**). PixelNhance works only on the entire image at once, just like iPhoto.

An ultra-easy interface sets PixelNhance apart from other image editors. A movable bar separates two sections of the photo; one section shows how it looked originally, the other displays a preview of how your changes would affect the image (**Figure 4.42**). You can download it (with the company's other programs) from ftp://ftp.cs.unm.edu/pub/stone/StoneStudio/CaffeineApps.dmg.

GraphicConverter

Lemke Software's \$30 GraphicConverter is one of the most popular Mac shareware applications. Although its claim to fame is conversion of graphic files between a vast number of formats, it also offers extensive image-editing features. You can sharpen images, adjust color levels, change brightness and contrast, modify image resolution, and mirror images, among many other features. GraphicConverter's more technical interface isn't as straightforward as PixelNhance's, but it can work on portions of a photo (Figure 4.43). You can download a copy of the current version from www.lemkesoft.com.

Another Recommended Image-Editing Program

What if you want more power than PixelNhance and GraphicConverter offer? Look to Adobe Photoshop Elements, the baby brother of industry heavyweight Photoshop. Learn more about the program at www.adobe.com/products/photoshopel/.

Reasons you might want Photoshop Elements:

- Where iPhoto and PixelNhance let you work only on an entire photo, Photoshop Elements provides sophisticated selection tools that help you edit only portions of an image.
- Photoshop Elements offers a helpful set of "recipes," or canned procedures that walk you through fixing photos in common ways. The recipes are both useful in their own right and help you learn how to use many tools in Photoshop Elements (Figure 4.44).
- Whereas editing in the other programs I've mentioned involves changing the actual image, Photoshop Elements lets you create a "layer" (like a sheet of clear plastic over the image) and overlay changes on the layer over the original.
- You can use the filters and effects in Photoshop Elements to turn normal photos into amazing images that look like they were painted, embossed, or drawn with charcoal.
- You can buy other books that both teach you more about Photoshop Elements and extend the program's capabilities; I like Jack Davis's Adobe Photoshop Elements 2 One-Click Wow! Books about Photoshop may have useful techniques that also work in Photoshop Elements.

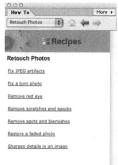

Figure 4.44 Start with the recipes in Photoshop Elements to learn how some of its tools work.

Dealing with Layers

Layers in Photoshop Elements are wonderful, since they let you work on a photo without changing the base image. However, you can't save layers in a JPEG file (likely the original format of your photo), and if you save as a Photoshop file, iPhoto won't acknowledge the edited photo. So, when you're sure you're done editing, choose Flatten Image from the Layers menu in Photoshop Elements, and then save the photo with its original name and location. That way, when you return to iPhoto, it will see your changes to the photo, though you lose access to the separate layers for future editing.

If you want to retain layers for multiple editing sessions, follow these steps:

- **1.** Drag a photo from iPhoto to the Photoshop Elements icon in the Dock.
- **2.** Add a layer, but don't make any other changes, so you retain a clean original.
- **3.** Save the photo as a Photoshop file on your Desktop. Close the file.
- **4.** Drag the photo from your Desktop back into iPhoto to re-import it. Delete the copy on your Desktop.
- **5.** From then on, use iPhoto to edit the photo *only* in Photoshop Elements.

CREATING BOOKS

If I had to pick one feature that sets iPhoto apart from the crowd, I'd choose the way iPhoto creates custom photo albums that can be professionally printed and bound. Numerous programs can help you edit and organize photos. But when it first appeared, iPhoto instantly became the undisputed champion of sharing pictures in attractive ways, largely because of the customized photo albums iPhoto calls "books."

The beauty of the books, apart from their linen covers and quality printing on heavy, glossy paper, is that they help bridge the gap between the analog and digital worlds. Those of us who have grown up with computers are happy sharing our photos via slideshow, a digital camera hooked to a TV, or a Web page. But many people are still more comfortable with prints ensconced in acetate in a traditional photo album. Forget all the advantages of the digital world; for these people, the images somehow aren't real unless they're in a book. It's the "That's nice, dear" syndrome.

By the time you're done with this chapter and the next one (which covers ordering the books you create), you won't have to worry about your digital photo collection being a second-class citizen when it comes to being displayed in a "real" book.

Switching Modes while Creating Books

To switch into book mode, click the Book button while one of your albums is selected in the album list. That's both predictable and easy, but book mode is unusual in that you'll want to switch back and forth with other modes—mostly organize and edit—while working in book mode.

To enter book mode:

 Select any normal album (not the Photo Library, any of the Last... albums, or a smart album), and click the Book button under the display pane (Figure 5.1).

Reasons to switch out of and back into book mode:

- To rearrange photos so they appear in the desired order in your book, switch to organize mode by clicking the Organize button, drag pictures into the right order, and then switch back by clicking the Book button.
- ◆ To crop a photo, eliminate red-eye, or adjust a photo's brightness or contrast, double-click the photo to switch into edit mode. Alternatively, click it to select it, and then click the Edit button. When you're done, switch back into book mode by clicking the Book button.

✓ Tip

■ When you're in book mode, clicking another album name lets you work on a book for that other album without switching modes. Each album remembers its own book settings.

Figure 5.1 To switch into book mode, click the Book button under the display pane.

Book Tools Overview

Here's a quick reference to the tools available in book mode (**Figure 5.2**).

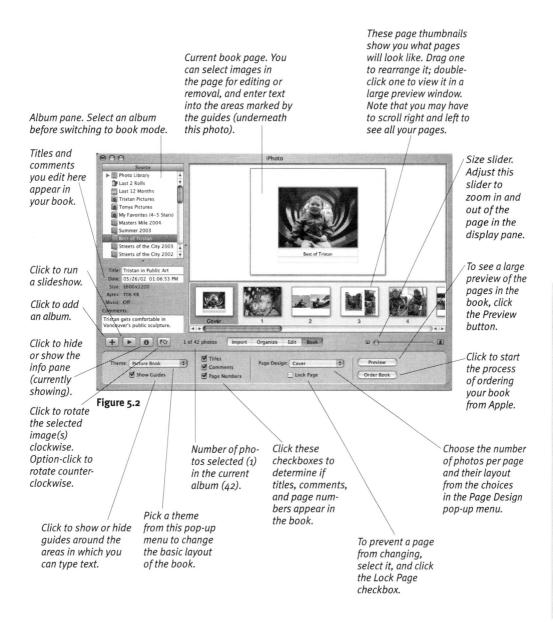

Creating Books

Even though books end up looking highly professional, they're still easy to create. Here we'll skim over the process of making a book; subsequent pages go into the details.

To prepare a book:

- 1. Make a normal album with the photos you want in your book (see "Creating Albums" and "Adding Photos to Albums" in Chapter 3, "Organizing Photos").
- 2. Click the album name to switch to it.
- **3.** Click the Book button under the display pane to switch to book mode.
- **4.** Pick a theme from the Theme pop-up menu in the book pane. Each theme offers different layout options.
- 5. Decide if you want titles, comments, or page numbers to show in your book. Not all themes display them regardless of how you set the checkboxes.
- **6.** Working left to right, choose the design for each page from the Page Design popup menu and add text as desired. To keep a page from changing, click Lock Page.
- 7. Click Preview at any time to see your book in its own window at a larger size. You can also print a draft book; choose Print from the File menu (Cmd(P)).
- **8.** When you're done, click the Order Book button, and run through the process of ordering your book. For details about this process, see "Ordering Books" in Chapter 6, "Sharing Photos."

✓ Tips

- Your book must contain at least 10 and no more than 50 pages (if you have fewer pages, you'll pay for blank pages).
- Remember that books cost \$3 per page.

Can You Customize iPhoto's Page Designs?

The short answer is, "No, you can't."

The long answer is, "Maybe, if you're willing to get your hands dirty and spend some money on test books." This procedure is **not** for the faint of heart nor do I in any way guarantee that it will work for you, so don't say you weren't warned. Try the following.

- 1. Using Apple's free Mac OS X
 Developer Tools (which may have
 come with your copy of Mac OS X;
 if not, sign up to download them at
 http://connect.apple.com/), you can
 create a new book theme.
- 2. Control-click a *copy* of iPhoto in the Finder, choose Show Package Contents, and navigate to Contents/Resources/English.lproj/Books.
- **3.** Duplicate the folder closest to the design you want, and then inside it double-click the .nib files that match the different page designs to edit them in Interface Builder.
 - You can move photo and text boxes around, resize them, overlap them, and change fonts.
- **4.** Open your new design's book.xml file in Property List Editor and change the Name property to give your design a new name.
- 5. Trash the iPhoto Cache folder in your user's Library/Caches folder before launching your modified copy of iPhoto again.

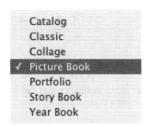

Figure 5.3 To switch between book designs, choose a theme from the Theme pop-up menu in the book pane.

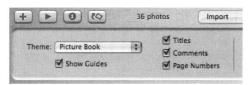

Figure 5.4 To control whether or not titles, comments, or page numbers appear in your book, click the appropriate checkboxes in the book pane.

Figure 5.5 iPhoto warns you if you try to switch themes after entering custom text.

Hacking the Book Design

There is one other way to get different book designs. When you click Order Book, iPhoto makes a PDF file to upload to Apple. You can, in theory, replace that PDF with one that contains custom pages you created in a page layout program. Be sure to duplicate the crop and printer's marks, the size and orientation of the pages, and the number of pages.

To find this book PDF in Mac OS X 10.2, choose Go to Folder from the Finder's Go menu, then type /tmp/iPhoto in the dialog that appears. In Mac OS X 10.3, choose Find from the Finder's File menu and search files whose names starts with Book- and that are invisible.

Designing Books

The first things to do after selecting an album and switching into book mode are to pick a theme for your book and to set the book-wide options that affect all pages.

To design your book:

- **1.** From the Theme pop-up menu, choose one of the seven themes built into iPhoto (**Figure 5.3**).
 - iPhoto switches to the new theme.
- 2. Click the Titles, Comments, and Page Numbers checkboxes to determine whether or not those items will appear in your book (**Figure 5.4**). iPhoto adds or removes those items from the current book design.

- If you enter custom text (any text other than titles or comments) in one theme, you'll lose it if you switch themes (**Figure 5.5**).
- The Collage and Picture Book themes contain no text other than the book title on the cover page and an introduction page, so the Titles and Comments checkboxes have no effect on books that use these themes.
- If you have page numbers set to print in a Picture Book, your order may fail due to a conflict between the page numbers and the photos, which try to print to the edges of the pages. If you don't care about page numbers, just turn them off; if you do want them, leave them on, but be prepared to turn them off if your order fails for an unspecified reason. The error is reportedly with the book printer, not with iPhoto.

Designing Pages

Once you've chosen which theme you want and set the other options that affect the entire book, it's time to turn your attention to the individual pages in your book. The first page must always be the cover design, and it will appear on the cover of your book. You control the layout on all other pages.

To set a page design:

- 1. Select a page thumbnail by clicking it.
- 2. From the Page Design pop-up menu, choose a design (**Figure 5.6**). iPhoto changes the design of the selected page, reflowing photos as necessary.

✓ Tips

- Hold Option when you choose a page design to apply that design to the rest of the pages to the right of the current page.
- Each book theme offers different page designs, so spend some time looking at the page designs in each theme to get a feel for which ones are most appropriate for your purposes.
- After the cover page, which is required, the other page designs are optional.
- The more photos in a page design, the smaller they appear on the page.
- The page designs all assume an aspect ratio of 4 x 3, so if you use a non-standard cropping ratio, photos may not line up as you expect (see "Cropping Photos" in Chapter 4, "Editing Photos"). A different page design or photo arrangement might help, or you may have to recrop the image or revert to the original.
- If you want your cover image to appear inside the book as well, you must duplicate it (see "Duplicating Photos" in Chapter 4, "Editing Photos").

Figure 5.6 To switch page designs, select a page and choose a design from the Page Design pop-up menu.

Working with Photos on Pages

For the most part, I recommend doing all your work with individual photos before you start working on a book. However, when laying out a book, it's entirely likely that you'll discover something you missed previously. There are a few things you can do in book mode after clicking a photo to select it.

- You can rotate the photo using the Rotate button or the commands in the Photos menu.
- ◆ You can duplicate the photo (in the current album) by choosing Duplicate ([Cmd[D]) from the Photos menu.
- You can delete the photo from the current album by pressing Delete.
- You can undo all your changes to the photo by choosing Revert to Original from the Photos menu.
- You can edit the photo by clicking the Edit button, double-clicking the photo, or Option-double-clicking it.
- You can set the photo's title by editing it in the Title field in the info pane or choosing Batch Change from the Photos menu.
- You can see more information about the photo by choosing Show Info (Cmd(I)) from the Photos menu.

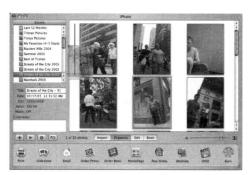

Figure 5.7 Drag your desired cover photo into the top-left position so it's the first image in the album.

Figure 5.8 To move a photo on a page, drag it to the desired location. iPhoto rearranges the photos in the album in organize mode automatically.

Figure 5.9 To move an entire page, drag its thumbnail to the desired location. iPhoto rearranges the photos in the album in organize mode automatically.

Arrangement Tips

Think about the best arrangement of photos in a book. A chronological layout may work well for vacation photos, whereas mixing shots of people might make more sense for party photos. Pay particular attention to the direction people are facing when placing multiple photos on a page for the best layouts.

Arranging Photos on Pages

As you design pages, you must arrange photos so they appear in the right order. Use a normal album, since you can't manually rearrange photos in a smart album.

To arrange photos on pages:

- **1.** Make sure that your desired cover photo is the first (top left) image in the album in organize mode (**Figure 5.7**).
- **2.** Switch to book mode and select the second page. Choose a page design for it; all themes have an optional Introduction design with plenty of room for text.
- 3. Click the next page thumbnail and choose a page design. Choosing a design with more spots for photos pulls them from the pages to the right; choosing a design with fewer photo spots pushes the photos to the pages on the right.
- **4.** To rearrange photos on the same page, drag them to the desired locations (**Figure 5.8**).
- **5.** To move an image to another page, switch to organize mode, and drag the image to the desired location. Switch back to book mode.
- **6.** To move a page containing multiple photos, drag it to the desired location. The other pages hop out of the way as you drag (**Figure 5.9**).
- **7.** Repeat steps 3 through 6 until done.

- Work left to right because the pictures to the right move around based on the page designs you pick. This is important!
- The Lock Page checkbox works, but isn't necessary if you always work left to right.

Dealing with Warning Icons

One problem that can appear any time you print a digital photo is poor quality, or rather, your inability to predict the quality of a print. Numerous variables can play a part in reducing the quality of a printed image, but iPhoto tries to help prevent one of the most common—printing an image at a size larger than is appropriate for the image's resolution. When you have an image that's too low resolution for the proposed size in a book, iPhoto displays a triangular warning icon to alert you to the problem (**Figure 5.10**).

Ways to deal with a lowresolution warning icon:

- Choose a different page design so the photo with the warning icon shrinks small enough that the icon disappears.
- Move the image to a different location on the current page or another page where it will appear at the necessary smaller size (Figure 5.11).
- Cropping a photo makes it more likely that the image won't be large enough to print properly. To remove cropping, select the image, and from the Photos menu choose Revert to Original. Remember that this will remove all your changes, not just the cropping. Try again after cropping the image less heavily.
- If you run into this problem regularly, make sure your camera is set to take pictures at its highest resolution (and buy a larger memory card if file size is what's causing you to reduce the resolution).
- If you decide to live with a low-resolution warning icon, note that it won't appear on the printed page.

Figure 5.10 When a page design calls for a photo to be printed larger than its resolution allows (for good quality), iPhoto places a warning icon on the offending image (all three on the page above).

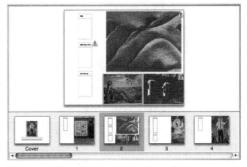

Figure 5.11 To make the warning icon disappear, move the offending image to another location where the printed size better matches the resolution of the image. Note how the mermaid picture no longer has the warning icon now that it's set to print smaller.

Text Warning Icons

If you see a small, yellow, triangular warning icon next to a text box while designing pages (see the screen shots above), it's because the text doesn't fit in the box. The font size is predetermined by the theme, but you can switch to a different font or shorten the text.

I've seen earlier versions of iPhoto generate these warning icons spuriously when you're zoomed all the way out. If that happens to you, zoom in, and if the icons go away, everything should print fine.

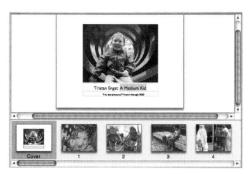

Figure 5.12 To edit or enter text, click a text box and enter new text or edit the existing text. If there is too much text in the text box, a warning icon appears to alert you when you click out of the box. No scroll bars will appear; you must edit the extra text blindly.

Can't Delete Introduction Pages?

Once you have entered text into an Introduction page, iPhoto won't let you change that page to show photos, although it unfortunately provides no error messages to let you know why. The reason is because doing so would delete your text. The workaround is to switch to another theme (save your custom text first by copying it and pasting into another application), and then back again. All custom text is lost when you switch book themes.

Entering and Editing Text

Once you have all your pages laid out to your satisfaction, you can enter or edit the text that appears with the photos.

Ways to enter or edit text:

- Click a text box indicated by the guide lines and either enter new text or edit the existing text (Figure 5.12).
- ◆ You can use all the standard editing techniques and commands that you've become accustomed to as a Mac user—commands like Cut, Copy, and Paste, not to mention double- and triple-clicking.
- You can check the spelling of your text.
 See "Checking Spelling" in this chapter.

- Leave individual text boxes empty to hide them. Deselect the Titles and Comments checkboxes to hide all title and caption text boxes. Photos don't take over the empty space; it just prints blank.
- iPhoto picks up existing album names, titles, and comments for books; changes you make to titles and comments in the book appear in other modes as well.
- If you find the guide lines too obtrusive, deselect the Show Guides checkbox to turn them off. It can be difficult to locate text boxes without the guides, but they still show in the page thumbnails.
- iPhoto tries to simplify editing by zooming in on the page in the display pane so the text displays larger. When you click outside the text box, iPhoto zooms out. This feature is not entirely reliable; sometimes you must use the size slider to zoom manually. Editing can be easier in the preview window; click the Preview button to open it.

Typing Text "Correctly"

You're going to crop your photos perfectly and arrange them just so—are you then going to write text that looks downright trashy? Follow a few simple rules to make sure your text looks as good as your pictures and iPhoto layouts (if you don't believe me, look at the example captions to the right). For details, snag a copy of Robin Williams's classic book *The Mac is not a typewriter*.

Rules for classy looking text:

- Put only one space after periods, commas, question marks, parentheses, or any other punctuation.
- ◆ Use true quotation marks ("") instead of double hash marks (""). To get them, type Option (and Option (Shift) ().
- Use true apostrophes ('') instead of hash marks (''). To get them, type Option]
 and Option (Shift)].
- Punctuation goes inside quotes.
- ◆ Instead of double hyphens (--), use an em dash (—). Press Option Shift -.
- If you want to put a copyright symbol (©) in your book instead of (c), get it by typing Option (G).
- ◆ To make a list, use bullets (•) rather than asterisks (*). To type a bullet, press Option (8).
- In text boxes that have relatively long lines of text, edit to prevent the last line from containing only a single word.
- Avoid underlining text if possible.
 Unfortunately, iPhoto can't italicize a single word, which is the usual approach.
- Use uppercase sparingly, and only in titles. Uppercase text is hard to read.

The Wrong Way

Here it's a cold afternoon in March. Mary is gazing out over the GRAND CANYON at sunset--check out the sweater Grandma Bunny actually knitted for her. The other folks in this picture are:

- * My friend Samuel from work.
- * Mary's cousin JoAnn.
- * JoAnn's husband, who goes by "Chuck".

Copyright (c) 2002 Joe Schmoe

The Right Way

Here it's a cold afternoon in March. Mary is gazing out over the Grand Canyon at sunset—check out the sweater Grandma Bunny actually *knitted* for her. The other folks in this picture are:

- My friend Samuel from work.
- · Mary's cousin JoAnn.
- JoAnn's husband, who goes by "Chuck." Copyright © 2002 Joe Schmoe

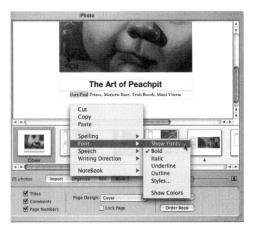

Figure 5.13 To change fonts and styles, Control-click a text box, and from the hierarchical Font menu, choose Show Fonts.

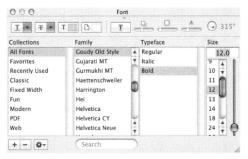

Figure 5.14 Then, from the Font palette, click a collection in the Collections column if you want to narrow the selection of fonts, click a font in the Family column, and choose a style from the Typeface column. Ignore the Sizes column—you can't change font sizes.

Forcing a Refresh

Sometimes a font or style change will affect the current caption text box, for instance, but won't seem to affect all the others on the page. To force iPhoto to refresh the display, switch to another page thumbnail, and then switch back.

Changing Fonts and Styles

iPhoto doesn't let you modify font size to increase the likelihood that your text will fit in the text boxes. You can change the font and style of text boxes, but frankly, I don't recommend messing with font settings; the results can be unpredictable.

To change fonts and styles:

- 1. From the Edit menu's Font menu, choose Show Fonts (CmdT), or Control-click a text box and from the hierarchical Font menu, choose Show Fonts (Figure 5.13). iPhoto opens the Font palette (Figure 5.14).
- 2. Click a text box (not necessary if you chose Show Fonts from the contextual menu). From the Family column, choose a font, and if there are multiple choices in the Typeface column, choose a style. iPhoto changes the text of the current text box and all others like it (such as all titles or all comments).

- To revert to the default font settings, switch to another theme and back, but keep in mind that doing so will also delete any custom text you've typed.
- As far as I can tell in iPhoto 4, using the Copy Font and Paste Font commands from the Edit menu is futile; iPhoto ignores whatever font changes you paste as soon as you leave the text box.

Changing Styles

iPhoto also provides several ways to change just the style of text.

To change styles (I):

 Click a text box, and from the Edit menu's hierarchical Font menu, choose Bold (Cmd B) or Italic.

iPhoto changes all the text in that text box and all others like it (such as all titles or all comments) to the selected style.

To change styles (II):

 Control-click either a text box or selected text within the box, and choose Bold, Italic, or Underline from the contextual Font menu.

For Bold and Italic, iPhoto changes all the text in that text box and all others like it (such as all titles or all comments) to the selected style. With Underline, iPhoto underlines just the selected text in the text box.

✓ Tips

- Bold and Italic are dimmed in the menus if the current font has no Bold or Italic typeface. Check the Font palette to verify.
- Unfortunately, iPhoto does not provide the standard keyboard shortcuts for Italic or Underline.

Wacky Style Behavior

When it comes to fonts and styles, iPhoto has always exhibited some odd behavior that I hope Apple fixes in a future version of the program.

- ◆ Bold and Italic are available from both the Edit menu's Font menu and the contextual Font menu, but Underline exists only in the contextual menu.
- Bold and Italic apply to the entire text box, but Underline applies only to text that you have selected in one text box.
- If a font has Bold and Italic styles, but no Bold Italic combination, you can switch from Bold to Italic using the menus, but not from Italic to Bold without first turning off Italic. It's a bug, not a feature.
- iPhoto doesn't retain any font and style changes made by using Copy
 Font and Paste Font. It would be good if Apple would thus remove those items from the Edit menu.

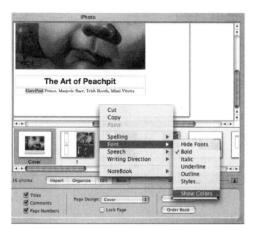

Figure 5.15 To open the Colors palette, Control-click a text box, and from the hierarchical Font menu, choose Show Colors.

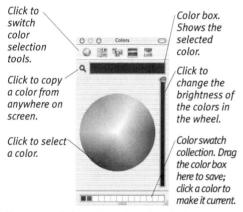

Figure 5.16 Click a color in the color wheel to put it in the color box and apply it to the selected text.

Changing Text Color

Although it's not obvious, iPhoto provides controls to change the color of text. Unfortunately, a bug in iPhoto 1.0, 1.1.1, 2.0, 4.0, and 4.0.1 prevents these changes from sticking, so don't bother trying to use these instructions until Apple fixes the bug.

To change colors:

1. To open the Colors palette, Control-click a text box and choose Show Colors from the Font menu (**Figure 5.15**).

01

In the Font palette, click the text color button.

iPhoto opens the Colors palette (**Figure 5.16**).

2. Select the text to which you want to apply a color, and click a color in the color wheel.

iPhoto changes the color of the text (but changes it back when you switch pages).

- The Colors palette offers five different color selection tools. Unless you understand the others, stick with the color wheel.
- To copy a color from elsewhere on the screen to the color box, click the magnifying glass icon, and then click a color anywhere on the screen.
- Drag the color box to one of the cells of the color swatch collection to save it for repeated use. Clicking one of the color swatches applies it to the selected text.
- Use color carefully and sparingly—it's too easy to make a book garish by applying too much color. You don't want your text to compete with your photos.
- Copying fonts also copies colors.

Checking Spelling

You won't be typing much in iPhoto, but since its editing environment is crude, typos are likely. The last thing you want in a beautifully designed book of great photos is a glaring typo, so I recommend you check the spelling of your titles and captions using iPhoto's spelling checker.

To check spelling in a window:

1. To open the Spelling palette, Control-click a text box and from the Spelling menu, choose Spelling (**Figure 5.17**).

or

Click a text box, and from the Edit menu's Spelling menu, choose Spelling (Cmd(:)).

iPhoto opens the Spelling palette and if there are any misspelled words, selects the first one (**Figure 5.18**).

2. To replace the misspelled word with one of iPhoto's guesses, double-click the guess, or click the guess and then click the Correct button. You can also edit the misspelled word or type a new one in the Spelling palette before clicking Correct.

To ignore the misspelled word for only this spell checking session, click Ignore.

To add the word to your system-wide Mac OS X dictionary, click Learn.

To check spelling inline:

- 1. Either Control-click a text box and from the Spelling menu, choose Check Spelling, or click a text box and from the Edit menu's Spelling menu, choose Check Spelling (Cmd;).

 iPhoto underlines and selects the next misspelled word.
- 2. Control-click the word and choose a replacement word, Ignore Spelling, or Learn Spelling from the contextual menu.

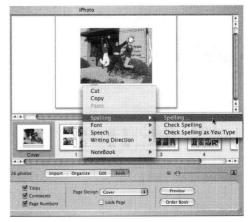

Figure 5.17 To open the Spelling palette, Control-click a text box and from the Spelling menu, choose Spelling.

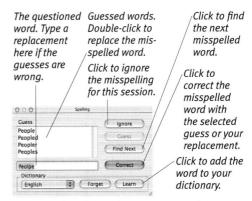

Figure 5.18 Use the controls in the Spelling palette to replace misspelled words, ignore them for this session, or add them to your user dictionary so they won't be flagged as misspelled ever again.

The Best Strategy for Checking Spelling

iPhoto's implementation of Mac OS X's spelling tools is primitive at best. Since you can check only one text box at a time, and iPhoto won't move from one to the next, the easiest approach to checking an entire book is to click in a text box, use the keyboard shortcut for Check Spelling, and then use the contextual menu to correct, ignore, or learn the word.

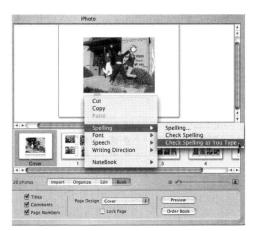

Figure 5.19 To make iPhoto mark misspelled words as you type, Control-click a text box and choose Check Spelling As You Type from the Spelling menu.

Figure 5.20 Note how iPhoto has underlined the misspelled words that I've typed. If we were in Oz rather than in a black-and-white book, the underlines would be red too, as they are on my screen and in the PDF.

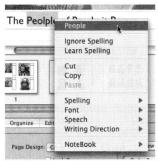

Figure 5.21 To replace a misspelled word with one of iPhoto's guesses, Control-click the word and choose a guess from the contextual menu.

Talking Captions

For longer spans of text, select all the text (Cmd(A)), Control-click it, and from the Speech menu, choose Start Speaking. iPhoto will actually read your text to you, which can help identify mistakes.

Checking Spelling As You Type

Although you don't do much typing in iPhoto, you can have the program check your spelling automatically while you type.

To check spelling as you type:

- **1.** Control-click a text box and from the Spelling menu, choose Check Spelling As You Type (**Figure 5.19**). *or*
 - Click a text box, and from the Edit menu's Spelling menu, choose Check Spelling As You Type.
- **2.** Type your text. iPhoto displays a red line underneath any words that aren't in the system-wide Mac OS X spelling dictionary (**Figure 5.20**).
- 3. Control-click a word with a red underline to display a contextual menu that enables you to replace the word with one of iPhoto's guesses, ignore the misspelling for this spell checking session, or have iPhoto learn the spelling by adding it to your system-wide Mac OS X dictionary (Figure 5.21).

- Unfortunately, iPhoto keeps the Check Spelling As You Type setting active only for the currently selected text box. In other words, it's useless unless you are typing a large chunk of text on a book's Introduction page.
- Since iPhoto ends a spell checking session when you switch pages, Ignore Spelling is useless—if you check that text box again later, iPhoto will have forgotten that you ignored the word.

Previewing Books

You'll certainly want to preview what you've done before having your book printed at \$3 per page.

To preview a book:

◆ Either double-click a page thumbnail or click the Preview button on the right side of the book pane (Figure 5.22). iPhoto opens a new window that shows only the contents of the current book page, along with controls for moving between pages and a checkbox that shows or hides the outlines of text boxes (Figure 5.23).

- You can enter and edit text in the preview window just as though you were working in the display pane. Working in the preview window may prove easier than using the display pane.
- For a better representation of what your page will look like, turn off the guides by deselecting the Show Guides checkbox at the top of the preview window.
- You can leave the preview window open behind the main iPhoto window and it will change as you switch pages. If it doesn't reflect a change you've made, switch pages to force an update.
- For instructions on how to order books from Apple, read "Ordering Books" in Chapter 6, "Sharing Photos."

Figure 5.22 To preview a book, either double-click a page thumbnail or click the Preview button in the book pane.

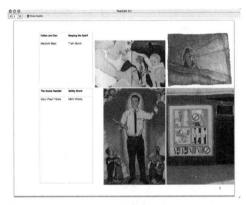

Figure 5.23 The preview window shows exactly what your pages will look like, and you may also find it a convenient place to enter and edit text as well.

Figure 5.24 To print a book on your own printer, make sure you're in book mode, then choose Print from the File menu to open the Print dialog. For additional options, such as a custom page range, click the Advanced Options button.

Ordering Books

For instructions on how to order books from Apple, read "Ordering Books" in Chapter 6, "Sharing Photos."

Printing Books on Your Own Printer

iPhoto makes it easy to preview a book on the screen, and it's equally easy to print a book on your own printer. Printing on your own printer is not only a good way to see what your book will look like when printed, it's also a great way to print multiple photos on a page with more control over text and size than you get when printing using iPhoto's normal printing options.

To print a book on your own printer:

- 1. Making sure you're in book mode, choose Print from the File menu (Cmd P). iPhoto displays the standard Print dialog (Figure 5.24).
- **2.** If desired, click Advanced Options, choose the options you want, and click the Print button.

- To print only one or two of the pages in your book, click Advanced Options and enter the appropriate page numbers in the Print dialog's Pages fields. Be sure to add one to the page number iPhoto displays underneath the page thumbnails, since it doesn't count the cover page, but your printer will.
- I like printing individual pages from a book layout to send to relatives—it's a great way to mix photos and text on a single page.
- Remember that you can also click the Preview button in the Print dialog to generate a PDF instead of printing. I like to do this before printing to double-check that I entered the correct page numbers. You can even save the PDF from Apple's Preview utility and then send the PDF to a friend.

Catalog Book Example and Ideas

The obvious use for iPhoto's Catalog theme is for a catalog listing products with names and descriptions. The grid-like layout works well for giving each item an equal amount of space with plenty of room for text. Catalogs are often throwaway items, so it might make sense to print catalogs on your own printer rather than paying \$3 per page, although getting one copy printed by Apple could make a good historical record of your sales. Along with the cover and introduction pages, you can have layouts with one, four, or eight photos (**Figure 5.25**).

Here I've used the Catalog theme for my prized collection of penguin mugs, which are definitely not for sale!

Ideas for the Catalog theme:

- Photos of expensive pieces for sale at a fancy auction.
- Object identification images for a teacher trying to familiarize a class with similar objects, such as bark and leaves from different types of trees.
- Photos showing houses sold by a real estate agent.
- Pictures of your possessions for a home inventory (print on your own printer).

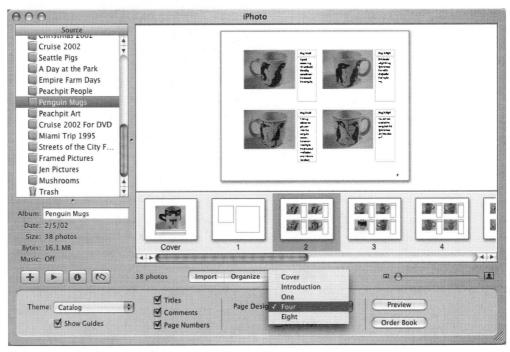

Figure 5.25 Catalog theme example.

Classic Book Example and Ideas

With the Classic theme, iPhoto attempts to mimic traditional photo albums, with a regular layout and both titles and captions underneath each picture. The Classic theme isn't exciting, but it's perfect for kid or trip photo collections where you need to add some commentary (which isn't possible in the Picture Book theme). Rearranging photos can result in more interesting layouts; play with it for a while. Page designs include the cover, an optional introduction page, and pages containing one, two, three, or four photos (**Figure 5.26**).

My example below shows a classic kid photo collection, with my own personal classic kid, Tristan.

Ideas for the Classic theme:

- Pictures of far-flung relatives so parents can help a small child learn what his or her family looks like. (We did this with Tristan, and it was a great success for helping him recognize relatives he saw infrequently.)
- Photos of appropriate people as a gift for a significant milestone, like a retirement party or 50th wedding anniversary.

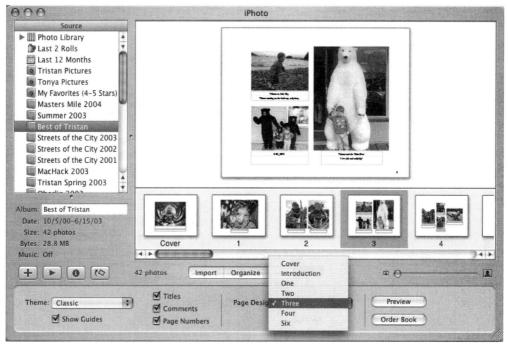

Figure 5.26 Classic theme example.

Collage Book Example and Ideas

iPhoto 4's new Collage book theme falls between the Picture Book and the Story Book themes, with little text and angled images. It's ideal for books in which you don't want text distracting the reader from the images, although the Introduction and One with Text page designs let you have some text. You can choose from page designs that contain one, one with text, two, three, four, or six photos, along with the usual cover and introduction layouts (Figure 5.27). Arrange photos carefully to make sure the images overlap attractively.

Here I've used it for a collection of widely varying mushroom photos I took during a wet summer hike.

Ideas for the Collage theme:

- Snapshots of familiar people or scenes that need no explanation but benefit from the jazzy layout.
- Any photos for which you'd otherwise use the Picture Book theme.

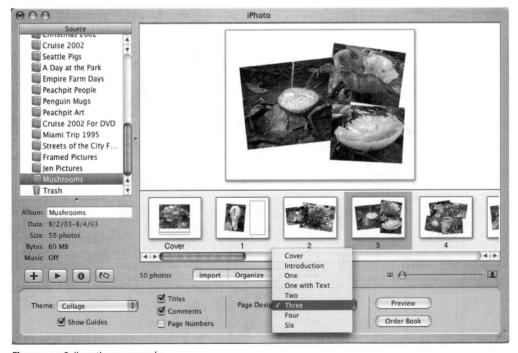

Figure 5.27 Collage theme example.

Picture Book Example and Ideas

iPhoto's Picture Book theme is ideal for books in which you don't want any text at all distracting the reader from the images (I even turned off page numbers below). Plus, in the Picture Book theme, the photos use more of the page than in any other theme. You can choose from page designs that contain one, two, three, or four photos, along with the cover and introduction layouts (**Figure 5.28**).

Here I've used it for my black-and-white pictures of people on the streets of New York City; I don't have anything particular to say about individual images, and the faces and poses speak for themselves.

Ideas for the Picture Book theme:

- Art photos that aren't improved or explained by titles and captions.
- Photos of extremely familiar subjects (such as kid pictures) that don't need captions or that were taken so close together that the cover or introduction text is sufficient.
- Real estate photos of a house and property in different seasons and times of day. A classy iPhoto book would be an improvement on the photo albums that many real estate agents create now.

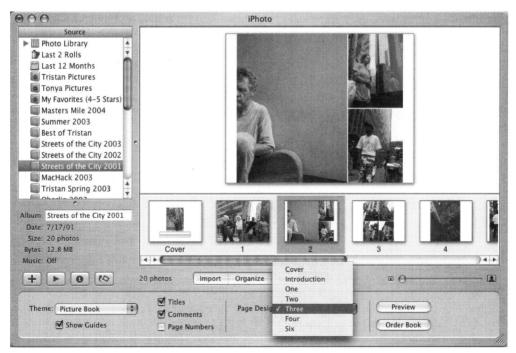

Figure 5.28 Picture Book theme example.

Portfolio Book Example and Ideas

iPhoto's Portfolio theme is clearly aimed at anyone who needs a classy, hardcover portfolio of their work. Like the Picture Book theme, the Portfolio theme tries to show pictures at the largest sizes reasonable, but it also includes text boxes for titles and captions. Aside from the cover and introduction, page designs in the Portfolio theme include layouts with one, two, three, or four photos each (**Figure 5.29**).

Below is a Portfolio book showing off original works created by four creative and talented artists: Marjorie Baer, Trish Booth, Gary-Paul Prince, and Mimi Vitetta.

Ideas for the Portfolio theme:

- Photos of an artist's work that need titles and captions. Many artists use portfolios that aren't as classy as an iPhoto book, so it could be a nice step up.
- A collection of photos of the pieces from a specific gallery or museum show.
- Pictures of craft projects to show off additional work not present at a crafts fair booth.
- Digital photos of a small child's artwork, so you can remember it without keeping reams of paper in the attic for the rest of time.

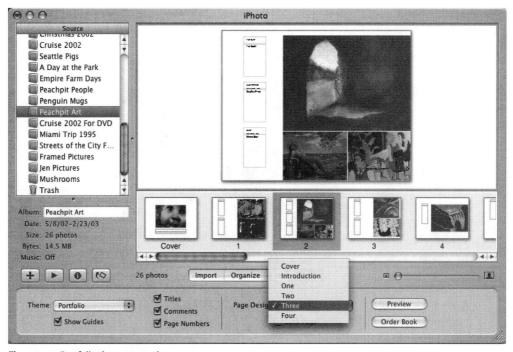

Figure 5.29 Portfolio theme example.

Story Book Example and Ideas

Most of the other themes are quite formal, but not the Story Book theme. Photos appear at angles, overlap, and share a single text box per page. Photo placement can also change radically with different size pictures. Be careful the overlap doesn't cover important parts of a photo—it's worth previewing books using this theme carefully. Available page designs include the cover and a unique introduction page that has photos on it, pages with one, two, or three images, and an ending page with a text box underneath the images (**Figure 5.30**).

Here I've used the Story Book theme for a chronological set of photos from the Alaskan MacMania cruise in 2002.

Ideas for the Story Book theme:

- Pictures of a trip, complete with the story of what's happening on each page.
- Pictures of local attractions for guests at a bed-and-breakfast to use when planning excursions for the day. (Think of it as a high-class brochure.)
- Photos of a child's favorite objects acting out a simple story.
- Snapshots from a family reunion or other significant party, made available for guests as a party favor.

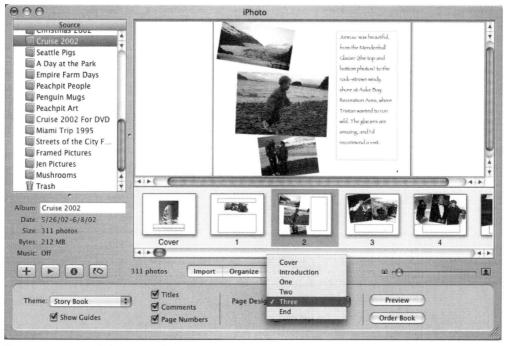

Figure 5.30 Story Book theme example.

Year Book Example and Ideas

Like the Catalog theme, the Year Book theme offers a highly regular, grid-like layout. In fact, the four-photo page design is almost identical between the two themes. But the Year Book theme goes on to offer page designs that include many more images on a page. Aside from cover and introduction pages, you can design pages that have one, two, four, six, eight, twelve, eighteen, twenty, or even thirty-two photos. The traditional yearbook, with names and descriptions, is the most obvious use for this theme (Figure 5.31).

The mug shots collected here are of some of the fine folks at Peachpit Press.

Ideas for the Year Book theme:

- ◆ Photos of the members of a sports team, day care, scout troop, music class, or any other group that might want a record of the faces of its participants, either for the organizer of the group (such as a day care provider wanting to remember the kids from a given year) or for the members (such as folks who want to remember a championship team).
- Annual photos of everyone in a family, so everyone in the family can keep up with how their relatives change over the years.

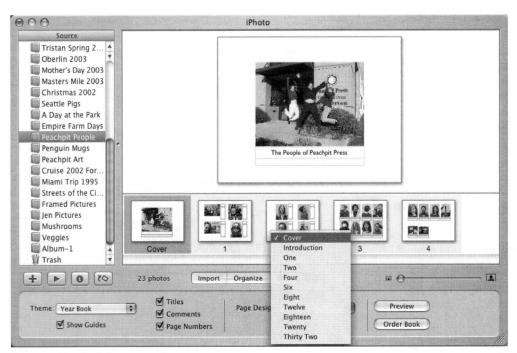

Figure 5.31 Year Book theme example.

Sharing Photos

I can imagine an avant-garde photo exhibit where all the frames are empty, because the artist is making a statement about his reluctance to transfer art from the hidden world of the camera to the open light of day. Luckily, I'm sure no one reading this book would suffer from such intellectual foolishness. We take pictures to look at them, and to share them with our family, friends, colleagues, and customers.

iPhoto shines when it comes to sharing photos. It lets you print photos on your own printer, run custom slideshows with music, email photos to friends, order higher quality prints than you may be able to coax out of your printer, order the books we created in the last chapter, publish photos on Apple's Web-based .Mac HomePage service, create custom screen savers, export pictures to individual files, create Web pages for posting on your own Web site, and even generate QuickTime movie slideshows that you can share with anyone. Phew!

For the most part, Apple has done a good job of implementing these features, although I'll help you avoid some pitfalls and tell you about some other programs and plug-ins that extend iPhoto's flexibility and power.

Accessing Sharing Tools

Since Apple believes that most iPhoto users will spend the majority of their time organizing and sharing photos, they made most of the sharing tools available in organize mode, with a few less-frequently used tools hidden away in the File menu.

Ways to access sharing tools:

- ◆ At any time, click the Organize button under the display pane (**Figure 6.1**). See "Entering Organize Mode" in Chapter 3, "Organizing Photos," for other methods.
- You can run a slideshow at any time.
 Just select an album or some individual photos, and then click the triangular slideshow button under the album pane.
- ◆ Some of the sharing tools are accessible from the File menu even when you're in other modes (**Figure 6.2**). You can print photos at any time by selecting one or more photos (or an entire album) and choosing Print from the File menu (Cmd(P))—it's the same as clicking the Print button. You can also print copies of books on your own printer, but the only way to do so is to choose Print from the File menu (Cmd(P)) when you're in book mode. Also, choosing Export from the File menu (Cmd(Shift(E)) is the only way to display the Export Photos dialog.

Import Organize	Edit	Book	
mipore organice		DOOR	λ

Figure 6.1 To access the sharing tools, switch into organize mode by clicking the Organize button.

Figure 6.2 You can access the Print and Export commands from the File menu.

Sharing Tools Overview

When you click a button for a sharing tool in the organize pane (**Figure 6.3**), expect iPhoto to open a window or dialog.

✓ Tip

■ Remember that exporting and printing books must be done from the File menu.

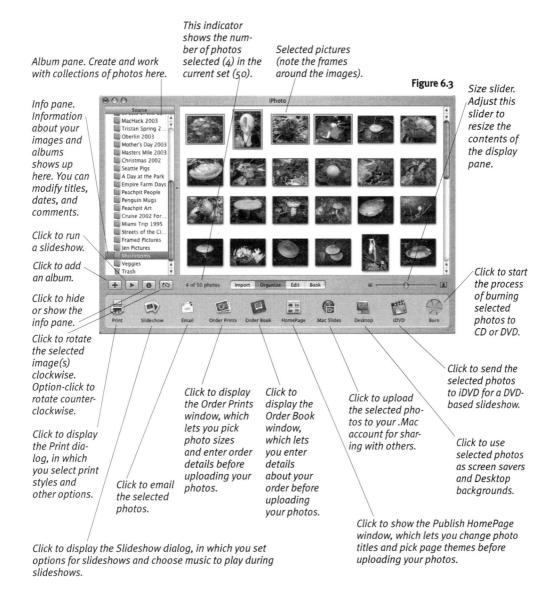

Printing Photos

Many people prefer to print their photos on inexpensive color inkjet printers rather than waiting for online orders.

To print photos:

- 1. Select one or more photos to print.
- Either choose Print from the File menu (Cmd(P)), or click the Print button in the organize pane.
 iPhoto displays the Print dialog (Figure 6.4).
- **3.** From the Presets pop-up menu, choose appropriate settings (the contents are printer-specific). If you don't like the presets, you can access all available settings by clicking Advanced Options.
- **4.** From the Style menu, choose the desired style: Contact Sheet, Full Page, Greeting Card, N-Up, Sampler, or Standard Prints.
- **5.** Set the options for the style you selected.
- **6.** Enter the number of copies to print.
- **7.** Click the Print button. iPhoto sends your photos to the printer.

✓ Tips

- In book mode, choosing Print from the File menu lets you print book pages that mix photos and text on a single page.
- If you see a yellow warning icon in the Print dialog, see "Dealing with Warning Icons" in Chapter 7, "Troubleshooting."
- If necessary, iPhoto shrinks images proportionally to fit, thus increasing the border size.
- Save changes made in Advanced Options for repeated use by choosing Save As from the Presets menu while you're viewing the Advanced Options settings.

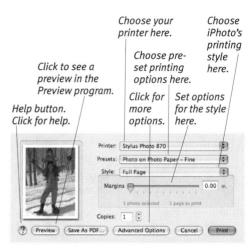

Figure 6.4 To print selected photos, choose Print from the File menu to display the Print dialog, select your desired options, and click the Print button.

Adding a Printer

If you've never printed from Mac OS X before, follow these steps to add a printer.

- **1.** In the Print dialog, choose Edit Printer List from the Printer pop-up menu to display the Printer List window in the Printer Setup Utility.
- **2.** Click the Add button to show the printer selection dialog.
- **3.** Choose a printer connection method from the pop-up menu at the top of the dialog.
- **4.** In the area below the pop-up menu, enter printer details or select a printer.
- **5.** Click the Add button to dismiss the dialog.
- 6. Quit the Printer Setup Utility.

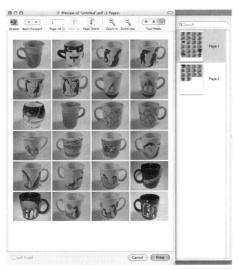

Figure 6.5 To preview a printout in Apple's Preview application (shown above), click Preview in the Print dialog.

Test, Test, Test!

A few things can affect how a photo looks when it comes out of your printer.

- Printer capabilities, both what they can do physically and what their drivers allow in the Page Setup and Print dialogs, vary by brand and model.
- Inkjet printers print very differently on different sorts of paper, and it's important to match the print settings to the type of paper you're using.
- iPhoto's print styles (covered next) offer a variety of options.

It may take several tries to determine the best combination of options. You may be able to try some in economy mode on cheap paper, but in the end, you may have to expend some ink on a few sheets of expensive photo paper. To reduce the waste and cost, keep good notes for subsequent printing sessions.

Previewing Prints

Ink and paper for color inkjet printers are expensive, particularly glossy photo paper. If you're unsure about what's going to print, it's best to preview the output before committing it to expensive paper. Another reason to preview your printout is that the preview in the Print dialog only shows you the first page of photos to print.

To preview prints:

- **1.** Select one or more photos to print.
- **2.** Either choose Print from the File menu (CmdP), or click the Print button in the organize pane to display the Print dialog.
- 3. Pick a style and set desired options.
- **4.** Click the Preview button. iPhoto "prints" the selected photos to a temporary PDF document called "Untitled" and opens it in Apple's Preview application (**Figure 6.5**).
- Click the thumbnails on the right side to see multiple pages, and when you're done, close the window.

- You can save the temporary document in the Preview application if you want a PDF version.
- Previewing in this fashion won't help you determine if your photos will fit within the margins of your printer. Also, any printer-specific changes you make (such as forcing black ink on a color printer) won't be reflected in the preview. See if your printer has an economy or draft mode you can use to test printer-specific features on a single page of photos.

Printing Contact Sheets

The first printing style iPhoto offers is the Contact Sheet style, which prints multiple images per sheet of paper (**Figure 6.6**).

Uses for contact sheets:

- Contact sheets are traditionally used to look at a number of photos at once, which is handy for comparing different versions of the same picture, or for letting relatives who don't have a computer pick which photos they'd like you to order for them as prints.
- You can buy special paper for stickers or decals, so printing a contact sheet could be an easy way to make custom stickers. You don't have enough control in iPhoto to print on perforated sticker stock, so you must cut out the stickers.

✓ Tips

- If you select only one photo and print a contact sheet, iPhoto replicates the photo to as many spots on the page as are available. That's handy for wallet photos.
- See "Printing N-Up Photos" in this chapter for slightly different options.
- The maximum number of photos to print across the page is 8; that gives you 13 rows for a total of 104 pictures.
- For more white space between photos and a layout that doesn't print all the photos in landscape orientation, deselect the Save Paper checkbox.
- If you want titles or comments printed as well, print pages from the Year Book or Catalog book theme instead.
- If you see a yellow warning icon on a photo in the Print dialog, try increasing the number of photos per page to print the photos at a smaller size.

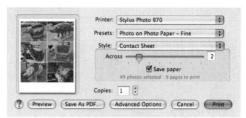

Figure 6.6 iPhoto's Contact Sheet style prints multiple images per sheet of paper.

ImageBuddy

For more control over your contact sheets, check out the \$18 ImageBuddy from KepMad Systems. ImageBuddy lets you set the number of columns and rows, whether titles will print under the images, and even the font and size of the titles. The demo version of ImageBuddy, which you can download from www.kepmad.com, prints the word Demo over each photo, but it should give you a good idea of whether or not you need ImageBuddy's extra capabilities.

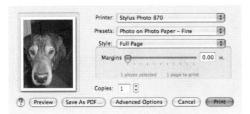

Figure 6.7 iPhoto's Full Page style prints a single photo at the largest size that will fit on a piece of paper.

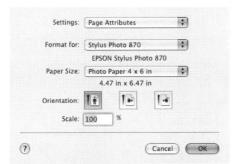

Figure 6.8 To print on 4" x 6" paper, you must first select the appropriate paper size in the Page Setup dialog, accessible by choosing Page Setup from the File menu.

Gimp-Print Drivers

What your printer can do is determined by its driver, system-level software provided by Apple or the manufacturer. There's also Gimp-Print, an open source set of drivers for over 500 printers, which offers support for printer options that the manufacturers may not support in Mac OS X. For instance, if you want to print on roll paper or other unusual paper sizes, you may need to use Gimp-Print. It's built into Mac OS X, and all you have to do is add a new printer normally and select the appropriate driver; make sure to give your printer a unique name. Be sure to check all the Page Setup and Print dialog options before printing using a Gimp-Print driver!

Printing Full-Page Photos

iPhoto's second printing style prints each selected photo at the largest size that will fit on a piece of paper (**Figure 6.7**).

Uses for full-page prints:

- Anything you want to print as large as possible but don't mind if it doesn't match standard aspect ratios.
- ◆ Prints on special 4" x 6" or roll paper; make sure to choose Page Setup from the File menu (Cmd\Shift\P) and select the proper paper size in the Page Setup dialog before printing (Figure 6.8).

- If a photo's aspect ratio does not match that of your paper, iPhoto shrinks the photo proportionally to make it fit, which increases the white borders.
- If your printer has the same margins on every side of the paper, you can enter the paper size into the Custom fields in the image editing window's toolbar before cropping to get the largest possible image on paper. (If the printer margins aren't the same on every side, convert the paper size to millimeters and subtract the margins from each side appropriately.)
- Don't assume iPhoto can print to your printer's minimum margins. Test a few full-page prints in economy mode first to learn what will come out.
- Don't bother entering your printer's minimum margins to get the smallest possible margins; any number (including 0.00) lower than the printer's minimum margins results in a printout that uses as much of the paper as possible.
- If you see a yellow warning icon in the Print dialog, try increasing your margins.

Printing Greeting Cards

iPhoto's third printing style offers two options for printing folded greeting cards (**Figure 6.9**).

Uses for greeting cards:

- Print your own holiday cards rather than buying pre-printed ones.
- Make custom birthday cards for friends and family.
- Print invitations to a party.

✓ Tips

- You can choose between single-fold and double-fold greeting cards. Single-fold greeting cards print the photo on half the paper; double-fold greeting cards print the photo on one-quarter of the paper.
- Cropping a photo to an aspect ratio of 8 x 5 increases the size of the photo for a single-fold greeting card. However, cropping to 5.5 x 4.25 for a double-fold greeting card doesn't make a noticeable difference because it's so close to the original aspect ratio of 4 x 3.
- There's no way to prevent photos from printing right at the folded edges, which looks particularly amateurish with double-fold cards. Easy Card (see sidebar) does a better job.
- iPhoto doesn't let you enter text inside the greeting cards or print a photo on the inside of the card. Consider one of the alternatives mentioned in the sidebar to work around this problem.
- You can buy special photo paper for greeting cards that's pre-scored for easier and more attractive folding.

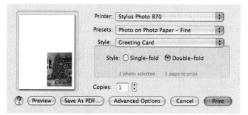

Figure 6.9 iPhoto's Greeting Card style lets you choose between single-fold and double-fold greeting cards. Unfortunately, it doesn't let you enter text.

Greeting Card Alternatives

So you want more control over your greeting cards? Yeah, me too. Here are some options:

- ◆ Most online photo processors enable you to print and mail customized greeting cards from your photos, and in fact, Kodak's Ofoto service, which is what Apple uses for ordering prints online, also offers this feature. Until iPhoto supports it internally, however, you'll have to upload prints to an online service manually and customize your greeting card on the Web.
- Buy a copy of Script Software's \$20
 Easy Card, which does a great job of creating and printing greeting cards and custom envelopes. You can even drop photos into it from iPhoto.

 Download a copy of Easy Card from www.scriptsoftware.com.
- Buy a copy of Nova Development's \$59.95 Print Explosion Deluxe or \$49.95 Art Explosion Greeting Card Factory, which are designed to create greeting cards, along with a wide variety of other printed materials. Find them at www.novadevelopment.com.
- Write your message inside the card by hand! (Perhaps that's obvious.)

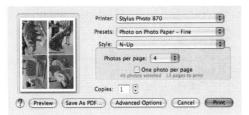

Figure 6.10 iPhoto's N-Up style lets you pick how many photos will appear on the page from a pop-up menu.

N-Up vs. Contact Sheet

The N-Up and Contact Sheet styles differ in two important ways:

- With the N-Up style, you pick how many photos will appear on the page, whereas with Contact Sheet you pick how many columns of photos will print on the page.
- The N-Up style does a better job spacing photos out so they fill the entire page. The Contact Sheet style can leave a large bottom margin.

Whether you use N-Up or Contact Sheet depends on precisely what you're trying to achieve, since their printing styles are very similar.

Printing N-Up Photos

iPhoto's fourth printing style looks and works much like the Contact Sheet style covered previously, but lets you pick exactly how many photos you want to appear on the page: 2, 4, 6, 9, or 16 (**Figure 6.10**).

Uses for N-Up prints:

- Full-page layouts of photos with even margins.
- Anything for which you might use the Contact Sheet style.

- If you select only one photo when using the N-Up style, iPhoto replicates the photo in as many spots on the page as are available. That's handy for wallet photos.
- If you want titles or comments printed as well, print pages from the Catalog book theme instead of using N-Up.
- If you see a yellow warning icon on a photo in the Print dialog, try increasing the number of photos per page to print the photos at a smaller size.

Printing Sampler Sheets

iPhoto's fifth printing style provides two templates that mix photos of different sizes. The first template places three photos on a page; the second arranges six photos on a page (**Figure 6.11**).

Uses for sampler sheets:

- Print collections of photos for relatives, instead of printing individual prints.
- Print your most recent photos for an informal, gallery-style display.

- Unless you plan to cut the printed photos out, make sure all the photos you print with a Sampler layout are of the same orientation. If you mix landscape (horizontal) and portrait (vertical) photos, iPhoto can't orient them all correctly.
- If you want your printed page to be in portrait orientation, use landscape photos with Template 1 (Figure 6.12) or portrait photos with Template 2. If you want your printed page to be in landscape orientation, use portrait photos with Template 1 or landscape photos with Template 2 (Figure 6.13).
- Pay close attention to iPhoto's preview to make sure you know exactly what will print before clicking the Print button!
- To control their page location, arrange the photos manually in an album first.
- If you select only one photo, iPhoto uses that photo in all the spots on the page.
- With careful trimming, you can fit a sampler sheet into an 8" x 10" frame.
- For different layouts, either print pages from a book layout or see "Printing Custom Layouts" later in this chapter.

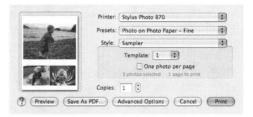

Figure 6.11 Template 1 of iPhoto's Sampler style prints three photos on a page.

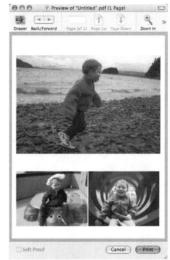

Figure 6.12 Here's the preview of landscape photos printed with Sampler Template 1, which results in a page in portrait orientation.

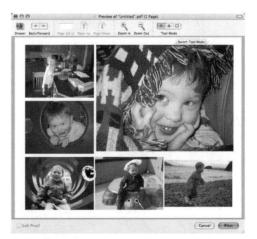

Figure 6.13 Here's the preview of landscape photos printed with Sampler Template 2, which results in a page in landscape orientation.

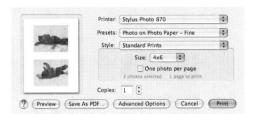

Figure 6.14 iPhoto's Standard Prints style enables you to print photos at traditional sizes so they fit in standard frames and photo albums.

Printing Standard Prints

iPhoto's sixth and final printing style prints photos in five standard sizes: $2^{\circ} \times 3^{\circ}$, $3^{\circ} \times 5^{\circ}$, $4^{\circ} \times 6^{\circ}$, $5^{\circ} \times 7^{\circ}$, and $8^{\circ} \times 10^{\circ}$ (**Figure 6.14**).

Uses for standard prints:

- Print photos for inclusion in traditional photo albums that accept only standardsize prints.
- Frame your pictures using standard frame sizes.

- It's important to crop photos to the appropriate aspect ratio before printing, because otherwise iPhoto shrinks the images proportionally to fit, increasing the white borders and ensuring that your photo will not be exactly the right size.
- If you are printing more than one 2" x 3", 3" x 5", 4" x 6", or 5" x 7" photo, deselect the "One photo per page" checkbox to print two per page, thus saving paper.
- You can buy photo paper in sheets of 4" x 6" paper that work with specific brands of printers. To print on paper of unusual sizes, you must change the paper size in the Page Setup dialog. Open it by choosing Page Setup from the File menu ((Cmd(Shift)P)) and selecting the desired paper size. You will see the best results by using the Full Page style instead; my printer doesn't fill the paper when I use the 4" x 6" option in Standard Prints.
- If you see a yellow warning icon in the Print dialog, check to see if you get the warning icon in the Full Page style as well. If not, the warning icon is probably spurious; otherwise pick a smaller print size. See "Dealing with Warning Icons" in Chapter 7, "Troubleshooting."

Printing Custom Layouts

Despite the availability of the Sampler style many people want more flexibility when printing custom layouts. iPhoto won't help you beyond what you can do with book layouts, but several third-party utilities will.

Portraits & Prints

The \$20 Portraits & Prints, from Econ Technologies, provides a number of layouts, some of which merely try to fit many same-size photos onto a page, others of which provide a mix of sizes (**Figure 6.15**). With the addition of the \$10 Portraits & Prints Template Maker, you can design your own custom layouts with photos, simple graphics (boxes and lines), and even text.

To bring photos in from iPhoto, just drag them from iPhoto to the Portraits & Prints window, then pick a template and choose which photo goes in which slot. Especially nice is the way Portraits & Prints lets you slide a photo around in its slot if the aspect ratios between the slot and the photo don't match. No need for cropping! Download from www.econtechnologies.com.

ImageBuddy

Another option, though trickier to use, is the \$18 ImageBuddy from KepMad Systems. As with Portraits & Prints, you drag your photos from iPhoto into the ImageBuddy window to import them, and once that's done, you can double-click a photo in the collection on the right side to add it to the page at the selected size. Although ImageBuddy is more aimed at printing contact sheets than custom layouts, if you check the Manual Layout checkbox, you can drag individual images around on the page to whatever location you want (**Figure 6.16**). X- and Y-coordinates for each image help you line things up. Download a copy from www.kepmad.com.

Figure 6.15 Portraits & Prints offers numerous layouts that mix different sizes of photos.

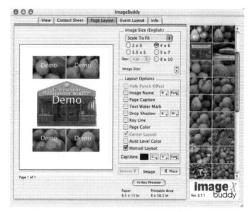

Figure 6.16 With the Manual Layout checkbox selected, ImageBuddy lets you drag images around wherever you want in your layout.

Remember Book Layouts

Keep in mind that the cheapest and easiest way to put a number of photos on the same page is by printing a page from a book layout. See Chapter 5, "Creating Books," for details.

Paper Types

Computer superstores sell a vast number of different types of inkjet papers. What should you buy? You're almost certain to get good results with paper made by the manufacturer of your printer. Papers from other manufacturers will likely work well too, but aren't as guaranteed. The basic paper types include:

- Plain paper. Use it only for drafts or text; photos will look awful.
- Matte paper. These papers are heavier than plain paper and have a smooth, but not glossy, finish.
- Glossy photo paper and film. These papers, which come in a bewildering variety of types and weights, are heavier yet and have a glossy surface that looks like standard photo paper. Glossy film is actually polyethylene, not paper. Use glossy paper for your best prints.
- Specialty papers. You can buy papers that look like watercolor paper, have a metallic sheen, are of archival quality, or are translucent. Other specialty papers can be ironed onto T-shirts, are pre-scored for folding, have magnetic backing, and more.

If you like printing photos on your own printer, I strongly encourage you to buy a variety of papers and see what you like. Also fun to try is a sample pack from Red River Paper, an online paper vendor at www.redrivercatalog.com.

Printing Tips

How can you achieve the best quality prints? Along with repeated testing, try these tips for working with your photos and your printer:

- ◆ Use a good quality inkjet printer. Sixcolor printers produce better output than four-color printers, and printers designed to print photos do a better job than general-purpose printers (but may not print text as well).
- ◆ Make sure your print head is clean and aligned. If your printouts don't look quite right, try cleaning the print head.
- Use good paper. Modern inkjets lay down incredibly small drops of ink, and standard paper absorbs those drops more than photo paper, blurring printouts.
- Make sure to print on the correct side of the paper (it's usually whiter or shinier).
- Don't handle the surface of the paper that will be printed on. Oils from your skin can mess up the printout.
- Remove each sheet from the output tray after printing, particularly with glossy films, and be careful not to touch the surface until it has dried
- In the Advanced Options of the Print dialog, make sure you're using the highest resolution and appropriate other settings. In particular, aim for settings that favor quality over speed.
- When printing black-and-white photos, make sure to print with only black ink.
- Make sure to crop photos to the right aspect ratio before printing, or you'll end up with larger white borders.

Setting up Slideshows

A slideshow is the easiest way to display your photos while at your computer. For playing music during your slideshow, iPhoto integrates with Apple's iTunes music software.

To configure slideshows:

- In organize mode, click the Slideshow button in the organize pane.
 iPhoto opens the Slideshow dialog. Click the Settings tab (Figure 6.17).
- **2.** Choose the transition type, direction, and speed.
- **3.** Enter the length of time you want each photo to remain on the screen, and select desired additional display options.
- **4.** If you want music to play during your slideshow, click the Music tab, select Play Music During Slideshow, choose a playlist from the Source pop-up menu, and, if you want only a single song to play, select it (**Figure 6.18**).
- 5. Click Save Settings or Play

- Scale Photos to Fill Screen displays only the center of portrait-orientation photos but eliminates black bands on the sides.
- Each album has its own music setting.
- To search for a song, enter the first few characters in its name or the artist's name in the Search field. iPhoto narrows the list as you type. Click the X button to clear the Search field and expand the list.
- To sort the list of songs, click the header of the Song, Artist, or Time column; sorting by time makes it easier to match the music to your slideshow's length.
- Click the triangular Play button to play the selected song; click it again to stop.

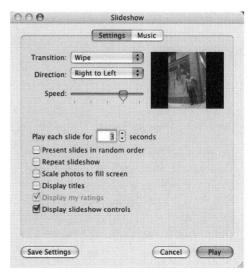

Figure 6.17 Configure how your slideshow displays using the Settings tab of the Slideshow dialog.

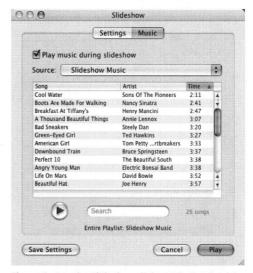

Figure 6.18 In the Slideshow dialog's Music tab, pick either an entire playlist or a single song to play during your slideshow. You can't select multiple songs other than as a full playlist.

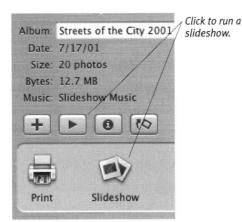

Figure 6.19 To run a slideshow, click either the permanent Slideshow button under the album pane, or click the Slideshow button in the organize pane to display the Slideshow dialog, and then click Play The permanent button is easier unless you need to change settings.

Ordering Your Slideshow

Slideshows start with the image in the upper-left position of the selection or the album. But if you have the "Place Most Recent Photos at the Top" option set in iPhoto's Preferences window, you'll find it impossible to show a chronological sequence of pictures. Turn that setting off in iPhoto's Preferences window and make sure to arrange by film roll (import order) or date to get a first-to-last ordering of your photos.

Running Slideshows

Configuring slideshows is easy, but running them is even easier.

To run a slideshow:

- **1.** Select the photos you want to display.
- Click the Slideshow button that's always available under the album pane (Figure 6.19).

or

In organize mode, click the Slideshow button, and then click Play in the Slideshow dialog.

To control a slideshow:

- ◆ To pause and restart the slideshow, click the Play/Pause button in the slideshow controls or press Spacebarl.
- ◆ To move back and forth between slides, whether or not the slideshow is paused, click the left or right arrow button in the slideshow controls or press either ← (the left arrow key) or → (the right arrow key).
- ◆ Press ↑ (the up arrow key) to speed up the slide display time by one second per slide; press ↓ (the down arrow key) to slow it down by one second per slide.
- To stop the slideshow, press any alphanumeric key or click the mouse.

- The slideshow controls are a great help, but note that keyboard shortcuts for rotating, rating, and deleting photos also work during a slideshow, whether or not slideshow controls are showing.
- Move the pointer during a slideshow to show the hidden slideshow controls.
- If no photos are selected, iPhoto shows all the photos in the current album.

Slideshow Tips

Although setting up and playing slideshows is easy, you can produce better results by keeping these tips in mind:

- ◆ To avoid black edges on monitors that don't use a 4 x 3 aspect ratio (such as most of Apple's flat-panel displays), either crop images to the size of your screen or set the Scale Photos to Fill Screen option.
- When possible, use photos in landscape orientation or set the Scale Photos to Fill Screen option, since portrait photos will have black bands on the edges.
- Avoid using images smaller than your screen (in pixels), since they will look jaggy when iPhoto scales them up to fit.
- If you really want to show small images, consider pasting them onto a larger background in a graphics program to increase their size and avoid iPhoto's scaling.
- Remember that PowerBooks and iBooks can display on TVs via an S-video cable (you may have to buy it separately). If you have a huge television handy, why not use that for a slideshow instead of the Mac's monitor?
- Another way of running a slideshow on a TV is to copy selected photos to your digital camera's memory card via a USB card reader and then display them via the camera, with its TV cable. Make sure to name them appropriately and put them in the right location to fool your camera into displaying them.
- If you're repeating a slideshow, select a large iTunes playlist. That way, the music plays as long as the slideshow runs.
- If you have two monitors, slideshows use the one containing the iPhoto window.

Other Slideshow Tools

iPhoto can play any MP3 or AAC file you have in iTunes, along with AIFF and WAV files. You can create MP3 and AAC files from your audio CD collection in iTunes, or you can download (legally!) MP3 files from the Internet; search with Google (www.google.com).

Depending on your Mac, you may be able to use Apple's GarageBand software to create instrumental tracks for playing during slideshows. GarageBand comes with new Macs and is included in the iLife '04 suite along with iPhoto.

Also check out SmartSound Software's SmartSound Movie Maestro program, which helps you generate soundtracks for movies and slideshows. It works with iPhoto and comes with a slew of soundtrack-type sounds that you can customize. The program costs \$49.95, and you can find more information at www.smartsound.com.

Finally, other tools can create more sophisticated slideshows than iMovie and either play them on your computer or export them to QuickTime movies. In particular, I recommend checking out Granted Software's free Still Life (www.grantedsw.com/still-life) and iView Multimedia's iView Media Pro 2 (www.iview-multimedia.com).

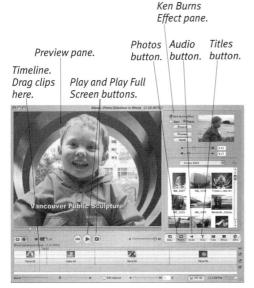

Figure 6.20 Use iMovie to produce and distribute slideshows that are significantly more complex than is possible in iPhoto alone.

Figure 6.21 To record audio, click the Audio button, click the round button to the right of the Microphone feedback, and speak. Click that button again to stop.

Figure 6.22 To add titles, click the Titles button and use the controls to type and format your title.

Creating an iMovie Slideshow

What if you want to add captions or narration to a slideshow? Turn to Apple's iMovie video editor. These instructions are just an overview; refer to iMovie's help or Jeff Carlson's iMovie 4 & iDVD 4 for Mac OS X: Visual QuickStart Guide for more details.

To create an iMovie slideshow:

- **1.** In iMovie 4, click the Photos button and drag your desired photos into the timeline (**Figure 6.20**). iMovie can see all your photos stored in iPhoto, and you can limit the display by selecting an album.
- **2.** Click the Audio button, click the button next to Microphone, and record your narration, clicking the button again to stop recording (**Figure 6.21**). Repeat for each photo's voice-over.
- **3.** In the timeline, arrange your photo clips with the voice-over clips underneath.
- **4.** Check the length of each photo's voiceover, and in the Ken Burns Effect pane, set the length of time for the photo clip to match that of the voice-over.
- 5. Click the Titles button, type your text in the available fields, and select a title style (**Figure 6.22**). Adjust the time the title will display to match the photo clip length. Drag the title style on top of the desired photo clip. Repeat for each photo.
- **6.** View your slideshow by positioning the timeline slider all the way to the left and clicking Play or Play Full Screen.

✓ Tip

■ To avoid applying the Ken Burns Effect (panning and zooming) to a photo, deselect the Ken Burns Effect checkbox and, if necessary, click the Update button.

Emailing Photos

For many people, email is the preferred method of communication, and it works well for sending photos to others.

To configure iPhoto for email:

 In the General tab of iPhoto's Preferences, choose your email program from the Mail Using pop-up menu (Figure 6.23).
 iPhoto changes the Email button's icon to match your email program.

To send photos via email:

- **1.** Select the photos you want to send.
- **2.** Click the Email button. iPhoto displays a dialog with options for your photos (**Figure 6.24**).
- **3.** Choose the maximum size you want the photos to appear from the Size pop-up menu, and, if you want to include titles and comments, select their checkboxes.
- 4. Click the Compose button.

 iPhoto exports the pictures (converting them to JPEG files in the process),
 launches your email program, creates a new message, and attaches the photos, which appear inline only in Apple's Mail (Figure 6.25).

- iPhoto lets you use only Apple's Mail, Eudora, Microsoft Entourage, or America Online. To use iPhoto with Mailsmith, PowerMail, QuickMail Pro, Outlook Express, or Claris Emailer, try Simon Jacquier's free iPhoto Mailer Patcher (http://homepage.mac.com/jacksim/ software/imp.html).
- If you send too many photos, or don't shrink their sizes enough, your message may be too large to be delivered.

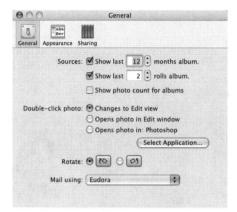

Figure 6.23 In the General tab of iPhoto's Preferences window, choose your email program from the Mail Using pop-up menu.

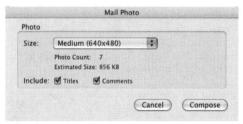

Figure 6.24 Make sure to set a reasonable size for your photos before sending them via email or they'll take too long to transfer for you and your recipient.

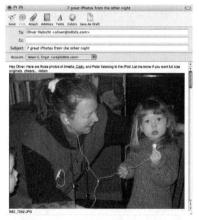

Figure 6.25 Here's what the message looks like in Mail. You don't get much control over the layout, but don't worry, since there's no way of telling what it will look like on the receiving end anyway.

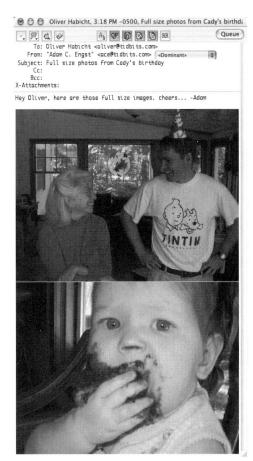

Figure 6.26 To send photos via email, drag them from iPhoto into an outgoing message window, as I've done here with Eudora.

Other Ways of Emailing Photos

Although I recommend that you use iPhoto's built-in support for sending photos via email, there are several alternative methods. In some situations, one of them might work better for you.

Ways to send photos via email:

- Drag one or more photos from iPhoto into a message window of your favorite email program (Figure 6.26).
- Drag one or more photos onto the Dock icon for your favorite email program.

- Dragging photos into new outgoing email messages or onto Dock icons works with at least Apple's Mail, Eudora, Mailsmith, and Microsoft Entourage.
- When dragging photos into an email program, remember that you aren't compressing or resizing them, so they may take a long time to send and receive.
- When you drag photos into an email message, only Eudora and Mail display the photos inline in the body of the message.
- When you drag photos onto an email program's Dock icon, only Mail displays the photos inline in the body of the message; the others treat the photos as normal attachments.

Setting up an Apple ID

Before you can order prints or books, you must have an Apple ID with 1-Click ordering enabled. If you haven't previously set up an Apple ID to order from the Apple Store, you can create one within iPhoto.

To set up an Apple ID:

- Make sure you're connected to the Internet, and in organize mode click the Order Prints button to display the Order Prints window.
- **2.** Click the Set Up Account button. iPhoto displays the Set Up Account dialog (**Figure 6.27**).
- 3. Click the Create Account button. iPhoto displays the first of three dialogs that collect the data necessary to create an account (Figure 6.28). The first asks for your email address and password, the second collects billing information, and the third garners shipping information.
- 4. Enter the necessary information, clicking the Step button to move through the process until you're done. Apple sends an email confirmation at the end of the process.

✓ Tips

- Remember that your Apple ID is always your email address.
- Choose a password that can't be easily guessed. Otherwise miscreants could go in, change your shipping settings, order prints or books with your credit card, and switch back without you realizing.
- If you have trouble with your Apple ID, visit http://myinfo.apple.com/ and confirm or re-enter your settings. You can also set up an Apple ID at this site if necessary.

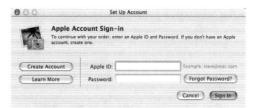

Figure 6.27 To create a new Apple ID, click the Set Up Account button in the Order Prints window to bring up the Set Up Account dialog. Then click the Create Account button.

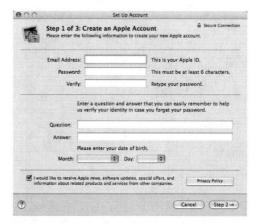

Figure 6.28 Enter your sign-in information, billing details, and shipping address in the dialogs that appear.

Strong Passwords

Apple requires that your password be at least six characters long, but you can make it stronger by ensuring that it contains numbers and punctuation along with uppercase and lowercase letters. One good strategy is to take a phrase you'll remember, like "Take me out to the ball game!" and use the first letter of each word, adding numbers where possible. The above phrase could be turned into this strong password: Tmo2tbg!

Whatever you choose, do not use a proper name or a word that will appear in the dictionary—they're too easy to guess.

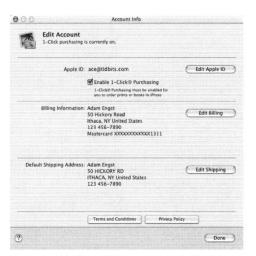

Figure 6.29 Verify and change your Apple ID settings in the Account Info dialog.

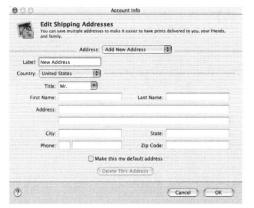

Figure 6.30 To enter a new shipping address, choose Add New Address from the Address pop-up menu, and then enter the new address in the Edit Shipping Addresses dialog.

Forgotten Passwords

If you forget your password, enter your email address in the Apple ID field in the sign-in dialog, click the Forgot Password button, and go through the necessary Web pages. Apple sends you an email message containing your password. The vagaries of Internet email mean that the message may not arrive immediately.

Using Your Apple ID

Once you have your Apple ID set up, you use it with Apple's print- and book-ordering services. It's also useful if you want to use some of Apple's online tech support services or order from the Apple Store. iPhoto usually remembers your Apple ID, but if not, you can always sign in.

To sign in using your Apple ID:

- 1. In either the Order Prints or the Order Books window, click either the Account Info button or the Set Up Account button to display the sign-in dialog (**Figure 6.27** on the previous page).
- **2.** Enter your email address and password, and then click the Sign In button. iPhoto displays the Account Info dialog (**Figure 6.29**).
- **3.** If 1-Click purchasing is turned off, select Enable 1-Click Purchasing.
- **4.** Verify that everything else looks correct (if not, click the Edit button next to the incorrect data and make the necessary corrections), and then click the Done button.

- You can switch between Apple IDs using the method above with two sets of email addresses and passwords. This is handy if multiple people want to order prints or books on separate accounts.
- You can add additional shipping addresses by clicking Edit Shipping in the Account Info dialog, choosing Add New Address from the pop-up menu, and filling in the details in the pane that appears (**Figure 6.30**). Switch between the addresses by choosing the desired one from the Ship To pop-up menu in the Order Prints or the Order Books window.

Preparing to Order Prints

You will want to spend some time preparing your photos for printing by cropping them to the appropriate aspect ratios for prints. But what if you, like me, want to use the same photos for a book, which uses a 4 x 3 aspect ratio? Follow these steps for a solution.

To prepare photos for printing:

- **1.** Make a new album, and add the photos that you want to order prints of.
- **2.** Switch to the album, and edit each photo as desired, other than cropping.
- 3. In organize mode, select all the photos (Cmd/A) and choose Duplicate from the Photos menu (Cmd/D) to make copies (see "Duplicating Photos" in Chapter 4, "Editing Photos," for details).
- **4.** Select just the copies in your album (again, "Duplicating Photos" in Chapter 4, "Editing Photos," explains this).
- **5.** Drag them to the album pane to create a new album of just the copies, and then return to the previous album and delete the copies from it.
 - You now have two albums with identical photos; one with the originals, the other with copies. To keep these albums straight, append "Prints" to the name of one. "Book" to the name of the other.
- **6.** Go through the photos in the Prints album again, this time cropping each to the desired aspect ratio.
- 7. If you're printing photos in different sizes, manually group them by size in the album. That makes keeping track of them in the Order Prints window easier.
- **8.** Now you're ready to order the prints, and the "Book" album is ready to be arranged and laid out in a book.

Pixels and Prints

You may have noticed that iPhoto reports how large your photo is in pixels in the info pane. But how does that match up with print sizes that you order? You mostly don't have to care, since iPhoto displays a low-resolution warning icon when a photo doesn't have enough pixels to print well at the desired size. For reference, here are the pixel sizes at which iPhoto starts adding the warning icon, given both in terms of the 4 x 3 aspect ratio of uncropped photos and with the appropriate cropping for the size at which you want to print.

Note that these are the *minimum* recommended resolutions. The larger your photos and the more they exceed these minimums, the better the final quality.

- ◆ For wallet-sized prints (about 2.4" x 3.4"), you need at least 450 x 337 pixels (when cropped to the above aspect ratio, keep the long side above 450 pixels).
- For a 4" x 6" print, you need at least 900 x 675 pixels (when cropped to 4 x 6, keep the long side above 900 pixels).
- ◆ For a 5" x 7" print, you need at least 1050 x 788 (when cropped to 5 x 7, keep the long side above 1050 pixels).
- For an 8" x 10" print, you need at least 1600 x 1200 pixels (cropped to 8 x 10, keep the short side above 1200 pixels).
- ◆ For 16" x 20" prints, you need at least 2132 x 1600 (when cropped to 8 x 10, keep the short side above 1600 pixels).
- ◆ For 20" x 30" prints, you need at least 2400 x 1800 (when cropped to 2 x 3, keep the long side above 2400 pixels).

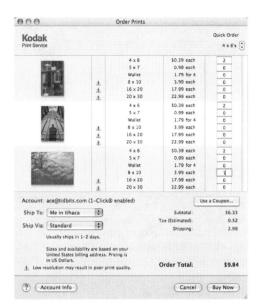

Figure 6.31 To order prints, select one or more photos, click the Order Prints button, and in the Order Prints window, enter the number of prints of each photo that you want. When you're ready, click the Buy Now button.

Shipping Details

With iPhoto 4, you can now have prints delivered not just to U.S. and Canadian addresses, but also to addresses in Japan and some European countries. For updates on where you can send prints, visit Apple's iPhoto Web page at www.apple.com/iphoto/.

Shipping charges vary with the number of prints you order. For 1 to 20 prints, it costs \$2.99. For 21 to 50 prints, it's \$4.99. And if you order more than 50 prints, you'll pay \$6.99 in shipping.

Ordering Prints

Once you've prepared your photos, it's time to order prints.

To order prints:

- Make sure you're connected to the Internet, select one or more photos, and click the Order Prints button. iPhoto opens the Order Prints window (Figure 6.31).
- **2.** For each picture, enter the number of each size print you'd like to order. iPhoto automatically updates the total cost as you add and subtract prints.
- **3.** Choose the appropriate shipping address and method from the Ship To and Ship Via pop-up menus.
- **4.** Check your order carefully to make sure you're getting the right number of each print, and confirm that each photo can print at the size you've selected.
- Click the Buy Now button. iPhoto uploads your pictures and alerts you when it's done.

- If nothing is selected when you click Order Prints, iPhoto includes all the photos in the current album.
- Uploading takes a long time on a slow Internet connection because iPhoto uploads full-size images for best quality.
- If you mostly want 4" x 6" prints, click the Quick Order 4 x 6's arrows to increase or decrease the number of 4" x 6" prints of each photo. You can reset the numbers for individual prints later.
- If you see a yellow warning icon next to a size you want, see "Dealing with Warning Icons" in Chapter 7, "Troubleshooting."

Ordering Books

Once you've designed a book (see Chapter 5, "Creating Books"), ordering it is easy.

To order a book:

- 1. Select the album for which you want to order a book, and verify that each page looks right in the preview window.
- 2. Making sure that you're connected to the Internet, click the Order Book button in either book or organize mode. iPhoto assembles the book, warning you if some photos aren't high enough resolution to print well (**Figure 6.32**), if some text doesn't fit, or if your book is under the 10-page minimum. iPhoto then opens the Order Book window (**Figure 6.33**).
- **3.** Choose a color for the cover from the Cover Color pop-up menu.
- 4. Choose the appropriate shipping address and method from the Ship To and Ship Via pop-up menus.
- 5. Enter the number of books you want to order in the Quantity field. iPhoto automatically updates the total cost as you add and subtract books.
- **6.** Click the Buy Now button. iPhoto uploads your pictures and alerts you when it's done.

✓ Tips

- Books cost \$3 per page, with a 10-page minimum and a 50-page maximum.
- Uploading takes a long time on a slow Internet connection because iPhoto uploads full-size images for best quality.
- If you're warned about low-resolution images, see "Dealing with Warning Icons" in Chapter 7, "Troubleshooting."

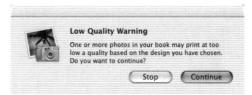

Figure 6.32 If some photos aren't of sufficient quality to print well, iPhoto warns you with this dialog.

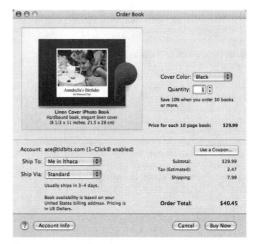

Figure 6.33 To order a book, click Order Book to open the Order Book window. Choose a cover color from the Cover Color pop-up menu, choose the shipping address and method, enter the number of books you want to order, and click the Buy Now button.

Shipping Details

With iPhoto 4, you can now have books delivered not just to U.S. and Canadian addresses, but also to addresses in Japan and some European countries. For updates on where you can send books, visit Apple's iPhoto Web page at www.apple.com/iphoto/.

It costs \$7.99 to ship a single book; each additional book shipped to the same address adds only \$1 to your total.

Book Observations

Since the relatively high cost of printing a book from iPhoto may cause some people to shy away from trying them, I thought I'd offer a few observations based on the books I've ordered.

The good stuff:

- The binding for the books is top-notch. It looks and feels completely professional.
- The paper is heavy stock, quite glossy, and acid-free, so it should last well (although it does show creases quickly).
- Turnaround time from placing the order to receiving a book is only about a week.
- ◆ The packaging for the book was very good, with the book inside a reusable plastic sleeve, everything packed snugly inside a cardboard box that protected the edges from being dinged, and all that inside a mailing box.

The bad stuff:

- ◆ The image quality of the photos in books isn't as good as prints you can order in iPhoto or prints you can create with an inexpensive, six-color inkjet printer like my Epson Stylus Photo 870. Overall, the book print quality is similar to what you'd see in a magazine, with the caveat that consumer-level digital cameras can't match the output quality of equipment used by professional photographers. That said, no one to whom I've shown a book has noticed this on their own.
- On one book I ordered, the cover photo was pasted on slightly crooked.

Similar Book Service

It turns out that if Windows users who can't use iPhoto want to order a book like those you can design in iPhoto, they can do so from a service called myPublisher at www.mypublisher.com. Apple won't comment on any possible relationship with myPublisher; it's possible myPublisher is printing the books for Apple, or Apple may have licensed the same technology that myPublisher uses.

Setting up a .Mac Account

Before you can use Apple's HomePage Web publishing tool or .Mac Slides tool, you need a .Mac account. It's easy to set up but does cost \$99 per year. Luckily, Apple offers a 60-day free trial so you can see if HomePage and .Mac Slides, along with .Mac's other features, are worth \$99 per year to you.

To set up a .Mac account:

- Choose System Preferences from the Apple menu to open the System Preferences window, and then click the .Mac icon to display the .Mac preference pane (the Internet preference pane in Mac OS X 10.2 Jaguar) (Figure 6.34).
- Make sure you're connected to the Internet and click the Sign Up button.
 Your default Web browser launches and takes you to the .Mac home page. Click the Free Trial button.
- 3. Enter your information in the fields provided (Figure 6.35). When you're done, click Continue.

 Your browser displays a summary page (Figure 6.36), offers you the chance to send an iCard announcing the fact that you have an optional new email address (yourusername@mac.com), and takes you to the .Mac home page.
- **4.** Return to the .Mac preference pane, and enter your new .Mac member name and password.
- 5. Close the System Preferences window.

✓ Tip

Since many people have registered .Mac accounts, you may need to choose a more awkward username than would be ideal. Try combining your first name and last name and, if all else fails, add a number.

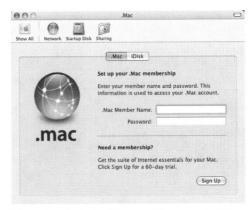

Figure 6.34 To start setting up a .Mac account, click the Sign Up button in the .Mac preference pane, which takes you to a .Mac signup page in your Web browser.

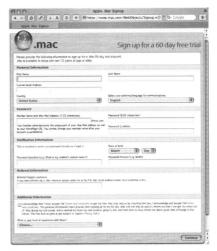

Figure 6.35 Enter your information in the .Mac signup page, and click the Continue button.

Figure 6.36 A confirmation page appears; copy the username and password from that page to the .Mac preference pane and you're done.

Figure 6.37
To use .Mac, connect to the .Mac Web page and click the links at the left of the page.

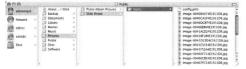

Figure 6.38 Your iDisk stores any pictures you upload to HomePage or .Mac Slides.

Figure 6.39 Use the HomePage Web publishing tool to create and manage a number of different types of Web pages.

Figure 6.40 Use the iCards tool to create personalized email greeting cards using your own photos.

Major . Mac Features

.Mac provides many features, some of which integrate with iPhoto. Click the icons at the left of the .Mac page at www.mac.com to configure and use each tool, to download the free software like Virex and Backup, and to access various special offers (Figure 6.37).

iDisk

Apple provides 100 MB of disk space for each .Mac user, accessed like any other disk—to mount your iDisk, choose My iDisk from the hierarchical iDisk menu in the Finder's Go menu (Cmd Shift)). Predefined folders store backups, documents, pictures, movies, public files to share, Web pages, music, and software you can download.

When you publish pictures using .Mac Slides or HomePage, the photos go in your Pictures folder (**Figure 6.38**), and the HomePage Web page itself goes in your Sites folder.

HomePage

The HomePage Web publishing tool enables you to create different types of Web pages without learning any HTML (**Figure 6.39**). If you know how to create Web pages, you can upload them to your Sites folder to make them available to anyone on the Web at http://homepage.mac.com/yourusername/.

iCards

The iCards tool helps you use the photos in your Pictures folder or Apple's images to send email greeting cards (**Figure 6.40**).

Mail

.Mac provides you with another address—yourusername@mac.com. You can either retrieve mail from it directly (via your email program or a Webmail client) or have it forward messages to another account.

Publishing Photos on the Web Using HomePage

It's easy for .Mac members to create a Webbased photo album from within iPhoto.

To publish photos using HomePage:

- **1.** In organize mode, select an album or the individual photos you wish to publish.
- 2. Making sure that you're connected to the Internet, click the HomePage button. iPhoto opens the Publish HomePage window, displaying a rough preview of how your page will appear (Figure 6.41).
- **3.** Enter or edit titles for the page and the individual photos (iPhoto picks up album and photo titles automatically).
- **4.** Pick a theme from the selection at the right to change the font and frame style.
- **5.** Select the desired .Mac account from the Publish To pop-up menu.
- **6.** Select how many columns you want to display, and if you want a counter or a "Send Me a Message" button to show.
- 7. Click the Publish button.

 iPhoto uploads your pictures to your
 iDisk, and, when it's done, shows a dialog
 that tells you the URL for your page and
 offers to let you edit the page or display it.

✓ Tips

- The photos appear in the same order as those in the album or your selection, but you can drag them to new locations within the Publish HomePage window.
- iPhoto compresses and resizes images to 800 x 600 to reduce upload time. To avoid this, you can upload photos to your iDisk and create albums manually in HomePage online at www.mac.com.

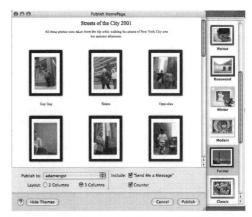

Figure 6.41 Preview your photos in the Publish HomePage window and click Publish when you're ready to upload them.

✓ More Tips

- Clicking Visit Page Now in the confirmation dialog loads the page in your Web browser, where you can easily copy the URL from the Address field.
- You can have up to 48 images in each HomePage photo album.
- Changes you make to photo titles in the Publish HomePage window are not reflected anywhere else, unfortunately.
- iPhoto's spell-checking tools work in the Publish HomePage window.
- You can't control line wrapping at all.
- Titles are limited to 40 characters, although you can enter up to 80 online.
- iPhoto tracks which albums you've published, and if you try to publish an album again, iPhoto asks if you want to create a new one, replace the old one, or edit the old one on .Mac (Figure 6.42, opposite). If you have a fast Internet connection and didn't do much work in the Publish HomePage window, replacing an album can be easier than editing it in .Mac.

Figure 6.42 If you attempt to publish an album to HomePage a second time, iPhoto asks if you'd like to create a new HomePage album, replace the old one, or edit the old one.

Figure 6.43 To edit a photo album, select it in the Pages list and click the Edit button. To delete an album, select it and click the Delete button.

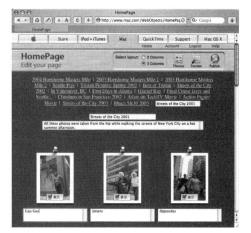

Figure 6.44 Edit your album in the Edit Your Page screen. After you have made changes to the text, the number of columns, the theme, or anything else, click the Publish button at the top of the page to save your changes. You can also click Preview to see what it will look like before you commit to publishing.

Managing HomePage Albums

You can only *create* or *replace* Web-based albums from within iPhoto (**Figure 6.42**). *Editing* albums after publishing requires using the .Mac Web site. For all these tasks, first log in to .Mac at www.mac.com and click the HomePage button at the left of the page.

To edit text:

 Select an album in the Pages list, click the Edit button underneath it (Figure 6.43), and in the Edit Your Page screen, change the text in the text boxes (Figure 6.44). Click Publish when you're done.

To remove photos:

◆ In the Edit Your Page screen, deselect the checkboxes on the photos you want to remove (they aren't deleted from your iDisk's Pictures folder; do that in the Finder). Click Publish when you're done.

To add photos:

 You can upload and add photos manually, but it's much easier to replace the album from within iPhoto.

To change the layout:

- To change the theme, in the Edit Your Page screen, click the Themes button and click the desired theme.
- ◆ To change the number of columns, select a columns radio button at the top.
- Drag photos to rearrange them.
- ◆ To show or hide the counter or the Send Me a Message button, select or deselect the checkbox at the bottom.

To delete an album:

 Select an album in the Pages list and click the Delete button.

Publishing . Mac Slides

Using the .Mac Slides Publisher feature of .Mac along with iPhoto, .Mac members can easily upload a set of photos that anyone with a Mac running Mac OS X 10.2 or later can use as a screen saver.

To publish photos as .Mac Slides:

- 1. Select the photos you want to publish, and click the .Mac Slides button. iPhoto displays a confirmation dialog (Figure 6.45).
- 2. Click the Publish button.

 iPhoto compresses and shrinks the size of the photos to reduce transfer time, and uploads the photos to your iDisk, showing a progress dialog as it uploads (Figure 6.46).

When it's done, it shows a confirmation dialog (**Figure 6.47**).

3. Click the Announce Slideshow button. In your selected email program, iPhoto creates a message with instructions you can send to the people who might want to subscribe to your .Mac Slides.

✓ Tips

- You can move the .Mac Slides upload progress window out of the way and keep working while iPhoto uploads in the background.
- You can find the .Mac Slides in your iDisk in Pictures/Slide Shows/Public.
- It appears that you can select as many photos to upload as .Mac Slides as you want, subject to the amount of free disk space available on your 100 MB iDisk.
- You can store only one set of .Mac Slides at a time—every time you click the .Mac Slides button, the selected photos replace the previous set.

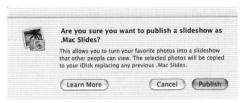

Figure 6.45 iPhoto checks to make sure you realize that publishing photos as .Mac Slides replaces the previous set of .Mac Slides.

Figure 6.46 iPhoto provides a visual progress dialog as it uploads your photos as .Mac Slides.

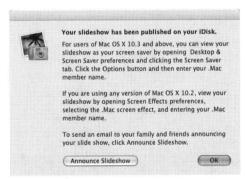

Figure 6.47 Once iPhoto finishes uploading your .Mac Slides photos to your iDisk, it lets you announce the slideshow via email to your friends and relatives.

Make a .Mac Slides Album

If you want to add to your set of .Mac Slides rather than overwriting the previous set, create a .Mac Slides album, add photos to it whenever you wish, and after each addition, publish the entire album.

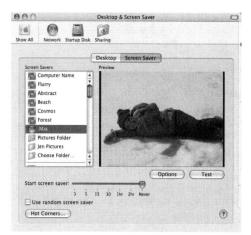

Figure 6.48 Configure the .Mac screen saver in the Screen Saver tab of the Desktop & Screen Saver preference pane.

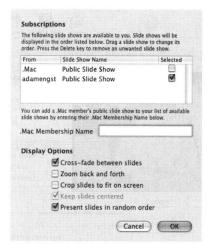

Figure 6.49 Enter the .Mac membership name of the person whose slides you want to view and set screen saver options in the Subscriptions dialog.

Using the Screen Saver

The screen saver comes on automatically after the idle time you set in the Screen Saver tab of the Desktop & Screen Saver preference pane. You can also invoke it manually by putting the pointer in a predefined "hot corner."

Subscribing to .Mac Slides

Although only .Mac members can upload .Mac Slides, anyone whose Mac runs Mac OS X 10.2 or later can subscribe to them and have them shown as a screen saver.

The instructions below are for Mac OS X 10.3; in Mac OS X 10.2, use the controls in the Screen Effects preference pane.

To subscribe to .Mac Slides:

- 1. From the Apple menu, choose System Preferences, click the Desktop & Screen Saver icon, and then click the Screen Saver tab (Figure 6.48).
- 2. Click .Mac in the Screen Savers list.
- **3.** Click the Options button to display the Subscriptions dialog.
- **4.** In the .Mac Membership Name field, enter the member name of the .Mac member whose slides you want to view and click OK.
 - iPhoto adds the .Mac member name to the available subscriptions and closes the dialog.
- 5. Click Options again to make sure the checkbox for your newly entered .Mac member name is selected, and select the other screen saver options from the checkboxes at the bottom of the dialog (Figure 6.49).
- 6. Click OK and close System Preferences.

- Mac OS X downloads the .Mac Slides in the background when you connect to the Internet.
- Because .Mac Slides are compressed and reduced in size, they're not as crisp as local pictures used for slideshows.

Setting the Desktop Picture

In Mac OS X, you can display a picture on your Desktop, and with iPhoto, putting one (or more, in rotation) of your photos on your Desktop is a matter of just clicking a button.

To set the Desktop picture:

- Select one or more photos, and click the Desktop button (Figure 6.50).
 If you selected only one photo, iPhoto immediately changes the picture on your Desktop (Figure 6.51).
 If you selected multiple photos, iPhoto opens the Desktop & Screen Saver preference pane (Figure 6.52).
- **2.** Choose how you want the images to appear on the Desktop, and set the rotation schedule.

- You can also display all the photos in any of your iPhoto albums on your Desktop by selecting the album in the folder list in the Desktop & Screen Saver preference pane's Desktop tab.
- If the picture is in landscape orientation, iPhoto scales the photo to make it fit.
- If the photo is in portrait orientation, iPhoto takes a landscape chunk out of the middle to display on the Desktop. Stick with photos in landscape orientation, or crop them appropriately first.
- iPhoto can put a picture on only one monitor. To put a picture on the second monitor, you must use the Desktop & Screen Saver preference pane in System Preferences; select the iPhoto Selection folder in your iPhoto Library folder to rotate through the same set of photos on the second monitor.

Figure 6.50 Click the Desktop button to set the selected photo as your Desktop picture.

Figure 6.51 With a single click, you can put the photo you have selected in iPhoto on your Desktop.

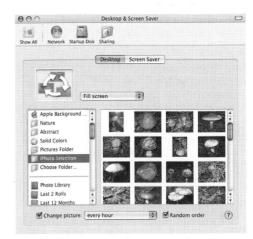

Figure 6.52 Configure how you want your Desktop pictures to appear, and how often they should rotate in the Desktop tab of the Desktop & Screen Saver preference pane.

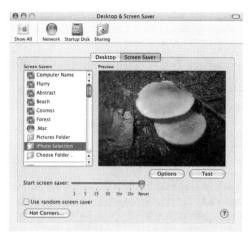

Figure 6.53 When you click the Desktop button in iPhoto, the Desktop & Screen Saver preference pane opens automatically.

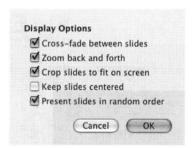

Figure 6.54 Configure how the screen saver displays your photos in the Display Options dialog. Play with these settings to see how they interact with the photos you're using—I've found varying results with different types and sizes of photos.

Creating a Screen Saver

The Desktop button in iPhoto does double duty, not just putting one or more photos on your Desktop, but also setting them as your screen saver.

The instructions on the previous page and below are for Mac OS X 10.3; in Mac OS X 10.2, use the controls in the Screen Effects preference pane.

To create a screen saver:

- 1. With more than one or no photos selected (in the latter case, iPhoto uses the current album), click the Desktop button.
 - iPhoto opens the Desktop & Screen Saver preference pane (**Figure 6.53**).
- 2. If necessary, click the Screen Saver tab.
- **3.** Adjust the Start Screen Saver slider to set how long the screen saver should wait for activity before kicking in, and if you want to set a hot corner, click the Hot Corners button and pick a hot corner in the dialog that appears.
- **4.** To configure options for how the screen saver slideshow looks, click Options and then select the desired checkboxes in the Display Options dialog (**Figure 6.54**). Click OK when you're done. iPhoto sets Mac OS X's screen saver to

use the selected photos or album. The next time your screen saver kicks in, you'll see it displaying those photos.

✓ Tip

Mac OS X 10.3 automatically includes your iPhoto albums in the Screen Savers list, so you can select one from there without going through iPhoto.

Creating a DVD Slideshow with iDVD

One of the ways iPhoto integrates with the rest of the iLife suite is through its capability to send a set of photos to iDVD 4 to create a DVD slideshow that can be viewed on any TV with a consumer DVD player. You must have a Macintosh with a SuperDrive to do make such a slideshow.

To create a DVD slideshow with iDVD:

- 1. Create albums containing up to 99 photos each, select the albums (Shift) or Cmd-click to select multiple albums), and click the iDVD button.

 iPhoto works for a bit, launches iDVD 4, and shows the iDVD main screen.
- 2. Click the Customize button, choose a theme from the Customize Panel that appears (iDVD has several themes that are perfect for photo slideshows), and customize it with text and images (Figure 6.55).
- **3.** To add audio to the main title screen, click the Customize Panel's Media button, choose Audio, select one or more songs, and click Apply.
- **4.** If you want to adjust the theme settings, click Settings and make your changes.
- 5. Double-click a slideshow icon to switch to a screen where you can add, delete, and rearrange photos, plus set slide transitions, select music, and set other options for the slideshow (Figure 6.56).
- **6.** As you work, use the Preview button to verify that your slideshows play as you desire. A small player window simulates a DVD remote control (**Figure 6.57**).
- **7.** When you're ready, click the Burn button *twice* to start burning your DVD.

Drawer Click to choose Click to set a buttons. a theme. photo and edit.

Burn

button.

Figure 6.55 Select a theme for your DVD slideshow and click the albums to select an initial photo and to change the title.

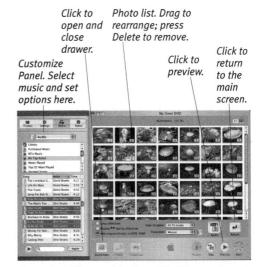

Figure 6.56 When working in a slideshow, you can set various options by clicking the Settings button in the Customize Panel and add music by selecting one or more songs in the audio pane and clicking Apply.

Figure 6.57 When you're previewing a slideshow, you can use the small player window to simulate the DVD's remote control.

Making Good DVD Slideshows

It may be easy to work with iPhoto and iDVD, but you must still expend some effort when creating a DVD-based slideshow if you want the best results. Keep in mind that no matter what, TV quality will be lower than the quality on the computer screen.

- Use iDVD's Preview heavily, and run through all your slideshows from start to end before burning.
- Landscape photos work better than portrait photos, which have large black borders.
- Make sure Always Scale Slides to TV Safe Area is set in iDVD's Preferences window (choose Preferences from the iDVD menu and click the Slideshow tab).
- It's tempting to put as many photos in each slideshow as possible, but resist the temptation and whittle down the slideshow to the most relevant photos. Very similar photos are boring when seen one after another.
- ◆ You can choose the duration between slides, but it's generally best to fit the slideshow length to the audio length. But don't pick so much music that slides stay onscreen for too long.
- Be forewarned; it can be hard to find good music for slideshows. Think about the subject and the mood of the photos and then browse through your iTunes collection to see what songs might fit. It's easier to browse quickly in iTunes than in iDVD.
- Click the Motion button to turn off the theme's motion while you work, but make sure it's on when you burn.

iDVD Slideshow Tips

Look to other sources for full instructions on how to use iDVD, such as Jeff Carlson's iMovie 4 & iDVD 4 for Mac OS X: Visual QuickStart Guide or Jim Heid's book and DVD-video combination The Macintosh iLife, also from Peachpit Press. That said, these tips should help you use iDVD more effectively.

Tips for using iDVD:

- When sending photos from iPhoto to iDVD, you are no longer limited to 6 albums per DVD but each album is still limited to 99 photos.
- Save your iDVD project with a good name: it's the disc name in the Finder.
- Turn on Show TV Safe Area in the Advanced menu to verify that everything you're doing will fit on the TV screen.
- iDVD automatically picks up the music (individual songs or entire playlists) attached to the album in iPhoto, but iDVD lets you choose multiple songs without selecting an entire playlist.
- If you select Add Original Photos on DVD-ROM in the slideshow window, iDVD also makes the photos available as files on the DVD for use with computers. These are stored as normal files, and not in an iPhoto Library folder.
- Quit all unnecessary applications when burning; if anything interrupts the burn process, it can ruin your DVD-R disc.
- DVD-R discs hold 4.7 GB, so you probably won't be able to fill one with slideshows.
 To use all the space, add video.

Sharing Photos on Disc

Although creating DVD slideshows is great, a better way to share photos with people who also use iPhoto is to burn the photos to a CD-R or DVD-R disc as files.

To burn an iPhoto disc:

- Select the photos you want to share by selecting entire film rolls or entire albums (Figure 6.58).
- 2. Click the Burn button. iPhoto asks you to insert a blank disc.
- 3. Insert a blank disc and click OK.

 In the info pane, iPhoto shows the name of the disc and information about how much data will be burned to the disc (Figure 6.59). The disc icon will be red if it can't hold the selected photos.
- **4.** Select fewer or more photos to use the space on your destination disc as desired.
- 5. Change the name of the disc if you want.
- **6.** Click the Burn button again, and when iPhoto asks you to confirm one last time, click Burn (**Figure 6.60**). iPhoto creates a disk image, copies the

selected photos to it, and burns the disc.

✓ Tips

- The info pane statistics aren't accurate until you click Burn the first time.
- If you select albums to burn, the iPhoto disc will retain those album references.
 Film roll information is lost, however.
- Titles and keywords are maintained.
- Your disc name appears in both iPhoto and in the Finder.
- On the disc, your photos are stored in an iPhoto Library folder like the main one.

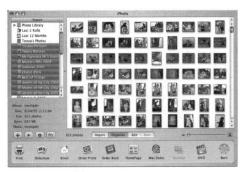

Figure 6.58 Here I've selected several albums, and I'm about to click the Burn button.

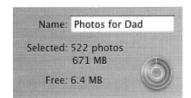

Figure 6.59 Once you've clicked the Burn button, the info pane lets you name your disc and gives you information about how much data will be burned to it.

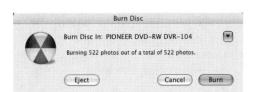

Figure 6.60 iPhoto verifies that you really want to burn a disc with one last confirmation dialog.

Backups and Non-iPhoto Users

Two additional notes. First, this is a great way to make backup discs to protect your irreplaceable photos in case of harm to your computer. See "Backing up Your Photos" in Chapter 2, "Importing and Managing Photos." Also, not everyone uses iPhoto (especially Windows users). For them, export files and burn CD-R discs in the Finder.

Figure 6.61 iPhoto discs appear in your album pane with any albums on the disc showing up under the disc name.

Figure 6.62 The easiest way to import files into iPhoto is to drag the desired files or folders into the display pane or the album pane, as I've done here.

Receiving an iPhoto Disc

What if friends or relatives who use iPhoto send you iPhoto discs containing their photos? Although you can view their photos directly from the disc, if you want to edit a photo or create a book, you must first import the desired images. (See Chapter 2, "Importing and Managing Photos," for more on importing photos.)

To import from an iPhoto disc:

- **1.** Insert the iPhoto disc into your Mac's optical drive and switch to iPhoto. iPhoto displays the disc in your album pane (**Figure 6.61**).
- 2. Select one or more photos and drag them to your Photo Library album to import them just into the Photo Library, into an album to import them and add them to that album, or to the bottom of the album pane to import them and create a new album (Figure 6.62). iPhoto starts importing the photos, showing thumbnails and a progress bar. Click Stop to halt a mistaken import.

✓ Tips

- iPhoto checks for duplicates when importing from iPhoto discs just as it does with other importing methods.
- To import an album from an iPhoto disc, click the album in the album pane, click in the display pane, select all the photos (Cmd(A)), and drag them to the bottom of the album pane to import them and create a new album.

Exporting Files

iPhoto's export capabilities are fairly limited, but they should suffice for most situations.

To export files:

- 1. Select one or more photos.
- 2. Choose Export from the File menu ((Cmd)(Shiff(E)).
 iPhoto displays the Export Photos dialog (Figure 6.63).
- **3.** If it's not already selected, click the File Export tab.
- **4.** Choose the format for the exported photos from the Format pop-up menu, select an image scale, and select how you want them named. Then click the Export button.
- **5.** iPhoto displays a Save dialog. Navigate to your desired folder and click OK to save your images.

✓ Tips

- iPhoto can export into only JPG, TIFF, and PNG formats. For other formats, use a tool like GraphicConverter; see the sidebar to the right.
- Only JPG files can be scaled to a different size; if you save in TIFF or PNG format, you're stuck with the full image size.
- When iPhoto scales an image, it does so proportionally with the limits you set.
- If you haven't changed the title of a photo, and you export with the Use Title button selected, don't check Use Extension as well, or else the filename extension will be duplicated.
- If you export only a single image, iPhoto gives you a chance to rename the image manually before saving (Figure 6.64).

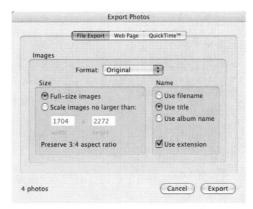

Figure 6.63 Use the File Export tab in the Export Photos dialog to choose the format, scale, and name for your exported images.

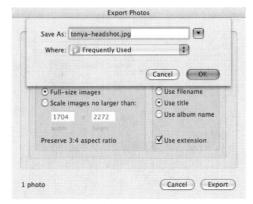

Figure 6.64 If you export only a single image, iPhoto lets you name it from within a dialog.

Use GraphicConverter

If you want to do anything more than basic exporting of files, try the \$30 shareware GraphicConverter, available at www.lemkesoft.com/us_index.html. GraphicConverter is far better at converting images between formats, resizing them, and performing many other useful tasks, a number of which can be done in batch mode on an entire collection of images.

Figure 6.65 For a quick export without any chance to reformat, rename, or resize the exported photos, just drag one or more to the Finder.

Exported Photos May Not Be Rotated

If you want to export a photo you've edited only by rotating it, you'll notice the exported file isn't rotated if you use the drag-to-the-Finder method of exporting. This error happens because iPhoto rotates only the photo's thumbnail initially, rotating the actual photo only if necessary.

You can work around this problem in two ways. First, use the Export Photos dialog instead of dragging to the Finder. Second, make another editing change to the photo, such as red-eye reduction, and then undo that change before dragging the photo to the Finder. Any editing change other than rotation forces iPhoto to modify the photo's file instead of just the thumbnail, which sets the rotation properly as well.

Exporting Files by Dragging

If you just want copies of a couple of photos and don't need to reformat or resize them, you can just drag the files to the Finder.

To export multiple files:

 Select one or more photos and drag the selection to a folder in the Finder (Figure 6.65).

iPhoto saves the files where you drop them, using each file's original name.

✓ Tips

- When you drag photos to export them, you aren't given the opportunity to change their scale or image format.
- You can also drag photos to other photorelated programs. So, for instance, you
 could maintain another photo catalog
 in a program like iView MediaPro by
 dragging photos from iPhoto into iView
 MediaPro's window. This is not actually
 exporting, since the other programs are
 working with the same file as iPhoto.
 Because of this, don't drag files to imageediting programs and make changes,
 because iPhoto won't be able to track
 those changes. And definitely don't delete
 photos from those other programs!
- If you want to export photos in order to burn them to a CD-R disc for a person who doesn't use iPhoto, your best bet is to drag photos from iPhoto to folders in the Finder, and then burn those folders. Watch out for the rotation problem; see the sidebar to the left.
- Unfortunately, you can't drag an album to the Finder to create a new folder containing the album's photos.

Exporting to Web Pages

Along with using Apple's HomePage Web publishing tool, iPhoto can export selected images to a set of Web pages you can upload to your own Web server or to Web space at your Internet service provider.

To export photos to Web pages:

- **1.** Select an album or the individual photos you wish to publish via the Web.
- Choose Export from the File menu (Cmd Shift E).
 iPhoto shows the Export Photos dialog.
- **3.** If it's not selected, click the Web Page tab (**Figure 6.66**).
- **4.** Enter the title for your Web page.
- **5.** Enter the desired number of columns and rows of photo thumbnails.
- **6.** If desired, select a background color or image.
- Select the maximum width and height for the thumbnails and the full-size images.
- **8.** Select the Show Title and Show Comment checkboxes as desired.
- 9. Click Export, navigate to the desired destination folder (it's best to create a new folder inside your user directory's Sites folder), and click OK. iPhoto exports the photos and builds the appropriate HTML files, naming everything for the enclosing folder.
- **10.** Switch to the Finder, open the folder in which you saved your Web page, and double-click the HTML file to open it in your Web browser (**Figure 6.67**).
- If necessary, upload the folder to your Web site using an FTP program like Interarchy (www.interarchy.com).

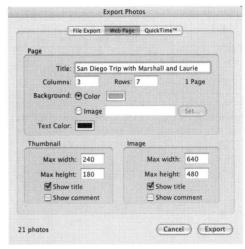

Figure 6.66 Use the options in the Web Page tab of the Export Photos dialog to set how your photos will appear on the Web page.

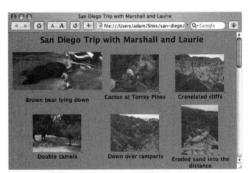

Figure 6.67 To see how your Web page turned out, switch to the Finder, open your destination folder, and double-click the HTML file inside it. To view an image at full size. click its thumbnail.

Export Plug-Ins

Although the only export plug-in available now is BetterHTMLExport (next page), which has its own installer, it's conceivable others may appear again.

To manage them, select iPhoto in the Finder, choose Get Info (Cmd I) from the File menu, and use the checkboxes and buttons in the Plug-ins pane to enable, disable, install, and uninstall the plug-ins.

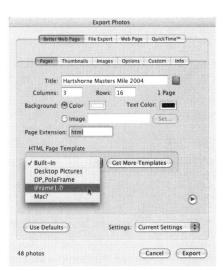

Figure 6.68 BetterHTMLExport provides all the functionality of iPhoto's Web export tool and much more (like templates!), while retaining an interface similar to iPhoto's.

BetterHTMLExport

Other tools can generate significantly more flexible Web-based photo albums, and one of them integrates tightly with iPhoto: Simon Leifer's \$20 shareware BetterHTMLExport 2.0.12. You can download a copy from Simon's site at www.droolingcat.com/software/betterhtmlexport/.

BetterHTMLExport improves on iPhoto's Web page export in a number of ways. It can control the quality of the exported images, lets you save your settings, and offers more flexibility than iPhoto.

Best of all, BetterHTMLExport lets you create and edit the templates from which it generates Web pages (**Figure 6.68**). You can even download and install (with a separate Template Manager program) templates created by other users, including some that run automatic slideshows, put thumbnails in frames, and more.

Web Page Export Tips

iPhoto's Web page export isn't particularly flexible, although it's totally fine for basic Web pages. There are workarounds for some of its limitations, though not for others.

Web page export tips:

- iPhoto doesn't let you add a line of descriptive text to your thumbnail page, as it does when using HomePage. If you knew a little HTML, you could easily add text to that page using a text editor.
- ◆ If you select a background image instead of a color, iPhoto tiles the image under the thumbnails. That can work well if the image is large and light colored, but avoid using small, dark background images—they make for a cluttered presentation.
- ◆ Assuming you have a permanent Internet connection (like DSL or a cable modem) and an IP address that never changes, you can make your pages available on your Mac by turning on Personal Web Sharing in the Sharing preference pane. If you have a permanent Internet connection but not a static IP address, you can learn more about how to work around this limitation with dynamic DNS. See www.technopagan.org/dynamic/ for more information.
- ◆ Although only BetterHTMLExport (see sidebar) integrates directly with iPhoto, you can drag photos from iPhoto into other tools such as the \$30 Image Rodeo from www.imagerodeo.com or the \$16 WebPics, which you can download from www.splons.com/m3/webpics.
- Want to serve photos from your own Mac without exporting? Check out the free myPhoto from Michael Mulligan; it's at http://agent0068.dyndns.org/~mike/ projects/myPhoto/.

Exporting to QuickTime Movies

iPhoto slideshows are great if people can gather at your computer, but iPhoto's QuickTime movie export is the easiest way to create a slideshow you can send to others in email or on CD. (It's much easier than iMovie or iDVD, though not as powerful.)

To export photos to a OuickTime movie:

- Select an album or the individual photos you wish to export.
- Choose Export from the File menu (Cmd(Shift)E).
 iPhoto displays the Export Photos dialog.
- **3.** If it's not selected, click the QuickTime tab (**Figure 6.69**).
- **4.** Enter the maximum width and height for the images, how long each image displays, and select a background color.
- **5.** If you want the music currently selected for use with the current album to play with the movie, select the Add Currently Selected Music to Movie checkbox.
- **6.** Click Export, name your movie in the Save dialog, choose a destination for it, and click OK to build the movie.
- **7.** Switch to the Finder, locate your movie, and double-click it to see the results in QuickTime Player (**Figure 6.70**).

✓ Tips

- Background images must be larger than the photo and show only when the photo doesn't take up the entire window.
- QuickTime movies support only a single song (not a playlist), and ignore the transitions you define in the Slideshow dialog.

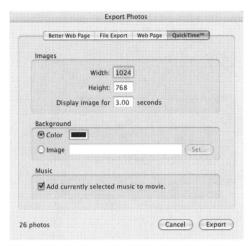

Figure 6.69 Use the options in the QuickTime tab of the Export Photos dialog to configure your QuickTime movie.

Figure 6.70 To see what your movie looks like, double-click it in the Finder to open it in QuickTime Player.

Flipping through Movies

No matter how you create a QuickTime movie of still images, you can flip through the final movie in QuickTime Player one photo at a time (plus transitions) by pressing ← or → (the left or right arrow key) while the movie is stopped.

Fast Start Movies

To make QuickTime movies viewed on the Web start as soon as possible when someone clicks the link, use these steps.

- **1.** Open your movie in QuickTime Player Pro (you need the Pro version).
- 2. Choose Export from the File menu.
- **3.** Click Options, and in the Movie Settings dialog, click the Settings button under Video to open the Compression Settings dialog.
- **4.** Choose Photo-JPEG from the pop-up menu, set the quality slider to Medium or High, and set the frame rate to match how long you set each slide to display in iPhoto. Click OK.
- **5.** Click the Settings button under Sound to open the Sound Settings dialog.
- **6.** Choose QDesign Music 2 from the Compressor pop-up menu. Leave the other settings alone and click OK.
- 7. Choose Fast Start from the pop-up menu under Prepare for Internet Streaming, and then click OK.
- **8.** Name your movie, select a location, and then click Save.

QuickTime for Windows

One of the nice things about QuickTime is that it's available for both the Mac and Windows. Many Windows users don't have QuickTime installed on their PCs, however, so you may need to tell them how to get it. Send them to www.apple.com/quicktime/download/ for a free copy.

Distributing QuickTime Movies

QuickTime movies can be an excellent way to distribute slideshows.

Ways to distribute QuickTime movies:

- Copy the movie to a CD-R. Don't worry about reducing the size of images when exporting from iPhoto.
- Send the movie via email, but be sensitive about the size of movies.
- If you have FTP or Web space available with your Internet account, upload the movie and send people the link. Similarly, if you're a .Mac member, you can upload to your iDisk's Public folder for others to download and play.
- If you're a .Mac member, copy the movie to your iDisk's Movies folder and use the HomePage Web publishing tool to make a movie page. Unfortunately, this method results in a rather small viewing size.
- ◆ If you're a .Mac member, you can also copy the movie to your iDisk's Sites folder and send people the link in the form: http://homepage.mac.com/membername/moviename.mov.
 - With this method, the movie plays at the size you chose in iPhoto, and the movie is hidden from the world (but not secured!).

✓ Tips

- Using QuickTime Player Pro (a \$29.95 upgrade from the free QuickTime Player; visit www.apple.com/quicktime/buy/), you can play movies at full-screen size.
- QuickTime Player Pro also lets you make some changes to your movies; see QuickTime 6 for Macintosh & Windows: Visual QuickStart Guide for details, or just use iMovie instead.

Sharing Photos via iPhoto Library Manager

Mac OS X is a multi-user operating system, so it's common for people who share a Mac each to have an account. But what if you want to share the same iPhoto Library among multiple users on the same Mac? You need to use Brian Webster's free iPhoto Library Manager utility, available from http://homepage.mac.com/bwebster/iphotolibrarymanager.html.

To share photos among users:

- With iPhoto not running, move your iPhoto Library folder from the Pictures folder to the Shared folder at the same level as your user folder (Figure 6.71). That folder may or may not contain other items. Rename it to Shared iPhoto Library folder to avoid confusion.
- 2. Open iPhoto Library Manager, and drag the Shared iPhoto Library folder from the Finder into the iPhoto Library Folders list in iPhoto Library Manager to add it to the list.
- **3.** For each user, log in (using Fast User Switching if you're running Mac OS X 10.3) and repeat step 2.
- 4. Log in to your main account again, select the Shared iPhoto Library folder in the list, choose Read & Write from each of the three Permissions pop-up menus, and select the two checkboxes underneath.

 These settings cause iPhoto Library Manager to fix the permissions on the Shared iPhoto Library folder whenever necessary (Figure 6.72).
- From now on, each user on your Mac should launch iPhoto by clicking the Launch iPhoto button in iPhoto Library Manager.

Figure 6.71 Store your iPhoto Library folder in the Shared folder at the same level as your user folder, preferably with a slightly different name to avoid confusion in iPhoto Library Manager.

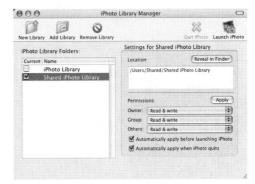

Figure 6.72 To set permissions properly for shared iPhoto Library folders, make sure all three popup menus are set to Read & Write and the two checkboxes underneath are selected.

Permissions Problems

You must jump through these hoops to share an iPhoto Library folder because of how iPhoto assigns ownership and permissions to newly imported photos.

iPhoto Library Manager works around the problem by fixing permissions constantly. The techniques on the opposite page have similar effects: turning on Ignore Ownership on This Volume for an external drive ignores permissions entirely, and the issue disappears with network volumes because each user logs in with the same user name and password, thus ensuring that all newly imported photos are written with the same ownership.

Figure 6.73 To use another hard drive to store a shared iPhoto Library folder, you must set the Ignore Ownership on This Volume checkbox.

Choosing Network Sharing Approaches

iPhoto's official method of sharing photos is discussed on the next page, "Sharing Photos via iPhoto Network Sharing." What's the difference between that approach and the shared volume method discussed on this page?

Use the shared volume method to share an entire iPhoto Library folder and have each person make changes that are seen by every other person. This method lets you share the work of editing photos, making albums, and assigning keywords.

In contrast, use iPhoto's photo sharing approach to let other people see and potentially copy your photos without making any other changes. This approach works best when each person has their own primary collection of photos but wants to access a few photos from other people.

Neither approach is "better," and which you choose depends mostly on whether you consider photos community property or personal property that can be shared.

Sharing Photos via a Shared Volume

There's one other trick you can use to share photos among multiple users of the same Mac, and as an added bonus, it also works for sharing an iPhoto Library folder across a network if iPhoto 4's new photo sharing feature doesn't do what you want.

This technique requires a "shared volume," which is either another hard drive or a Mac with Personal File Sharing turned on in the Sharing preference pane. If you're using a network, it must be at least 54 Mbps AirPort Extreme, and preferably 100 Mbps Ethernet; anything else will be too slow.

To share photos among users:

- 1. If you are using another hard drive as your shared volume, select it in the Finder, choose Get Info (Cmd) from the File menu, and in the Ownership & Permissions pane, select the Ignore Ownership on This Volume checkbox (Figure 6.73).
- **2.** With iPhoto *not* running, copy your iPhoto Library folder from the Pictures folder to where you want to store it on the shared volume.
- **3.** Rename the iPhoto Library folder in your Pictures folder to "Old iPhoto Library."
- 4. For each user (whether on the same Mac or over your network), select the iPhoto Library folder on the shared volume, hold down Cmd Option and drag it to the Pictures folder to create an alias to the shared iPhoto Library folder.
- **5.** From now on, each user should be able to launch and use iPhoto normally, although it's safest if only one person uses the shared iPhoto Library folder at a time.

Sharing Photos via iPhoto Network Sharing

With iPhoto 4, Apple added an extremely welcome feature: the capability to share your iPhoto Library folder, or just individual albums, with other iPhoto users on your network. It's easy to turn on and use.

To share photos among Macs:

- 1. From the iPhoto menu, choose
 Preferences (Cmd,) and click the
 Sharing tab.
 iPhoto displays the Sharing preferences
 (Figure 6.74).
- **2.** Select Share My Photos, and then select either Share Entire Library or Share Selected Albums.
- **3.** If you selected Share Selected Albums, select the albums you want to share in the list below (**Figure 6.75**).
- **4.** In the Shared Name field, enter a name for the album under which your shared photos will appear for everyone else.
- 5. If you want to restrict access to your shared photos, enter a password in the Require Password field. You'll then have to give that password to approved users (Figure 6.75).
- 6. Close the Preferences window.

✓ Tips

- You can't select the Require Password checkbox if the field next to it is empty.
- iPhoto sometimes complains that photo sharing can't be enabled. If you encounter this problem, verify that your network is working and quit and relaunch iPhoto before trying again.

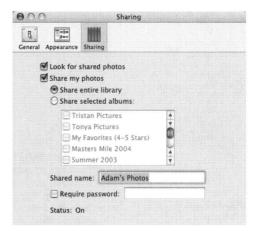

Figure 6.74 Turn on photo sharing in the Sharing tab of iPhoto's Preferences window.

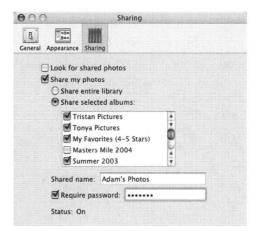

Figure 6.75 You can restrict shared photos to specific albums, and you can require that users enter a password to access your shared photos.

Turning off Sharing

To turn off photo sharing, simply deselect the Share My Photos checkbox in the Sharing tab of iPhoto's Preferences window. If anyone is currently connected to your photos, iPhoto asks if you're sure you want to turn off photo sharing first.

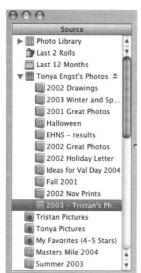

Figure 6.76 You access shared photos in the album pane; click the shared photo album to load it, after which its albums appear underneath it.

Actions Allowed for Shared Photos

Just because you can see shared photos in your album pane doesn't mean you can do everything with them that you can do with your own photos.

You can copy shared photos and albums to your iPhoto Library or albums, print shared photos, play a slideshow with shared photos, send shared photos to others via email, and upload shared photos to HomePage or .Mac Slides.

You cannot edit shared photos in any way, assign keywords and ratings (and have them stick), get photo info, make a new album on the remote Mac, use a shared album to make a book, put shared photos on your Desktop or use them as your screen saver, make an iDVD slideshow, or burn them to disc.

Basically, you can only view shared photos; for any action that requires making changes, you must first copy the photos to your Mac.

Accessing Shared Pho

Working with shared photos is similar to working with photos on an iPhoto disc.

To access shared photos:

- 1. Make sure the Mac with the shared photos is turned on, with iPhoto launched and photo sharing turned on. Also make sure the network between the two Macs is working.
- 2. On the Mac from which you want to access the shared photos, launch iPhoto, and from the iPhoto menu, choose Preferences ((Cmd),) and click the Sharing tab.

 iPhoto displays the Sharing preferences.
 - Make game Look for Chound Dhates is
- **3.** Make sure Look for Shared Photos is selected (**Figure 6.74**; opposite).
- **4.** Close the Preferences window. In the album pane, iPhoto creates an album for the shared photos.
- 5. Click the shared photo album to load it. If the shared photos are protected by a password, enter it when prompted. iPhoto loads the shared photos, displaying individual albums underneath the main album entry (Figure 6.76).

✓ Tips

- If more than one copy of iPhoto on your network is sharing photos, iPhoto creates a Shared Photos album and puts all the albums for shared photos inside it.
- To disconnect from a shared photo album, click the little eject button next to its name in the album pane.
- To import a shared album, select all the photos in it ((Cmd(A))), and drag them to the bottom of the album pane to import them and create a new album.

Extending iPhoto with AppleScript

One of Apple's least known but most useful technologies is AppleScript, a relatively easy programming language that lets AppleScript-savvy applications perform repetitive actions and communicate with one another. Since iPhoto supports AppleScript, you can write scripts to do all sorts of things that would have been tedious to do by hand before.

Needless to say, it's way beyond the scope of this book to teach you how to write AppleScript scripts. Check out Matt Neuburg's *AppleScript: The Definitive Guide* for help learning AppleScript.

To write an AppleScript for iPhoto:

- Launch Script Editor by double-clicking its icon in the AppleScript folder in your Applications folder.
 Script Editor opens a new, untitled script window.
- From Script Editor's File menu, choose
 Open Dictionary, and in the Open
 Dictionary dialog, select iPhoto and
 click Open to open iPhoto's AppleScript
 dictionary (Figure 6.77).
 An application's dictionary is a list of
 all the AppleScript commands that the
 application understands and their syntax.
- **3.** Write your script in the untitled script window, saving it when you're done (**Figure 6.78**).
- 4. Click Run to test your script.

✓ Tip

 Realistically, you'll probably go through many iterations of testing, changing something, testing again, and so on.

Figure 6.77 iPhoto's AppleScript dictionary lists the commands and syntax necessary to write AppleScript scripts that can control iPhoto.

Figure 6.78 Enter your script into Script Editor, and when you're ready to test it, click Run.

Crib Code, Ask Friends

When you realize you need to automate a repetitive action, a good way to start learning scripting is to find a script that does something similar and modify its behavior. Of course, it always helps to have AppleScript-savvy friends to ask for help, too!

Figure 6.79 Invoke AppleScript scripts by choosing them from the Scripts menu.

Installing the Script Menu

Although you can run a script by selecting some photos in iPhoto, switching to the Finder, and double-clicking the desired script, there's an easier way—a Script menu on your menu bar at all times. Follow these instructions to install the Script menu and populate it with Apple's scripts.

- 1. Open the AppleScript folder in your Applications folder. In it you'll see an application called Install Script Menu.
- **2.** Launch Install Script Menu. You should see a little scroll icon appear.
- **3.** Move the iPhoto Scripts folder that you downloaded from Apple into the Scripts folder inside your user's Library folder.
- **4.** From now on, when you want to invoke a script, select a photo and choose the desired script from the hierarchical iPhoto Scripts menu in the Script menu (**Figure 6.79**).

iPhoto AppleScript Scripts

Apple provides a number of scripts that are useful as examples (and sometimes on their own). Download these and other scripts from www.apple.com/applescript/iphoto/.

Apple's iPhoto AppleScript scripts:

- Assign Keywords for Last Import cycles through all the photos from the last import and presents a dialog for each that lets you assign keywords.
- Delete Album and Contents deletes an album and its contents, moving the album's photos to the Trash, which wouldn't normally happen. Be careful!
- Do Photoshop Action performs an action in Photoshop 7 for each of the selected photos, one at a time.
- Find Unassigned Images creates a new album called "Unassigned" with all photos not currently in another album.
- **Open in Preview** opens the selected photos in Apple's Preview application.
- Photo Summary creates an HTML page summarizing information about the selected photos and opens it in TextEdit.
- Photo to iDVD Background exports a photo to iDVD as a background image.
- Prepare for iDVD uses Photoshop to scale selected photos to 640 x 480, with the comment overlaid on the bottom of each photo as a caption.
- Show Image File displays the selected photo's actual file in the Finder.
- Speak Comments speaks the comments for selected photos.
- Talking Image Card creates a movie of the selected image with an audio track speaking the comments.

a kalang Simulatan dan Kabupatèn Bajan S

al Africa Santania (n. 1931). La lighter de la Santania (n. 1931).

military of the state of the st

TROUBLESHOOTING

The Trouble with Bugs

Many iPhoto problems that I've seen people report seem to be specific to their photos, a particular iPhoto Library folder, their Mac, or the phase of the moon, and I have been unable to reproduce them. I still pass on the potential problem and any solutions I've heard of or can think of, but this uncertainty makes it impossible for me to say when or if Apple has fixed some sort of incorrect behavior. As such, some of the problems and solutions listed in this chapter may no longer apply to iPhoto 4; there's simply no way to tell.

That said, I continue to pass on these suggestions even when I can't verify them because bugs are slippery, and just because I can't reproduce a particular problem in iPhoto 4 doesn't mean that you won't experience it. And then one of the suggestions in this chapter may save your bacon (or at least your photos).

Also keep in mind that updates to iPhoto very well may eliminate even those problems I've confirmed in iPhoto 4, so be sure to use Software Update to check for new versions on a regular basis.

The world of iPhoto is no more a perfect place than the real world. No one, iPhoto's developers least of all, wants problems, but bugs are a fact of life, and you may have a problem with iPhoto at some point.

One advantage iPhoto has in this respect is that it runs only under Mac OS X, which boasts a feature called protected memory. That means that if one program, such as iPhoto, crashes, no other program should be affected. Also on the positive side is the fact that iPhoto saves your changes frequently and automatically, so you're unlikely to lose much work even if it crashes. Put simply, if iPhoto crashes, just relaunch the program and pick up where you left off. If the crashes happen regularly, you may need to do some troubleshooting. One way or another, keep good backups! (See "Backing up Your Photos," in Chapter 2, "Importing and Managing Photos.")

Of course, most of the problems you might encounter won't result in a crash. It's more likely you'll have trouble importing photos from an unusual camera, printing a photo at the exact size you want, or convincing iPhoto to update a thumbnail after editing a photo in an external program. Those are the sorts of problems—and solutions—I'll focus on in this chapter.

General Problems and Solutions

Some problems you may experience in iPhoto aren't related to particular activities. Others are, and subsequent pages in this chapter will address issues with importing, editing, slideshows, printing, and more.

Performance Problems

iPhoto 4 is far faster than previous versions, but if you find it's slow to perform certain operations, try these tricks. Some are obvious (if expensive); others less so:

- Turn off title, rating, and keyword display using the View menu.
- Use the triangles next to film rolls to hide thumbnails you don't need to see.
- ◆ Quit other programs that are running. In my experience, there is usually one culprit, which you can identify by launching Activity Monitor (Mac OS X 10.3) or Process Viewer (Mac OS X 10.2) from your Utilities folder and clicking the %CPU column title to see which applications are using the most processor time.
- ◆ To quit everything that was running, log out by choosing Log Out from the Apple menu ((Cmd)(Shift)(Q)) and log back in.
- Restart your Mac by choosing Restart from the Apple menu. Restarting is especially helpful if you don't have much free disk space, which cramps Mac OS X's virtual memory techniques.
- ◆ Add more RAM to your Mac. iPhoto works with 256 MB of RAM, but it likes a lot more, and RAM is cheap. I always recommend at least 512 MB.
- Buy a faster Mac. That's always fun.

Photos Disappear

Some people report having troubles with photos disappearing from iPhoto's display pane, even when the files are still present in the corrupt iPhoto Library folder (see "iPhoto Directory Structure" in Chapter 2, "Importing and Managing Photos"). Try the following procedure to fix the problem.

Don't follow this process unless absolutely necessary, since it will cause you to lose all your film rolls, albums, keywords, titles, and so on. You end up with your photos, and that's what's important.

Remember that you can recreate film rolls by using the New Film Roll from Selection command from the File menu.

- 1. Hold down Shiff Option while clicking the iPhoto icon in the Dock to launch it. This should cause iPhoto to ask to rebuild your library and may solve the problem. If rebuilding doesn't work, follow the rest of these steps to reimport your photos into a clean iPhoto Library folder.
- **2.** Drag your corrupt iPhoto Library folder to the Desktop, and launch iPhoto to create a new iPhoto Library.
- 3. Download the free iPhoto Extractor (http://homepage.mac.com/butlers/iPhotoExtractor/). After you've unpacked and installed it, drag your corrupt iPhoto Library folder to iPhoto Extractor to extract only your photos. When iPhoto Extractor is done, you'll end up with two folders: Pictures (which contains the current version of each photo) and Originals (which contains the original versions of edited photos).
- **4.** Drag those folders into iPhoto to import all your photos again.

Flaky Behavior or Crashes

Sometimes iPhoto just acts strangely, and I've come up with a few ways of dealing with weird behavior:

- Quit iPhoto and relaunch it.
- ◆ Log out by choosing Log Out from the Apple menu (Cmd Shift).
- Restart your Mac by choosing Restart from the Apple menu.
- Quit iPhoto. From the Preferences folder inside your user's Library folder, drag the file com.apple.iPhoto.plist to the Desktop and launch iPhoto again.
- Quit iPhoto. From the iPhoto Library folder, drag the files Thumb32.data, Thumb64.data, and ThumbJPG.data to the Desktop and launch iPhoto again.
- Run Disk Utility and use the buttons in the First Aid tab to verify and repair both permissions and the disk.
- Reinstall a fresh copy of iPhoto, deleting the old one first.
- ◆ If you believe your Photo Library is corrupted or damaged, force iPhoto to rebuild it by holding down (Shift)(Option) while launching iPhoto. Don't do this unless you believe you already have problems, but it could be useful in such a case.
- Try exporting all your photos manually, creating a new iPhoto Library folder, and reimporting your photos.
- Moving or deleting the Library.iPhoto or Dir.data files will corrupt your iPhoto Library. Don't do it.
- I strongly encourage you to report problems you have to Apple by choosing Provide iPhoto Feedback from the iPhoto menu and then filling in Apple's Webbased feedback form.

Other Problems

A number of other problems have specific solutions:

- If other iApps can't see your photos, or if some photos or albums are missing, quit all the iApps, drag the file AlbumData.xml from the iPhoto Library to the Desktop, launch iPhoto, create a new album, quit iPhoto, and try the other programs again.
- Note that the Colors panel can sometimes appear behind dialogs that you must move to see it.
- If you have trouble with iPhoto's photo sharing or the sharing tools that upload data, shut off or bypass your firewall to see if it's blocking necessary ports.
- If iPhoto complains about being unable to establish a connection when uploading to .Mac, set the date correctly in the Date & Time preference pane.
- If iPhoto complains about an unexpected error when uploading to HomePage, the culprits are photos named with high ASCII characters (anything typed with the Option) key, or characters in other alphabets). Export them, rename them, reimport them, and delete the originals.
- If you can't upload to HomePage, or if the HomePage button disappears, repair permissions using Disk Utility. If that doesn't help, delete iPhoto and reinstall.
- If mailing a photo in Apple's Mail doesn't result in an enclosure, and another user on the Mac has done the same thing, restart the Mac and try again.
- ◆ If you want to delete files in the Originals directories (not recommended!), use iPhoto Diet from http://pages.cpsc.ucalgary.ca/~fuhrer/personal/freestuff/. Don't do this lightly!

Importing Problems and Solutions

I've had little trouble importing photos into iPhoto. However, because importing involves interacting with an unpredictable outside world of cameras, card readers, and files of varying formats, problems can occur.

Camera or Card Reader Isn't Recognized

Mac OS X and iPhoto support many common digital cameras and card readers, but not all of them. And sometimes iPhoto may not recognize specific memory cards, even if it recognizes the card reader in general. Try the following tips:

- If you haven't yet purchased a camera or card reader, check the compatibility list Apple publishes on its iPhoto Web pages at www.apple.com/iphoto/.
- Make sure the camera is turned on, in review mode, and plugged in via USB properly. I know it seems obvious, but we've all made this mistake before.
- Use Software Update, accessible in System Preferences, to make sure you have the latest version of Mac OS X, since Apple continually adds support for more digital cameras and card readers.
- If your camera is incompatible with Mac OS X and iPhoto, buy a card reader that supports the memory card used by your camera. It's often easier to use a card reader anyway, and they're cheap.
- iPhoto has had trouble with some large memory cards. People have resolved the issues by reformatting the card in the camera, using a memory card reader, or using smaller cards.

- Some cameras must be placed in Picture Transfer Protocol mode to communicate with iPhoto. And if that doesn't work, try other modes. Check the manual for help.
- If you have two cameras connected at once, or a camera and a scanner, iPhoto may become confused about which device to use. Connect only one device at a time if this causes trouble for you.
- ◆ If your user account can run only certain applications, that may prevent you from importing in iPhoto. The only fix is for an administrator-level user to increase the capabilities of your account in the Limitations tab of the Accounts preference pane.
- iPhoto won't recognize an empty MemoryStick card.
- If you have a Compact Flash card that works in iPhoto, but doesn't appear in the Finder, read this Apple article for help: http://docs.info.apple.com/ article2.html?artnum=75509.

Nothing Appears After Import

In a few cases, after you import files from the hard drive, nothing appears in iPhoto. People who have run into this have come up with a few solutions:

- If the files you imported are in the iPhoto Library folder, iPhoto assumes they've already been imported and won't do so again. To solve the problem, move the files out of the iPhoto Library folder and try again.
- Instead of using the Import command in the File menu, drag the images (or a folder containing them) onto iPhoto's display pane. I've seen reports that this technique works better on occasion.

- Like all Mac OS X applications, iPhoto is quite sensitive to proper permissions. So, if you've moved your iPhoto Library folder and are trying to import from another user, verify in the Get Info window for the iPhoto Library folder and all enclosed folders that the appropriate user has Read & Write permissions.
- The photos might be duplicates, which iPhoto imports only if you tell it to do so.
 See Chapter 2, "Importing and Managing Photos."
- ◆ I've seen reports of iPhoto losing the last import. Check the iPhoto Library folder to see if the files were actually written to disk (remember that it's a chronological directory structure) and **never** set iPhoto to erase your camera after import.
- ◆ If you have erased your camera and need to recover the original photos, check out the \$29 PhotoRescue (a free version will tell you if it's going to work). Learn more at www.datarescue.com/photorescue/. Also try Andrew Toth's \$25 Salvage from www.andrewtoth.com/salvage/.

Damaged Photos Warning Appears During Import

Sometimes when you import photos, you may see an error dialog complaining about unreadable photos. It can occur for a variety of reasons:

- You're accidentally importing nongraphic files, such as aliases to photos, HTML documents, or other data files.
- The image files may actually be damaged. See if you can open them in Preview or GraphicConverter. If so, you may be able to run them through a conversion process that eliminates the corruption.

- iPhoto supports a number of common graphic formats, including BMP, GIF, FlashPix, JPEG, MacPaint, PICT, PNG, Photoshop and Photoshop Elements (with layers), SGI, Targa, and TIFF, but if your files are in an unsupported format, try using GraphicConverter to convert the images to JPEG.
- ◆ In particular, RAW images from Canon cameras aren't supported by iPhoto, but Canon provides a free File Viewer utility that turns them into TIFF files that iPhoto can import. Download it (and other Mac OS X versions of Canon's software) from www.powershot.com/powershot2/customer/macosx.html.
- Sometimes the problem may relate to a
 USB communications failure between
 your camera or card reader and your
 Mac. Try plugging the camera or card
 reader directly into one of the Mac's
 USB ports rather than into the keyboard's
 USB port or a port on a USB hub.
- ◆ iPhoto can display the damaged photo error message if your hard drive is full. Since iPhoto duplicates every photo when importing from files, if you're importing hundreds of megabytes of photos from files, it's by no means unthinkable that you could run out of disk space. Clear some space and try importing again.
- ◆ Photos taken with Apple's QuickTake 100 and QuickTake 150 digital cameras must be converted from the special format Apple used into the JPEG format. I solved this problem with a custom AppleScript that works with PhotoFlash (which came with the QuickTake cameras) to convert batches of photos. Email me if you'd like a copy of this script.

Other Importing Problems

Here are a miscellany of importing problems and solutions that don't fit larger categories:

- iPhoto may crash if you disconnect your camera while photos are transferring.
- Make sure your camera won't go to sleep while transferring photos.
- ◆ If iPhoto fails to warn you about duplicates, the reason is likely that the date and time on your camera are wrong. If they are incorrect, iPhoto instead uses the date and time of the import, creating matching folders in the iPhoto Library chronological hierarchy. Thus, if you import again the next day, iPhoto won't see the photos as being duplicates because it creates new folders again.
- Some cameras can automatically rotate photos to the correct orientation, but iPhoto doesn't honor that rotation unless you drag the images in from the Finder.
- iPhoto 2 won't recognize discs burned in iPhoto 4, though the reverse works fine.
- ◆ If you're using a Belkin Media Reader and your iPod to store photos, checking the Erase Camera Contents after Transfer checkbox removes the photos, but not the folders they were stored in. These empty folders won't do any harm, but you can remove them by deleting them from the iPod in the Finder.
- ◆ If you import a file that is misnamed—
 a TIFF file with a . jpg filename extension, for example—iPhoto may display the picture strangely when editing, refuse to let you order prints or use Apple's HomePage tool, or even crash. Delete the misnamed picture from your Photo Library; then rename it appropriately in the Finder before importing it again.

Slideshow Problems and Solutions

Slideshows generate a surprising number of complaints from users. Try these solutions:

- If slideshows look wrong, try switching to "Thousands" of colors in the Displays preference pane.
- If a slideshow takes a long time to start, it may be because of a very large music file you've set to play. Pick a smaller file to speed start time.
- If slideshow transitions are slower than you've set, it may be because your photos are too large or your screen resolution is too high. Setting a lower resolution in the Displays preference pane or using smaller photos should speed transitions.
- ◆ If you can't see your iTunes music library when selecting music for a slideshow, open each iLife application in this order: iTunes, iPhoto, iMovie, and then iDVD. If that doesn't work, quit all the iApps, move the iTunes Music Library.xml file in your iTunes folder (likely in the Music or Documents folder) to your Desktop. Relaunch iTunes, create a new playlist, quit iTunes, and try again in iPhoto.
- If you can't play music purchased from the iTunes Music Store, upgrade to the latest version of QuickTime (version 6.2 or later is required). Download from www.apple.com/quicktime/download/.
- Changes you make to a photo's rating while a Smart Album slideshow is playing won't take effect until you play the slideshow again.
- Slide transitions and playlist selections aren't exported to QuickTime movie slideshows.

Printing Problems and Solutions

Many printing problems you'll experience will be specific to your particular printer and setup, so read your printer manual carefully and be sure to test before printing at the highest quality on expensive paper.

Prints Don't Appear Correctly on the Paper

You may have trouble getting prints to show in exactly the right location on the paper. Try these solutions to the problem:

- Set the paper size appropriately in the Page Setup dialog. This is essential for unusual paper sizes.
- Make sure the margins are set correctly for your printer and paper combination.
- Verify that you load paper into your printer properly. This solution is common with unusual paper sizes.

Photos Print at Incorrect Sizes

Even if you ask iPhoto to print a standard size print, the image that comes out of the printer might not be the size you want. This can happen for a few reasons:

- Make sure your image is cropped to the appropriate aspect ratio. Otherwise, iPhoto shrinks the image proportionally to make it fit, adding borders in one dimension to accommodate the size change.
- Changing the layout to print multiple pages per sheet of paper in the Advanced Options of the Print dialog will likely result in unpredictable photo sizes.
- Changing the scale in the Page Setup dialog has no effect.

Poor Print Quality

The main complaint with printing occurs when print quality doesn't meet your expectations. Here are a few suggestions for addressing print quality problems:

- Make sure your inkjet cartridges aren't clogged. Once my black ink cartridge clogged and it took me an hour to figure out that the clog caused color photos to print oddly. Your printer manual should tell you how to clear clogs.
- Change your ink cartridges. It's possible that one is low on a specific color and not yet reporting the problem.
- Use different paper. You'd be amazed how much better print quality is on paper designed for photo printing.
- Make sure your paper is loaded correctly to print on the printable side. It's usually whiter or glossier than the other side.
- Make sure you select the appropriate settings in the Print dialog for your printer to use high-quality mode.
- ◆ If iPhoto put a low-resolution warning icon on the picture in the Print dialog's small preview, there isn't enough data in the image to print at the size you requested. Print at a smaller size. See "Dealing with Warning Icons" later in this chapter.
- CMYK files, which you can create in some programs (but won't come from a standard digital camera), don't print correctly in iPhoto. Try converting them to RGB.
- Verify that the problems aren't inherent to the original image. If so, you may have to edit the image in another program to correct the issue.

Editing Problems and Solutions

Most photo editing problems stem from using another program to edit the photos.

Photos Don't Open in an External Program

Although it is unlikely that you'll run into this problem, it could be frustrating. Here are a few reasons it could happen:

- ◆ If you have changed the name of the photo's file in the Finder, it may not open when double-clicked in iPhoto.

 The solution? Change the filename back to what iPhoto expects, and don't mess with any filenames within the iPhoto Library folder. It's a bad idea!
- Double-check to make sure iPhoto's preferences are set to open photos in an external program, that the program is present on your hard drive, and that you can launch it and open photos normally.

iPhoto Crashes When You Double-Click Photos

There are a few reasons iPhoto might crash when you double-click a photo to edit it within iPhoto:

- Changing the photo's filename in the Finder can cause this problem. Did I mention that it's a bad idea to change anything inside the iPhoto Library folder using the Finder? Don't do it!
- ◆ A corrupted photo can cause iPhoto to freak out. Editing and saving the original file in another application might eliminate the corruption, or you could delete the corrupt photo and import it again, assuming you have another copy.

iPhoto Doesn't Allow Editing

Some people have reported importing images from a CD that they later couldn't edit in iPhoto. As a workaround, convert the images in GraphicConverter from JPEG to TIFF, for instance, and see if you can import and then edit those versions. My hope is that GraphicConverter will reset an attribute that tells iPhoto it can't edit the images.

Revert to Original Dimmed

There are a few reasons you might see the Revert to Original command in the File menu dimmed, even after you know you've made a change. Here are a few fixes. Luckily, only the first one is likely to be necessary in iPhoto 4; the others happened only when using iPhoto 1.0.

- Don't drag a photo from iPhoto to another program to edit the photo. If you do that, iPhoto will be unable to track changes you've made and Revert to Original will be dimmed.
- Using an external application to edit images increases the likelihood that the Revert to Original command won't be available after editing an image. As a workaround, crop the image in iPhoto before you edit in the other application to force iPhoto to start tracking changes (iPhoto copies the original image in a folder called "Originals" in the folder that holds the photo in the Finder).
- ◆ Use the Show Image File AppleScript script to locate its file in the Finder. There should be an Originals folder in the same folder as the photo; open it and Option-drag the original file for the problematic photo to the Desktop to make a copy. Switch back to iPhoto, delete the problematic photo, and reimport the original that you copied to the Desktop.

iPhoto Crashes When You View a Thumbnail

Some people have reported editing a photo in an external program and then having iPhoto crash every time it tries to display the thumbnail for that photo in organize mode. I suspect this relates to corruption in the photo's thumbnail.

To delete a corrupted thumbnail (I):

- 1. Figure out which image causes the problem by zooming in so only one picture shows in the display pane in organize mode (arrange photos by film roll), then scroll through photos until iPhoto crashes, noting which photo showed just before the crash. Repeat the process to the point just before the crash, and then select the last good photo and use the Show Image File AppleScript script to show it in the Finder.
- 2. In the same folder as the photo you've found, there should be a Thumbs folder. Look at the files in that folder to identify the offending thumbnail.
- **3.** Drag that thumbnail to the Desktop, duplicate another thumbnail, and give it the same name as the one you moved to the Desktop.
- **4.** Launch iPhoto and see if the crash still occurs. If everything works fine, fix the appearance of the replacement thumbnail using the next technique.

To delete a corrupted thumbnail (II):

- 1. In organize mode, zoom in so you can see only two images side by side. Now scroll down until just before iPhoto displays the corrupted thumbnail and crashes (this may require several tries).
- **2.** Use the Show Image File AppleScript script to help you locate the files that

- correspond with the photos in the film roll containing the corrupted thumbnail. The actual files you want to import are in the folders named for days of the month. Don't worry about being too accurate, there's no harm in saving too many files.
- **3.** Copy those files to another location in the Finder for later importing.
- **4.** Back in iPhoto's Photo Library, click the film roll icon (make sure film rolls are showing) to select all the photos in that film roll containing the corrupted thumbnail, and deselect all those up to the corrupted one (which should be off-screen).
- **5.** Delete the remaining selected photos, which deletes the corrupted thumbnail.
- **6.** Reimport the photos you previously copied in the Finder.

Thumbnails Don't Reflect Changes

If a thumbnail doesn't reflect changes you've made or looks wrong, select the photo, click the Edit button, make a change like redeye correction, choose Undo from the Edit menu, and click Organize.

If iPhoto crashes when you click the thumbnail, relaunch it, edit the photo next to the corrupted thumbnail, move to the corrupted photo by pressing an arrow key, make any change, and switch back to organize mode to test the thumbnail. If this technique fails, you may need to export and reimport.

Beware Too Much Editing

One quick warning about editing. iPhoto saves edited photos using the lossy JPEG compression format, which throws away information in the image to keep file sizes small. That's no problem in normal usage, but an excessive number of edits could cause a slight degradation in image quality.

Print and Book Problems and Solutions

A few common problems have cropped up when working with prints and books.

Photos Don't Upload

Some people have had trouble uploading photos to Apple's servers to have them printed or turned into a book. Here are a few things to try:

- Try again later. Many Internet problems come and go, so a second try an hour or a day later may succeed.
- If possible, see if the problem occurs uploading to HomePage as well. If not, the problem may be limited to the specific servers used for prints or books.
- If possible, verify that you can upload a large file using a different program. If that fails, the problem is likely with your Internet connection. If it works, the problem is probably in iPhoto.
- ◆ If iPhoto complains about an error while accessing your account information, make sure the date and time on your computer are set properly in the Date & Time preference pane. It's a good idea to select "Set Date & Time Automatically" in that preference pane to eliminate the problem in the short term. If your Mac is several years old and loses track of the date and time regularly, you need to buy it a new clock battery.
- Contact your Internet service provider's tech support department.
- Contact Apple by sending email to internetservices@apple.com or calling 1-800-709-2775.

Prints or Books Aren't What You Expect

It's highly frustrating to order (and pay for) prints or books that aren't of the quality you expect. Follow these tips to avoid common problems:

- Prints ordered via iPhoto often come back darker than is ideal. This may be because Mac and PC monitors have different color contrast settings, something called gamma. Macs usually use a gamma of 1.8, whereas PCs use a darker gamma of 2.2. The belief is that Kodak serves more PC customers and has thus tweaked its equipment so PC users don't think their prints look washed out. You can adjust your monitor to use PC gamma settings when working with photos. In the Color tab of the Displays preference pane, click the Calibrate button to run the Display Calibrator Assistant. Then work through the Display Calibrator Assistant, picking 2.2 Television Gamma in the third screen. When you're done, save the profile you created, and select it in the Color tab of the Displays preference pane.
- Prints use a three-color process whereas books use a four-color process. Because black is added to photos in books, they can be slightly darker than the same photo as a print.
- ◆ If prints in your order from Apple are garbled, the problem may be that the photos were modified in another application (like Photoshop) to use CMYK or grayscale format. To fix the photos, use another application to change the color space to RGB, which Apple requires for ordered prints and books.

 To avoid truncated text in books, don't apply other styles and use only these fonts: Helvetica Neue, Century Gothic, Papyrus (only in Story Book layout), Gill Sans, Markerfelt, Baskerville, and Brush Script.

You Don't Receive Prints

There are several problems that can prevent Apple from printing photos you've uploaded. You should receive email telling you about the problem, but there are two main issues:

- If a photo has a ? in the filename, it won't print. Export the photo, change the filename, reimport, and delete the original.
- ◆ Damaged photos may not print.

 To identify damaged photos,
 connect to Apple's Web site at
 www.apple.com/internetservices/
 yourorderstatus/, where you can
 look for missing or partial thumbnails for the order in question. Once
 you've identified the damaged files,
 try exporting, opening in another
 application, saving a copy, and
 reimporting the copy to eliminate
 the corruption.

Pages Jump Around in Book Mode

When making large books with lots of photos and many locked pages, some people have experienced pages and images seemingly jumping around. Avoid the problem (caused by the Lock Pages checkbox) entirely by arranging photos in organize mode first, and then working left to right in the book. For more about this method, see "Arranging Photos on Pages" in Chapter 5, "Creating Books."

Print and Book Ordering Problems and Solutions

Whenever a program like iPhoto has to interact with the outside world, as it does when you order prints or books, there's an opportunity for problems to arise.

- ◆ If you order prints of an image that indicates it may be subject to another person's copyright, Apple puts your order on hold pending verification that you have the right to make a copy of the photo. You must complete and submit an iPhoto Print Consent form; Apple will tell you how to do this when you're contacted.
- ◆ If over half of the page numbers in a book are hidden by photos, Apple may cancel your order automatically. This problem occurs most commonly with the Picture Book and Portfolio themes, and you can use the Preview window to see if any pictures are covering the page numbers. It's easiest to deselect the Page Numbers checkbox before placing the order, although you could also change the theme or page design to one in which photos don't cover the page numbers.
- ◆ If you receive email from Apple saying your order can't be processed, you can wait for Apple to contact you with details, or you can try to figure out what went wrong, cancel the order, and then resubmit it. Apple gives you up to 90 minutes to cancel the order yourself; do this by logging in with your Apple ID to www.apple.com/internetservices/yourorderstatus/ and clicking the Cancel Order link.

The two most common reasons why orders can't be processed are damaged files and files that contain a question mark in the filename.

Can't Enable 1-Click Ordering

A number of people have reported problems with enabling 1-Click ordering within iPhoto, even though they have a 1-Click account with Apple that works on Apple's Web sites. A lot of the early problems seemed to relate to people who had joined the Apple Developer Connection (ADC), and it's unclear if that particular issue has been completely addressed. To fix the problem, try one of these solutions:

- ◆ Connect to http://store.apple.com/, click the Your Account link, and log in to your Apple Store account. Click the "Change Apple ID or Password" link, log in again, and then change your password (changing other data wouldn't hurt either). The goal here is to force the Apple database to update so you can connect to it via iPhoto. (Try the same procedure at http://myinfo.apple.com/.)
- Follow the above procedure, but instead of clicking "Change Apple ID or Password," click "Change 1-Click Settings." Again, make some changes and toggle 1-Click via the Web to see if that enables iPhoto to connect.
- If you can set up a new email address easily, create it and then add a new Apple ID that uses the new email address. This generally seems to work, but isn't an ideal solution, since then you have to keep track of an extra email address.

Errors During Ordering

You may encounter a few problems during the process of ordering prints or books:

 If you see an error dialog complaining that a network connection could not be established, verify that your Internet connection is working by checking in a Web browser or other program.

- ◆ You may see a confusing error message that says "The changes to your account information could not be saved." Ignore the message, and enter your credit card information again, making sure the card hasn't expired. If that doesn't work, try a different credit card.
- ◆ If you see an alert that your password is invalid, but it works fine in the Apple Store, change your password to be less than 30 characters. The Apple Store allows 32-character 1-Click passwords, whereas iPhoto allows only 30-character 1-Click passwords.
- Different aspects of iPhoto may request access to your password keychain during ordering. That's totally normal and completely acceptable.
- If you have a firewall that blocks port 80, try turning your firewall off, or allowing data to pass through on port 80, to solve upload errors.

Order Doesn't Arrive or Is Damaged

There are three ways to learn more about your orders. Apple includes this information with each confirmation message.

- Check the status of your order at www. apple.com/internetservices/ yourorderstatus. You need your Apple ID and password to sign in.
- Send an email query to Apple at internetservices@apple.com. Be sure to include the text of the confirmation message Apple sent you so they have your order details.
- Call Apple toll-free at 1-800-709-2775.
 Make sure you have your order details at hand. If you're unhappy with what you ordered, you'll have to call this number.

Figure 7.1 Start with Apple's iPhoto support pages for general help and pointers to other resources.

Figure 7.2 For detailed troubleshooting articles, search in Apple's Knowledge Base.

Figure 7.3 If all else fails, ask for help on Apple's iPhoto discussion boards.

Help Resources

I'm sure other problems and solutions will become known after I finish writing. Along with iPhoto's online help (choose iPhoto Help from the Help menu), a variety of Internet resources provide assistance.

Places to look for more help:

- Check Apple's iPhoto support pages at www.apple.com/support/iphoto/ (Figure 7.1).
- Search for "iPhoto" in Apple's Knowledge Base at http://kbase.info.apple.com/ (Figure 7.2). Narrow your search by adding terms, so if you're having trouble importing, search for "iPhoto import" or something similar.
- Try asking a question on Apple's iPhoto Web-based discussion forums at http://discussions.info.apple.com/iphoto (Figure 7.3). In my experience, these discussions are good for straightforward questions; harder questions tend to go unanswered. When posting, state your problem clearly and include relevant information while at the same time keeping the question concise.
- Ask questions on this book's Web site at http://iphoto.tidbits.com/.
- For order-related problems, send email to internetservices@apple.com or call 1-800-709-2775. Make sure you have your order details at hand.
- Subscribe to *TidBITS*, the free weekly newsletter I publish. It contains tons of useful information on all sorts of topics, including digital photography. Visit www.tidbits.com to read back issues or subscribe to receive issues in email.

Dealing with Warning Icons

Let's say you want to print a photo in a book, on your printer, or via Kodak's online print service, and iPhoto is displaying a warning icon on the book page thumbnail, on the preview in the Print dialog, or next to a specific size you want in the Order Prints window. What can you do to resolve this situation?

Ways to handle warning icons:

- You can simply print at a smaller size. When printing photos and ordering prints, try a smaller size (Figure 7.4); with a book, choose a different page design or rearrange the photos so the offending one prints at a smaller size (Figure 7.5).
- ◆ If the photo is too small because you cropped it, you can select it, choose Revert to Original from the Photos menu, and crop it again to a larger size. I'd recommend you do this primarily if you think you're right on the edge of receiving the warning icon.
- This solution definitely takes more effort, but you can also increase the size of your image using GraphicConverter or Adobe Photoshop. The way these programs scale the photo up might look better than iPhoto's method.

✓ Tips

- For exact details about how many pixels photos must have to print at different sizes, see "Preparing to Order Prints" in Chapter 6, "Sharing Photos."
- To learn how image resolution relates to what comes out of a printer, read "Understanding Resolution" in Appendix A, "Deep Background."

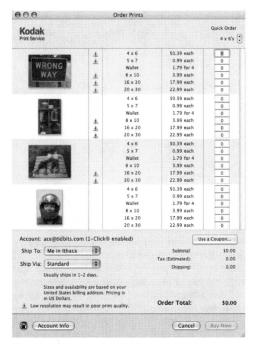

Figure 7.4 Note how the four images showing here have warning icons applied to different print sizes. The first image (640 x 480 pixels) can print well only at wallet size. The second (847 x 1271 pixels) won't print well at 8" x 10" or larger. The third image (1600 x 1200 pixels) drops out at 16" x 20". And the final image (1920 x 2560 pixels) will print fine at any size.

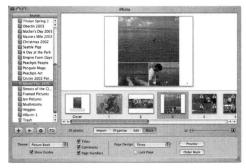

Figure 7.5 Note how all these photos, which were taken with my old QuickTake 100 at 640 x 480 pixels, show low-resolution warning icons except the two smaller photos in the three-up page design. A 640 x 480 image must be quite small to print acceptably.

DEEP BACKGROUND

Right off the bat, let me say that you don't need to read this appendix. It's deep background, the kind of detail that you might wish to delve into when you're attempting to understand how iPhoto works, perhaps because you've just printed a photo and you're unhappy with the results.

The following pages contain "Understanding Aspect Ratios," "Understanding Resolution," and "Understanding Color Management." Each of these discussions examines an aspect of digital photography from which iPhoto, for the most part, tries to shield you. That's great most of the time, but if you're trying to understand how cropping removes information from a photo, thus making it print at a lower quality, you'll want to come here for the explanation.

Lastly, although I've called this appendix "Deep Background," these topics are so complex that entire books have been written about each one. If these discussions leave you with more questions, I'd encourage you to visit a library or bookstore and browse its collection of books on photography, digital imaging, and pre-press. I especially recommend *Real World Scanning and Halftones, Third Edition*, by David Blatner, Conrad Chavez, Glenn Fleishman, and Steve Roth.

Understanding Aspect Ratios

iPhoto makes it easy to select and crop a portion of a photo using a specific aspect ratio, but why is this important? It matters because aspect ratios differ between traditional and digital photos.

An aspect ratio is the ratio between the width of the image and its height, generally expressed with both numbers, as in the line from Arlo Guthrie's song "Alice's Restaurant Massacree" about "Twenty-seven, eight-byten, color glossy photographs with circles and arrows and a paragraph on the back of each one."

The aspect ratio of 35mm film is 4 x 6 (using the standard print size rather than the least common denominator of 2 x 3) because the negative measures 24mm by 36mm. Thus, traditional photographs are usually printed at sizes like 4" x 6", 5" x 7", or 8" x 10", all of which are close enough to that 4 x 6 aspect ratio so photos scale well. When there's a mismatch between the aspect ratio of the original negative and the final print, either the image must be shrunk proportionally to fit (producing unsightly borders) or some portion of the image must be cropped. (The alternative would be to resize the image disproportionally, which makes people look like they're reflected in a fun-house mirror.)

The equivalent of film in digital photography is the CCD (charge-coupled device), which is essentially a grid of many light-sensitive elements that gain a charge when exposed to light. Through much digital wizardry, the camera translates those charges into the individual dots (called pixels) that, put together, make up the image. Zoom in on a picture all the way, and you can actually see these pixels. So if your digital camera, like many others, uses a CCD that can capture

Figure A.1 This is a 4 x 3 image with a 4 x 6 landscape selection. A bit of the bottom of the image would be lost, which is fine.

Figure A.2 This is a 4 x 3 image with a 5 x 7 landscape selection. Very little of the bottom of the image would be lost to cropping.

Figure A.3 This is a 4 x 3 image with an 8 x 10 landscape selection. Losing the right side of the image would be somewhat problematic.

Figure A.4 This is a 4 x 3 portrait image with a 4 x 6 portrait selection. A bit on the left would be lost, which is fine (a better crop would take some from the left, the right, and the top).

Figure A.5 This is a 4 x 3 portrait image with a 5 x 7 portrait selection. A very small amount on the left would be lost, which is fine.

Figure A.6 This is a 4 x 3 portrait image with an 8 x 10 portrait selection. As with the landscape image on the previous page, the aspect ratios match badly for this image, since the selection cuts off the top of Tristan's head.

Figure A.7 This is a 4 x 3 portrait image with a square selection. As you can tell, the square selection is a lousy choice for this image.

a picture composed of 1600 pixels wide by 1200 pixels high, basic math shows that your photos will have a 4 x 3 aspect ratio.

Why did digital camera manufacturers choose a 4×3 aspect ratio when 4×6 is the 35mm film standard? It matches the aspect ratios of most computer monitors. Whether your monitor runs at 640×480 , 800×600 , or 1024×768 , division reveals that it has a 4×3 aspect ratio. Displaying a photo at full screen size without cropping thus requires a 4×3 aspect ratio. (And why do computer monitors use a 4×3 aspect ratio? Because that's the aspect ratio used by televisions. Since HDTV uses a 16×9 aspect ratio, some monitors are starting to use that as well.)

Hopefully the choices in iPhoto's Constrain pop-up menu make more sense now. If you're starting from a photo with a 4 x 3 aspect ratio, and you want a 20" x 30" print (a 4 x 6 aspect ratio), there's no way to print that photo without borders or cropping because of the mismatch in aspect ratios. The same applies to the other standard print sizes—they don't match the 4 x 3 aspect ratio of most digital photos. Rather than suffering borders or automatic cropping, it's better to crop the image yourself so you can be sure the important parts are retained. Figures A.1 through A.7 show how cropping a 4 x 3 image at the other common aspect ratios works for two sample images (results will vary by image).

The 4×3 aspect ratio plays an important role in output too, since iPhoto's book designs all assume images in the 4×3 aspect ratio so you don't have to do as much cropping. The books vary the final image size depending on the page design, but as long as the aspect ratio of your images remains 4×3 , the layout will work as Apple intended. You can use different aspect ratios in a book, of course, but the layout may not work as well.

Understanding Resolution

Understanding how the dimensions of a digital photo relate to what comes out of a printer is hard. That's why iPhoto merely alerts you with a warning icon when a photo won't print well at a specific size. Read these two pages to learn why iPhoto displays warning icons; "Dealing with Warning Icons" in Chapter 7, "Troubleshooting," offers help.

Pixels and Dots

Every digital photo is made up of a rectangular grid of points, called pixels, each of which can display one of sixteen million colors or several hundred shades of grey. For instance, photos from my camera are 1600 pixels wide by 1200 pixels high. Monitors also display rectangular grids of pixels, often 1024 pixels wide by 768 pixels high.

Not all of a 1600×1200 photo can fit on a 1024×768 monitor when every pixel in the image is mapped to a pixel on the monitor. To display a photo so it fills a monitor, iPhoto removes pixels on the fly, a process called *downsampling*.

You can't perform the same one-to-one mapping when it comes to print, though, because most printers (which have only four or six colors) can't display a pixel's exact color in a single dot. Instead, they use collections of single-colored dots to fool the eye into seeing that color. For this reason and other more complex ones, the main fact to grok is that, in general, the more pixels in the image, the better it will look printed.

This fact is particularly relevant when you're printing images at large sizes. For instance, why does an image that looks fine when printed at 4" x 6" appear fuzzy at 8" x 10"?

Imagine a knitted blanket. If you stretch it to make it larger, you can see through the holes between the strands of yarn. Expanding a

Figure A.8 The original image at 100 percent.

Figure A.9 Shrink the image to 17 percent of original size and the loss of detail caused by downsampling makes it hard to see the stripes on the penguin's tie.

Figure A.10 Expand the image to 400 percent of the original and the fuzziness added by interpolation becomes evident.

Figure A.11 The original 1600 x 1200 pixel image, with a small area to crop selected.

Figure A.12 Crop the image to 206 x 183 pixels and you can see how the horse looks much fuzzier due to all the interpolation necessary to expand it to the desired size.

Get the Electronic Edition!

You may be able to see the differences between these pictures better in the full-color PDF version of the book. To find out how to get it, send an email message to get-iphoto4-vqs@tidbits.com.

photo to print at a larger size works similarly, except the printer fills in each hole with dots of roughly the same color as the dots surrounding the hole, a process called *interpolation*. The more pixels in the image, the smaller the holes that need to be filled, and the less interpolation is necessary.

Downsampling vs. Interpolation

Downsampling onscreen works well, since it's easy to remove similarly colored pixels without changing the image particularly. Even though the photo loses pixels and thus some detail, quality doesn't suffer much (**Figure A.8** and **Figure A.9** on the previous page). Along with the fact that onscreen images are extremely bright because monitors *emit* light, whereas paper *reflects* light, minimal downsampling helps explain why photos look good on monitors at full size.

Interpolation, particularly on a printer, is different. There's no way to avoid the fact that expanding a photo requires adding dots that didn't exist before, and because those dots exist only by virtue of the dots around them, they make the image look fuzzier (Figure A.8 and Figure A.10 on the previous page). Interpolation simply cannot add details to the image that weren't originally present. Scale an image too large, and iPhoto warns you that so much interpolation will be needed that you won't like the result.

Cropping Implies Interpolation

Cropping exacerbates the problem because it removes pixels, making the photo smaller and requiring more interpolation to expand the image back up to the desired size.

To see this, compare the original image in **Figure A.11** with **Figure A.12**, which shows a heavily cropped version of the same image, displayed at the same size as the original. Notice how the cropped horse is fuzzier.

Understanding Color Management

You've probably noticed that iPhoto lacks tools for manually adjusting color saturation or amounts of any given color in a photo. Although the Enhance tool does some of this, Apple's decision to keep color correction an entirely automatic operation wasn't a bad one. Why? Color correction of any sort is devilishly difficult to do right (and as you may have noticed, even Enhance can get it wrong at times). Color correction suffers from two basic problems: the fact that color is highly perceptual and the fact that different devices render color in different ways.

Color Perception

Everyone sees color in different ways. My wife and I, for instance, frequently disagree on whether a given color is green or blue, and the fact that my opinion generally seems to match what others think as well doesn't change the fact that she is perceiving a different color. Add that to the fact that at least 10 percent of the population suffers from some level of color blindness.

The conditions in which color is perceived also make a huge difference, as you've probably realized if you ever purchased a shirt in a store lit with fluorescent lights and were surprised by how the shirt looked when you tried it on at home under incandescent lights. Similarly, when painting a room, you have to consider how the color will look in sunlight during the day and with artificial lighting at night. The differences can be striking.

The lesson here is that you cannot define color objectively—there is no right answer. Always keep that in mind and it will remove some of the stress about achieving the perfect color in your photos.

Rendering Color

Digital cameras, computer monitors, inkjet printers, and commercial photo processing equipment all use different methods of rendering color. Even with monitors, there's little common ground between normal CRT-based monitors and the increasingly popular LCD flat-panel monitors.

When you're trying to take a picture with your camera, look at it on your Mac, print a copy on your printer, and order a large print of the image from Kodak, you would like the colors in the image to match closely at each step. The engineers designing these devices have managed to make the color produced by each one match fairly well, but not perfectly. Here's how it works.

Imagine a three-dimensional graph, with the X-, Y-, and Z-axes representing the amount of red, green, and blue in every possible color. (Don't worry about this turning technical, that's as bad as it gets.) Now imagine an amorphous blob in the graph that represents the specific set of colors any given device can capture (for digital cameras) or display (for monitors or printers). That blob is called the *gamut*, and every type of device has a gamut that's at least slightly different.

The problem with matching color across completely different types of devices is that each device can render only colors in its gamut. When a color, say a specific light green, falls into an area where there's overlap between gamuts, each device does the right thing and renders the exact same light green. However, when a color falls outside the set of colors a device can render, it's a problem. There's no way the device can render a color outside its gamut, so it makes an educated guess about what color to render instead.

Color-Matching Systems

Many efforts have been made to address this problem, but the one you're most likely to have heard about, being a Mac user, is Apple's ColorSync technology. The particular approach it uses to make educated guesses about which colors to render on different devices is immaterial; suffice to say that its goal is consistency. In theory, if you have chosen or set up a ColorSync profile for your monitor and your printer, for instance, it should help ensure that the colors you see on your monitor match those printed by your printer.

Without getting into too many details, you can calibrate your monitor by choosing System Preferences from the Apple menu, clicking the Displays preference pane, clicking the Color tab, and clicking the Calibrate button to run and work through the Display Calibrator Assistant. Then, when you're printing, look for a ColorSync setting in the Color Management panel of the Print dialog. Whether it's present or not depends on your printer driver, but if the setting is present at all, it's usually the default. That's all there is to basic use of ColorSync, and on the whole, it works pretty well.

You may not be limited to ColorSync's educated guesses about how to render color (my Epson's Photo-Realistic mode sometimes produces better results), and in fact, none of the commercial photo processing companies, including Kodak, use it. Why not? Two reasons.

First, photos are displayed on monitors and on paper totally differently. Monitors *emit* light, causing photos to be extremely bright. Paper *reflects* light, so unless you shine a floodlight on a photo, you can't come close to the amount of light emanating from a monitor.

Second, color is highly perceptual, and Kodak and other photography companies have done incredible amounts of research to determine not so much how to match colors exactly, but how to print photographs that meet people's expectations.

In the end, the problem of matching color perfectly between devices is just too hard. Even with technologies like ColorSync, the differences between a photo on a light-emitting monitor and light-reflecting paper mean that the photo processing companies have a better chance of satisfying customers if they concentrate more on producing a photograph that looks desirable than on matching colors perfectly in an imperfect world where everyone sees color differently.

Should You Correct Colors?

Color correction is complex, and the necessary tools are also usually complex (PixelNhance is a notable exception—see "Recommended Image Editing Programs" in Chapter 4, "Editing Photos"), so Apple didn't want to shackle a program like iPhoto with difficult tools. Hopefully you see now why Apple decided to restrict iPhoto's color-correction tools to the one-click Enhance button. It's nice to see Apple acknowledging that even normal users need some help correcting color problems, but iPhoto will never compete with Adobe Photoshop.

Now that you know how hard it is to achieve reliable, predictable results, should you bother using a tool like PixelNhance to color correct your photos? It all depends on how much you want to play. For those who don't like to fuss, no, don't bother. If you like fiddling with your photos so you can make them just right, then yes, go ahead. And for the majority of us who fall between those two poles, I recommend doing manual color correction only on the images you like the most and that will benefit from it the most.

TAKING BETTER PHOTOS

iPhoto will make you a better photographer, for the simple reason that the best way to improve a skill is constant practice. Thanks to iPhoto, it's easier to take and review photographs than ever before.

But there's no reason you must discover all the ways you can take better photos on your own. Having the best equipment for the kind of photos you want to take will help, as will learning some of the basics of different types of photography. This appendix offers that advice, ranging from choosing the best camera for your needs to tips on how to take great pictures of kids. (Hint: The posed portrait is unlikely to work.)

So skim these few pages, and even if you integrate only a tip or two into your own photographs, the time you've spent reading will have been worthwhile.

If you want to see all the photos in this appendix in full color (which does help the photos illustrate the tips better) send email to get-iphoto4-vqs@tidbits.com to find out how to download a PDF version of the book.

What Kind of Photographer Are You?

When choosing the camera that will help you take the best photos, it's important to choose one that matches the kind of photos you actually take. But what sort of photographer are you? In one way of thinking, there are two types of photographers: artistic and documentary (and as is usually the case, most people overlap somewhat).

You're an artistic photographer if:

- You care more about the overall look of a photo than the subject of the picture (Figure B.1).
- Objects and landscapes fill many of your photos and stand alone as aesthetic representations of your reality.
- Display and print quality is of the utmost importance. You regularly print and display your best photos.
- You're willing to take time to set up the perfect shot, and you do things because they give you photo opportunities.

You're a documentary photographer if:

- Who or what appears in the photo is more important than the overall look (Figure B.2).
- The most common subjects of your photos are people and places, and they usually fit into and support a larger story.
- You're willing to trade quality for convenience, ease of use, or speed of shooting.
- ◆ You don't have the free time or patience to set up shots, and you prefer to snap a few pictures quickly in the hope that at least one will turn out well. You carry your camera to record events or in the hope of getting a good shot.

Figure B.1 There's not much of a story in this photo—I was just intrigued by the color of the leaf underneath the new-fallen snow. We're definitely looking at an artistic photograph here.

Figure B.2 In contrast, here we have a picture of me and my grandmother at my 35th birthday party. Whether or not it's a good photo is almost immaterial—what's important is that it reminds me of a special meal with my family. It's a pure documentary photograph.

Choosing a Camera

Once you've determined what sort of photographer you really are (and that may be different from the type of photographer you'd like to be in an ideal world), working through the variables that differentiate digital cameras becomes significantly easier.

Form Factor

Digital cameras come in a wide variety of sizes, and for documentary photographers, small size can be important so the camera fits in a pocket and so the fact that you're taking pictures doesn't overwhelm the event. Artistic photographers are often willing to carry larger cameras because of the increased quality and flexibility of larger cameras. Most cameras probably fall in a middle ground, so it's best to hold the camera to see how it feels in your hand before buying it.

Megapixels/Quality

Within the form factor that matches your shooting style, you should always try to get the most megapixels (larger cameras have larger CCDs and can thus capture more pixels). But lens quality makes a difference too, and the best way to determine lens quality is to read detailed camera reviews. Artistic photographers need to pay the most attention to quality issues.

Lens Capabilities

For documentary photographers, this mostly comes down to whether or not the camera has a decent optical (ignore digital) zoom for capturing far away events. For artistic photographers, zoom capabilities are important for those times when you simply can't (or shouldn't) get close enough to the subject (such as a grizzly bear). Also important are macro capabilities, for stunning close-ups of flowers, insects, and other small objects.

Extra Features

Extra features may be important, so documentary photographers may appreciate a short movie capability, whereas artistic photographers might look for the capability to use an external flash or different lenses. Also pay attention to factors like the camera's battery type: AA batteries are cheap and easily found, and you can buy good rechargeable batteries, but the smallest cameras generally have their own battery packs and chargers.

Price

Everyone has a budget, and here's where you must decide how much to pay. Documentary photographers will pay more for truly tiny cameras with decent quality, whereas artistic photographers pay more for quality, manual controls, and the capability to add additional lenses. Although more money will buy a better camera, you can take good pictures with almost any camera.

Interface

Some cameras are easier to use than others, which is important for documentary photographers who need to be able to set options quickly before missing a particular shot. Artistic photographers care more about control, so the camera interface should help them twiddle manual settings easily.

Speed

Digital cameras can be quite slow, with a few seconds to start up, a lag between when you press the shutter release and when the picture is taken, and a few-second lag between shots. Documentary photographers in particular should look for faster cameras, so as to avoid missing that perfect shot due to camera lag. Artistic photographers interested in action shots should also pay attention to speed or risk losing great photos.

Where to Read Camera Reviews

After you've determined roughly what kind of camera you want, you have a few choices. You can go to a store and buy whatever the salesperson recommends after hearing your story. You can depend on a friend who has already researched a similar type of camera. Or you can do the research yourself. Be forewarned—if you're not a camera buff, you may find reading numerous camera reviews overwhelming, thanks to the incredible detail provided. I've found the sites below useful for reviews, buyer's guides, news, discussions, and other digital photography information.

Camera review sites:

 Digital Photography Review has an especially detailed tool for comparing the specs on different cameras, along with a buying guide.

Find it at: www.dpreview.com

- Digital Camera Resource Page offers an interactive buyer's guide that works on how you plan to use the camera instead of just your opinion of different features.
 Find it at: www.dcresource.com
- Imaging Resource stands out from the pack with its Comparometer, which lets you compare sample photos taken with different cameras. The site also offers a simple camera shopping guide.

Find it at: www.imaging-resource.com

 Steve's DigiCams offers detailed reviews that are unfortunately broken into multiple pages, making reading clumsy.
 Find it at: www.steves-digicams.com

Camera Accessories

Although all you need to take good photos is a camera, there are some accessories that can help at times.

Bigger Memory Card

Most cameras ship with small memory cards, often only 8 MB or 16 MB. That's too small, and you may feel as though you should shoot at a lower resolution to save space. Don't do it—just buy a larger memory card and use the highest resolution available. Visit www.dealram.com to compare prices at multiple vendors for the type of memory card your camera uses.

USB Card/PC Card Reader

If you have friends with digital cameras, a USB card reader that accepts all the types of memory cards can make it easy to share photos of an event right then, without having to mail them around later. Folks with PowerBooks might also look for a PC Card adapter that lets you plug your memory card right into the laptop.

Also check out the Belkin Media Reader attachment for Apple's iPod music player; it lets you offload photos from your camera to your iPod. Learn more at www.belkin.com.

Monopod/Tripod

In low-light situations, if you don't want to use the flash, you risk your photos coming out blurry. The solution? Attach the camera (most have the appropriate threaded mount) to a monopod or a tripod. Documentary photographers are less likely to want to use even a monopod (which is smaller and faster to use than a tripod) because of it getting in the way, whereas artistic photographers are more likely to accept a little extra annoyance in exchange for the highest quality photos. Either way, make sure it's easy to use.

Extra Batteries

It's unfortunately common to run out of power at a bad moment, particularly if you're using your camera's flash or LCD display a lot. Avoid missing great photos because your camera is dead by carrying an extra battery pack or set of batteries. Proprietary battery packs tend to be expensive, but my experience is that it's worth buying the camera vendor's battery rather than one from an independent manufacturer. Other cameras take standard AA batteries; you can use any normal battery, but it's cheaper and more environmentally friendly to use rechargeable batteries, such as those available from Quest Batteries; visit www.questbatteries.com.

Lens Cleaning Kit

Perhaps this is obvious to anyone from the analog camera world, but for those of us who have used only digital cameras seriously, it's well worth getting a special lens cleaning kit that can remove dust and dirt from your lens and LCD (and for cameras with removable lenses, the CCD inside). Normal cloth might cause scratches. Any camera store should be able to recommend a lens cleaning kit.

Printer

With iPhoto, you can always order prints from Apple. But you may want to print them yourself, perhaps for instant gratification, greater control, or privacy reasons. For that you'll need a color printer. There are a number of different technologies, such as inkjet, laser, and dye-sublimation. Inkjet printers are the most common (buy a six-color printer for the best photo quality) and offer excellent quality but have high per-print materials costs. Dye-sublimation printers have the best quality for photos, but are more expensive. And color laser printers are the cheapest to run for many prints. Camera review sites also often review printers.

General Photo Tips

No matter what type of photos you take, a few general tips will take you a long way.

- ◆ Consider the Rule of Thirds. Divide the image into a 3 x 3 grid and try to have the main subject of the photo where the lines intersect (**Figure B.3**). If your photo will have strong horizontal (as in a horizon) or vertical lines (as in a building), try to keep them on the horizontal or vertical lines. Centering can work, but tends to be a bit dull for anything but portraits.
- ◆ Pay attention to where the light comes from and try to avoid shooting into strong light. It's better to shoot with light at your back (make sure your subjects aren't squinting) or to one side whenever possible. If you have to take a picture of people who have the sun behind them, turn on your flash to light up their faces, which will otherwise be too dark.
- Don't be afraid to shoot from odd angles or unusual heights. Digital cameras encourage experimentation, and playing around can produce some great shots.
- Avoid a busy background that will distract the eye from the subject of the photo (Figure B.4).
- Keep the camera steady, particularly when you're shooting in low light without the flash. The beauty of the LCD screen on the camera is that you can set the camera on a solid object to shoot, even when it's not at a comfortable height.
- Remember that the flash on most small digital cameras works well only to about 10 feet. Relying on room light is tricky, but the more light you can throw on the subject in a normal room, the better.

Figure B.3 Note how Tristan and his cousin Madeline are at the intersections of the grid, increasing visual interest and emphasizing their interaction.

Figure B.4 This photo shows the value of an uncluttered background—the blank wall helps the eye focus on the man in the scene. Note too that the fact that he's only half in the frame increases the power of the photo. Sometimes in photography, as in graphic design, some white space can improve the image.

Figure B.5 Portrait orientation makes all the difference for this picture of the long, deep gorge that runs through Cornell University.

Figure B.6 This close-up of my wife's face works in large part because it's so close and out of focus.

More General Photo Tips

Here are a few more tips that can help.

- Try to match the orientation of the subject to the orientation of the photo (Figure B.5). Landscape orientation, where the photo is wider than it is tall, usually works best for landscapes (with specific exceptions, such as the gorge in Figure B.5), whereas portrait orientation, where the photo is taller than it is wide, works best for people. Computers and TVs use landscape orientation, so keep that in mind if you plan to do a lot of slideshows.
- ◆ Try to avoid posing your subjects. Most people aren't very good at describing exactly what they want the person in the photo to do, and most people aren't good at adopting a specific pose without it looking forced. Give it a try and you'll appreciate how hard professional photographers and models work.
- Figure out exactly what interests you about a scene before shooting. That helps you set up the shot and find different ways of emphasizing the subject.
- Take lots of photos—they don't cost anything. This is especially important when the scene is changing, but even with shots you set up, it's worth taking a couple, just in case one shot works better than another.
- As a corollary, try alternative ways of taking a given picture, such as with and without the flash. Do this enough and you'll start to figure out when to use certain settings for your desired effect.
- Don't be afraid to get close and fill the frame with the subject, even when it means cutting off parts of people's bodies or faces (Figure B.6).

Portrait Photo Tips

For many of us, pictures of people make up the bulk of our photo collections. Use these tips to improve your portraits of family and friends in the future.

Portrait photo tips:

- Get closer. A lot of portraits are taken from too far away, lessening the impact of having that particular person in the photo. Of course, since getting closer isn't always feasible, a good zoom lens can help.
- When you're taking pictures of traveling companions, break the previous rule a bit so you can add context to the shot. Signs work well for reminding you of where and when a picture was taken, particularly if they're in other languages.
- ◆ For candid snapshots, which are often the best kind, make sure you have enough light and just point the camera in the right direction and shoot from the hip (Figure B.7). Lots of these shots will be terrible, but the effort of tossing them is well worth the occasional amazing shot you'll get.
- ◆ Don't warn people in advance that you're going to take a photo unless you want forced smiles. If you need people to look at you, pre-focus your camera by pressing the shutter release button halfway, then say something to get their attention. As soon as they look at you, and before they realize you're taking a picture, press the button the rest of the way down.
- In group photos, make everyone crunch together and overlap. The presentation is much more interesting than if everyone just lines up by height (Figure B.8).

Figure B.7 I took this photo while holding the camera at my waist and walking normally down the street.

Figure B.8 This group photo from my family reunion works well because the different levels provided by the stairs help everyone overlap neatly.

Figure B.9 Getting a cat and a child both looking photogenic at the same moment can be tricky unless you're willing to take lots of shots.

Figure B.10 The fact that the camera is on Tristan's level, about a foot off the ground, provides a good perspective.

Figure B.11 Since Tristan loves trains, these abandoned mine trains at the Last Chance Basin Mining Museum in Juneau, Alaska, were a big hit. He asked me to take this photo and even agreed to pose in it.

Child and Pet Photo Tips

People may be the most common subjects of photos, but I'll bet most of those photos are pictures of children. And those folks who don't have children around often seem to replace kid photos with pet photos. Children and pets require similar shooting styles.

Child and pet photo tips:

- Adults are usually capable of at least that oh-so-familiar forced smile, but kids often don't want to participate, and it's almost impossible to convince pets to pose. Give it up and shoot surreptitiously.
- When kids or pets are playing, they may not notice you, so work fast and take lots of pictures (Figure B.9). Try to avoid calling out names, since that will almost certainly break the spell.
- If the kids or pets realize what you're doing, just be patient and stay prepared in case you get another chance.
- If you plan to take pictures of your child, encourage him to wear brightly colored clothing that day. Lots of color can really help a picture.
- With both kids and pets, get down on their level (Figure B.10). Otherwise you end up shooting the tops of their heads.
- At zoos or similar attractions, try to photograph the child reacting to, or interacting with, the animals.
- It can be great fun to involve kids in the decisions about what pictures to take, particularly if you're on a trip. Ask them what they'd like you to take pictures of, and let them set the scene (Figure B.11).
- Outdoor photos often work the best, perhaps because it's easier to get good, uncluttered backgrounds.

Landscape Photo Tips

There are places where it seems almost impossible to take a bad photo (glaciers and mountain vistas, for instance), but a few tips can help improve other landscape pictures.

Landscape photo tips:

- Take advantage of the long light early in the morning (less haze) or just before dusk (sunset colors), since you get more interesting shadows and interplay between light and dark. Try to keep the sun at your back or your side.
- Keep the horizon level, especially since iPhoto has no way to straighten photos (Figure B.12). Luckily, GraphicConverter and most other image-editing applications do, and it's worth making the effort to straighten an otherwise good photo.
- Keeping the Rule of Thirds in mind, if the land is the subject of your photo, make two-thirds of the photo be land, with one-third sky. If the sky is the focus of the photo (sunset photos can produce the most amazing colors), then reverse those proportions so the sky fills most of the frame.
- ◆ Try to include an object in the foreground to catch the eye, rather than leaving the entire landscape in the far distance (Figure B.13). A foreground object has the added advantage of indicating the magnitude of the scenery.
- When possible, eliminate distracting elements, such as telephone poles or electric lines. Otherwise, try to use them in the composition of the photo.
- Try using reflections in water or windows for interesting effects and perspectives (Figure B.14).

Figure B.12 It's hard to take a bad picture of a glacier...unless you can't hold the camera straight. A quick trip to GraphicConverter fixed this shot.

Figure B.13 The misty woods in the background evoke a mood, but Tristan running away from the camera down the mown strip in the field lends focus.

Figure B.14 This picture, although seemingly a normal landscape of trees and the sky, is actually a reflection in a pond, giving the scene added depth.

Figure B.15 Having Tristan pose in front of our cruise ship, with its name visible in the background (though hard to read at this size), made for a perfect travel picture.

Figure B.16 Make sure to have other people take pictures of you. You'll especially appreciate having done this if you decide to make a book of your trip in iPhoto.

Travel Photo Tips

Although the tips for landscapes and portraits apply equally as well when you're traveling, there are a few other tips that can help improve your vacation photos.

Travel photo tips:

- Try to include your traveling companions in the shots when possible, because without them, you could just buy a postcard.
- See if you can take photos that remind you of an area or event. Shoot details such as buildings, signs, or natural landmarks, but take them from your perspective and, when possible, with your traveling companions (Figure B.15).
- ◆ Don't get sucked into the trap of posed shots of your companions in front of whatever the local attraction may be. Have some fun and keep it light, partly so you get better shots, and partly so your traveling companions don't get sick of your camera.
- Ask one of your companions, or a passerby, to take pictures that include you.
 Otherwise it may seem as though you weren't along on the trip (Figure B.16).
- Take pictures of the people you meet (it's best to ask for permission first), and if possible, make notes so you remember each person later.
- Plan ahead so you can take lots of photos. That may entail carrying an extra memory card or two, getting a rechargeable digital wallet drive to which you can download photos, or bringing a laptop along (at which point you can post Web pages of your travel photos for friends and family back home). It's also worth doing a bit of culling every night to free up space used by the truly bad shots.

INDEX

1-Click ordering

can't enable, 164

enabling, 123
A
accessing sharing photos, 149
Account Info dialog, 123
album pane
creating albums in, 39
dragging photos into, 39
illustrated, 9, 17, 31, 81
iPhoto disc display on, 17, 139
albums. See also books; smart albums
adding photos to, 46
backing up, 24
creating, 39
deleting, 44
deleting photos from, 20
duplicate images in, 65
duplicating, 42
film rolls in Photo Library, 12
importing from iPhoto disc, 17
importing photos and creating, 15 keywords vs., 39, 52
Last Roll, 12, 65
making .Mac Slides, 132
managing HomePage, 131
removing photos from, 47
renaming and rearranging, 43
selecting multiple, 45
Albums folder, 19
aligning photos to grid, 33
Appearance preference pane (Mac OS X), 35
Appearance tab (Preferences window), 33, 48
Apple
checking on order status, 170

```
downloading iPhoto AppleScript scripts, 151
  iPhoto help, 165
  not all prints received from, 163
  setting up .Mac account, 128
  shipping information for books and
        prints, 125
Apple ID
  email address as, 122
  setting up, 122
  sign in with, 123
Apple .Mac Signup Web page, 128
AppleScript scripts for iPhoto, 150-151
archiving photos, 25
arranging photos
  on book pages, 85
  by date, 48
  for slideshows, 117
Art Explosion Greeting Card Factory, 110
artistic photography, 176
aspect ratios
  constraining Desktop photos to fit
        screen, 134
  constraining selection to, 60
  including extra space on edges of photos, 72
  moving and resizing selection rectangle while
        maintaining, 70
  specific and custom, 71
  understanding, 168-169
assigning
  comments, 50
  keywords, 53
  titles, 49
assigning ratings, 55
Audio button (iMovie), 119
automatic launching of iPhoto, 7, 12, 13
```

D	•
В	C
B & W button, 60, 68	cameras. See digital cameras
backing up photos	card readers
to discs, 24–25, 138	importing photos from, 11, 14
recovering photos, 21, 75	not recognized in iPhoto, 156
Batch Change, 49, 51	removing memory card from, 14
batteries, 179	Catalog book theme, 96
BetterHTMLExport, 143	CCD (charged-coupled device), 168
black-and-white images, 68	CDs
bold text, 90	backing up photos to, 24-25, 138
Book button, 80	burning iPhoto, 25, 26, 138
book mode	importing photos from backup, 17
defined, 8	importing photos from Photo CD/Picture
pages jump around in, 163	CD, 16
printing photos and text from, 106	receiving iPhoto, 139
switching in/out of, 80	reusing CD-RW discs, 25
book themes. See books; themes	using CD-R for archiving, 25
books, 79–102	changing layout
about, 79	for display pane, 32
arranging photos, 48, 85	for HomePage albums, 131
Catalog book theme, 96	Check Spelling As You Type command, 93
checking spelling, 92–93	checking spelling, 92–93
choosing theme for, 83	checkmark keyword, 53
Classic book theme, 97	chevron for pop-up menus, 63
Collage book theme, 83, 98	child photos, 183
creating, 82	Classic book theme, 97
customizing page designs, 82	Collage book theme, 83, 98
deleting introduction pages, 87	color
designing pages, 84	changing text, 91
entering or editing text, 87	color-matching systems, 173
font changes, 89	correcting, 173
low-resolution warning icons, 86	perception of, 172
1-Click ordering, 123, 164	rendering, 172
ordering, 126	selecting book cover, 126
Picture book theme, 99	color-matching systems, 173
Portfolio book theme, 100	Colors palette, 91
previewing, 81, 94	comments
printing on own printer, 95	adding to books, 83
Story Book theme, 101	on albums, 43
styles, 89, 90	assigning to photos, 50
switching in/out of book mode, 80	printing for contact sheets, 108
text color changes, 91	Comments field, 50
tools in book mode, 81	Constrain pop-up menu, 60, 61, 169
typing punctuation and text, 88	Contact Sheet print style, 108, 111
Year Book theme, 102	contextual menu shortcuts, 34, 59
brightness, 69	contrast, 69
bullets, 88	copyright symbols, 88
Burn button, 24, 105, 138	correcting color, 173
Burn Disc dialog, 24, 138	crashes
burning photo CDs, 25, 26, 138	troubleshooting, 155
buttons. See also specific button by name	when photo double-clicked, 160
dimmed, 60	when viewing thumbnail, 161
mode. 9	creating keywords, 52

cropping photos	digital hub applications, 3
Crop button for, 60	disappearing photos, 154
low-resolution warnings when, 72	disconnecting camera volumes, 13
pixels and, 171	discs. See CDs
steps for, 72	display pane, 9
culling photos, 20	changing layout, 32
current book page, 81	editing tools in, 60
custom aspect ratios, 71	manually switching to import mode, 12
custom stickers, 108	resizing contents of, 31
Customize button, 61	zooming photos, 64
customizing	distributing QuickTime movies, 145
book PDF files, 83	documentary photography, 176
page designs, 82	Download Some button (Image Capture
toolbar, 62	window), 18, 27
_	downloading
D	image thumbnail display during, 13
damaged photo warnings, 157	images from Image Capture, 27
Data folders, 19	iPhoto AppleScript scripts, 151
dates	QuickTime for Windows users, 145
arranging photos by, 48	downsampling, 170–171
editing film roll, 36	dragging
editing photo, 51	creating selection rectangle by, 70
deleting	files and folders into iPhoto, 15, 17
albums, 44	images to albums, 46
HomePage albums, 131	multiple images, 45
introduction pages, 87	photo files to Finder, 46, 141
keywords, 52	photo to Trash album, 47
photos, 14, 20, 84	photos between film rolls, 38
deselecting photos, 45	photos into album pane, 39
designing books	photos to other applications, 34
arranging photos on pages, 85	photos to outgoing email window, 121
customizing page designs, 82	thumbnails to arrange photos, 81, 85
designing pages, 84	drivers
setting design theme and preferences, 83	Gimp-Print, 109
Desktop & Screen Saver preference pane, 133,	for USB still cameras, 13
134, 135	Duplicate Photo dialog, 18
Desktop button, 105, 135	duplicating
Desktop photos, 134	albums, 42
Desktop tab (Desktop & Screen Saver	duplicate images after import, 17, 18, 158
preference pane), 134, 135	photos, 65, 84
digital cameras. See also photography	DVD slideshows, 136–137
accessories for, 179	_
choosing, 177	E
compatible, 2	Easy Card, 110
disconnecting, 13	Edit button, 58
drivers for USB still cameras, 13	Edit commands, 34
editing photo dates, 51	Edit in external editor command, 76
erasing contents of, 13	edit mode. See also editing
importing images from, 13, 156–158	defined, 8
not recognized in iPhoto, 156	entering, 58
reviews of, 178	editing, 57–78
setting iPhoto to launch when connecting, 7,	aspect ratios, 71
12, 13	avoiding excessive, 161

Batch Change, 49, 51	F
brightness and contrast, 69	
contextual menu shortcuts for, 59	File Export tab (Export Photos dialog), 140
cropping photos, 72	file formats
customizing toolbar, 62	for export, 140
duplicating photos, 65	RAW movie files, 13
edit tools for display pane, 60	rotating and converting GIF images to
enhancing photos, 67	JPEG, 66
entering edit mode, 58	supported, 13, 15
in external editor, 76	File menu, 104
film roll title and date, 36	files. See also exporting photos; file formats
image-editing programs, 77-78	importing photos; PDF files
making black-and-white images, 68	compatible iPhoto formats, 13, 15
photo dates, 51	don't appear after import, 156–157
photos on book page, 84	exporting photo, 140, 141
reducing red-eye, 73	importing photo, 15
retouching photos, 74	manually finding original, 75
rotating photos, 66	stopping photo importing, 15
selecting parts of photo, 70	stored in Trash, 21
setting preferences for, 58	film rolls
smart albums, 40	adding photos to, 36
text, 87	arranging photos by, 48
thumbnails don't reflect, 161	creating for imported folders, 15
toolbar for, 63	creating new, 37
tools for separate window, 61	editing, 36
unable to edit photos, 160	moving photos between, 38
undoing changes, 75, 76	in organize mode, 31
zooming photos, 64	showing or hiding, 32
electronic edition of book, 1	tracking imports as separate, 12
Email button, 105, 120	Finder
emailing photos, 120–121	dragging photo files from, 46
Enhance button, 60	exporting photos to, 141
enhancing photos, 67	locating images in, 19
entering text, 87	managing export plug-ins from, 142
erasing contents of digital camera, 13	Fit button, 61
errors during ordering, 164	folders. See also iPhoto Library folders
Export commands, 104	creating iPhoto Library, 22
Export Photos dialog, 140	directory structure of, 19
export plug-ins, 142	importing, 15
exporting photos	locating iPhoto Library, 23
after rotating, 141	merging iPhoto Library, 26
by dragging to Finder, 141	switching between iPhoto Library, 23
dragging photos to other applications, 34	fonts, 89, 90
file export, 140	Fonts palette, 89
to Finder folders, 25, 26	forgotten passwords, 123
to QuickTime movies, 144	Full Page print style, 109, 113
to Web pages, 142–143	C
Exposure tab (Photo Info window), 56	G
external editors	gamma, 162
photos don't open in, 160	GarageBand, 118
using 76	General tab (Preferences window), 33

getting started, 1–9 acquiring iPhoto software, 3 feature comparison of iPhoto 2 and 4, 6 first time, 7 hardware and software requirements, 2 iPhoto interface, 9 iPhoto modes, 8 launching, 7, 12, 13 updating from 2 to 4, 6 updating with Software Update, 5 GIF images, 66 Gimp-Print drivers, 109 GraphicConverter, 77, 140 Greeting Card print style, 110 guide lines, 81, 87	Import Photos dialog, 15 importing photos adding photos to film roll, 36 from card reader, 11, 14 from digital camera, 13 dragging photo files from Finder, 46 entering import mode, 12 from files, 15 film rolls created when, 37 importing selected images, 18 from iPhoto disc, 17, 139 from Kodak Photo CD or Picture CD, 16 multitasking while, 11 permissions for imported photos, 146 stopping, 15
ш	troubleshooting, 156–158
hard disk, backing up photos to external, 25 hardware requirements, 2 help, 165 HomePage about, 129 managing albums, 131 navigating to, 131 publishing photos using, 130 HomePage button, 105	info pane assigning title in, 49 Comments field of, 50 defined, 9 editing photo dates, 51 illustrated, 31, 36, 105 viewing photo information, 56 inkjet printers, 107, 115, 179 installing iPhoto, 4
Hot Plug Action, 7	Script menu, 151 interpolation, 171
1	iPhoto, 1–9
l	AppleScript scripts for, 150–151
iCards, 129	comparing versions of, 6
icons. See warning icons iDisk	compatible email software, 120
about, 129	contextual menu shortcuts, 34, 59
locating .Mac Slides on, 132	crashes when photos double-clicked, 160
iDVD	directory structure, 19 getting started first time, 7
creating slideshows, 6, 136-137	hardware and software requirements, 2
illustrated, 136	importing images from backup disc, 17
using, 137	installing, 4
iDVD button, 105 iDVD folder, 19	Knowledge Base, 165
iLife, 3, 4	launching, 7, 12, 13
Image Capture	modes, 8
downloading photos with, 27	preventing copying of duplicates, 18 Script menu installation, 151
resetting Hot Plug Action in, 7	sources for software, 3
Image Rodeo, 143	supported file formats, 13, 15
ImageBuddy, 108, 114	updating, 5–6
image-editing programs, 77–78	user interface, 9
image-editing window, 64 iMovie, 119	version numbering for, 3
import mode	iPhoto Library folders
connecting camera and switching to, 13	copying albums to, 17
defined, 8	creating multiple, 22 locating, 23
entering, 12	maintaining contents of, 19

maging 26	iDisk, 129
merging, 26	Mail, 129
setting access for photos in, 146 sharing photos on network, 26, 147–149	setting up, 128
switching between, 23	.Mac preference pane, 128
iPhoto Library Manager, 22, 23, 146	.Mac Slides
italic text, 90	publishing photos as, 132
iTunes, 116, 118	subscribing to, 133
iView Media Pro, 118	.Mac Slides button, 105
Trien media 110, 110	Mac OS X
Ī	adding printer for, 106
IDEC in a man (C	changing scrolling behavior, 35
JPEG images, 66	Developer Tools, 82
V	driver for USB still camera, 13
K	protected memory, 153
Ken Burns Effect pane (iMovie), 119	version compatibility with iPhoto, 2
keywords	Macintosh
albums vs., 39, 52	acquiring iPhoto, 3
assigning and removing, 53	change Mac OS X scrolling behavior, 35
attached to imported photos, 17	hardware requirements for iPhoto, 2
checkmark, 53	network sharing of photos, 26, 147–149
creating, renaming, or deleting, 52	sharing photos with users on your, 146
retaining in merged iPhoto Library folders, 26	Mail, 129
searching via, 54	Mail Photo dialog, 120
showing or hiding, 32	Mail Using pop-up menu (Preferences
undoing assignments, 53	window), 120
Keywords window, 52 Knowledge Base, 165	managing photos
Kodak Photo CD or Picture CD, 16	backing up photos, 24–25
Rodak I noto eb oi i ictare eb, io	creating multiple Library folders, 22
L	culling photos, 20 deleting photos, 20
	directory structure of iPhoto, 19
landscape view	Image Capture, 27
for Desktop photos, 134	merging iPhoto Library folders, 26
DVD slideshows in, 137	recovering photos, 21, 75
printing sampler sheets and, 112 for screen savers, 135	switching between iPhoto Library folders, 23
switching to portrait, 71	memory, 154
landscapes, 184	memory cards
Last Roll album, 12, 65	buying bigger, 179
launching iPhoto, 7, 12, 13	deleting photos from, 14
layers in Photoshop Elements, 78	removing from card reader, 14
lens cleaners, 179	troubleshooting problems with, 156
Library folders. See iPhoto Library folders	merging iPhoto Library folders, 26
Lock Page checkbox, 81, 85	Microsoft Windows, QuickTime movies for, 145
Low Quality Warning dialog, 126	mode buttons, 9
low-resolution warning icons	modes
dealing with, 86	book, 8, 80
heavy cropping and, 72	edit, 8, 58
troubleshooting, 166	import, 8, 12
	organize, 8, 30
M	monopod/tripod, 179 movies
.Mac account	creating iMovie slideshow, 119
HomePage, 129, 130	exporting to QuickTime, 144
iCards, 129	unable to download, 13
	and the second s

MP3 files, 118	entering, 30
multiple photos	tools in, 31
adding titles for, 49	organizing photos, 29–56. See also albums;
assigning comments to, 50	keywords; ratings
editing dates of, 51	adding comments, 50
exporting, 141	adding photos to albums, 46
selecting, 45	arranging photos, 48
music	assigning and removing keywords, 53
for slideshows, 116, 118, 137	assigning titles to photos, 49
troubleshooting slideshow, 158	changing display pane layout, 32
Music tab (Slideshow dialog), 116	changing display preferences, 33
My Rating, 55	contextual menu shortcuts, 34, 59
myPhoto, 143	creating albums, 39
myPublisher service, 127	deleting albums, 44
M	duplicating albums, 42
N	editing film rolls, 36
naming smart albums, 40	editing photo dates, 51
navigating	entering organize mode, 30
to HomePage, 131	managing keywords, 52
images listed on memory card, 14	navigating through photos, 35
and selecting images for importing, 15	removing photos from album, 41, 47
through photos, 35	renaming and rearranging albums, 43
network sharing of photos, 26, 147-149	searching via keyword, 54
N-Up print style, 111	selecting photos, 45
	smart albums for, 40–41
0	tools for, 31
Ofoto service, 110	viewing photo information, 56
Open dialog, 58	orientation. See landscape view; portrait view
opening Spelling palette, 92	Originals folders, 19
Order Book button	n
illustrated, 81, 105	Р
process initiated with, 82, 126	Page Design pop-up menu, 84
viewing PDF file of book, 94	page numbers for books, 83
Order Book window, 126	Page Setup dialog, 109
Order Prints button	pages. See also albums; books; themes
illustrated, 105	arranging photos on book, 85
ordering prints with, 125	customizing design of, 82
Order Prints window, 125	deleting introduction, 87
ordering books and prints. See also shipping	designing book, 84
information	jumping around in book mode, 163
about ordered books, 127	printing single book, 95
damaged or missing orders, 164	working with photos on, 85
errors during ordering, 164	paper
not all prints received from Apple, 163	sizes for standard prints, 113
1-Click Ordering, 123, 164	types for printing, 115
ordering books, 126	passwords
print orders, 124, 125	Apple Store and iPhoto, 164
troubleshooting, 163–164	creating, 122
viewing PDF file of book, 94	forgotten, 123
Organize button, 30, 104	.Mac account, 128
organize mode	setting for shared photos, 148
accessing sharing tools in, 104	pause/play indicator, 117
defined, 8	PC Card adapters, 14, 179

DDE 61ee	finning through Ouigle Time movie 144
PDF files	flipping through QuickTime movie, 144
customizing book design in, 83	importing from iPhoto disc, 139
downloading this book as, 1	including extra space on edge, 72
viewing book, 94	landscape photos, 184
perception of color, 172	layout on book pages, 85
performance problems, 154	moving between film rolls, 38
permissions for imported photos, 146	ordering in slideshows, 117
pet photos, 183	paper sizes for standard prints, 113
Photo CD/Picture CD, 16	portrait photos, 182
photo info pane, 56	previewing before printing, 107
Photo Library album, film rolls in, 12	printing custom layouts of, 114
Photo tab (Photo Info window), 56	printing from book mode, 106
photography	publishing, 130, 132
artistic and documentary, 176	ratings for, 55
child and pet, 183	recovering, 21, 75
choosing cameras, 177	reducing red-eye, 73
color, 172–173	removing from smart albums, 41, 47
finding reviews of cameras, 178	retouching, 74
general tips for, 180–181	rotating, 66
landscape, 184	selecting parts of, 70
portrait, 182	sepia-toned, 68
resolution, 170–171	showing all, 51, 54
slideshow tips, 118, 137	titles for, 49
tips for printing, 115	travel photos, 185
travel, 185	undoing changes, 75, 76
understanding aspect ratios, 168–169	working with on book pages, 84
photos. See also books; importing photos;	zooming, 64
managing photos; organizing photos;	Photoshop Elements, 78
sharing photos	Picture Book theme
adding/removing HomePage photos, 131	about, 99
archiving, 25	text and page numbers for, 83
arranging by date, 48	Pictures folder, 19
artistic vs. documentary, 176	PixelNhance, 77
	pixels
backing up, 24–25	downsampling vs. interpolation, 171
black-and-white, 68	
burning disc of, 25, 26, 138	pixels-to-inches conversion, 124
can't edit, 160	resolution and, 170–171 "Place Most Recent Photos at the Ton"
can't upload, 162	"Place Most Recent Photos at the Top"
child and pet photos, 183	checkbox, 48 Play (Play Evil Serson buttons (iMexic) 110
crashes when double-clicked, 160	Play/Play Full Screen buttons (iMovie), 119
cropping, 60, 72	Portfolio book theme, 100
culling, 20	portrait photos, 182
damaged photo warnings, 157	portrait view
deleting, 20	Desktop photos and, 134
disappearing, 154	DVD slideshows in, 137
displaying on Desktop, 134	printing sampler sheets and, 112
don't open in external program, 160	switching to landscape, 71
dragging into album pane, 43	Portraits & Prints, 114
dragging to Trash album, 47	preferences
editing date of, 51	changing display, 33
emailing, 120–121	setting Image Capture, 27
enhancing, 67	setting scrolling, 35
erasing from memory card, 14	Preferences window
exporting, 140, 142–143, 144	Appearance tab, 48

choosing email program, 120 General tab, 33 selecting another program for editing, 76 setting editing preferences, 58 setting rotation direction in, 66 Sharing tab, 26 Preview button, 81	poor quality, 159 printing at incorrect size, 159 standard sizes for, 113 too dark, 162 protected memory, 153 Provide iPhoto Feedback command, 18 Publish HomePage window, 130
Preview pane (iMovie), 119	1 ablish Homer age window, 150
previewing	Q
books, 81, 94	
photos in Publish HomePage window, 130	quality ordered books, 128
prints, 107	print, 159
Print button, 105	QuickTime movies, 144–145
Print commands, 104	QuickTime Player Pro, 145
Print dialog	QuickTime tab (Export Photos dialog), 144
illustrated, 95	quotation marks, 88
options described, 106	quotation marks, oo
yellow warning icon in, 108	R
Print Explosion Deluxe, 110	
print styles	RAM, 2, 154
Contact Sheet, 108, 111	ratings
Full Page, 109	assigning, 55
Greeting Card, 110	illustrated, 31
N-Up, 111	searching for photos by, 40
Sampler, 112	showing or hiding, 32
Standard Prints, 113	RAW movie files, 13
printers	recovering photos, 21, 75
adding, 106	Red-Eye button, 60, 61
Gimp-Print drivers for, 109	red-eye reduction
selecting color, 179	aspect ratios and, 71
testing output of, 107	editing tips for, 73
printing. See also print styles; prints	refreshing display, 89 removing
book page numbers, 83	albums, 44
books on own printer, 95	HomePage photos, 131
contact sheets, 108	keywords, 53
custom layouts, 114	photos from albums, 41, 47
full-page photos, 109 greeting cards, 110	renaming
including extra space on edges of photos, 72	albums, 43
paper types for, 115	exported images, 140
photos, 106	keywords, 52
poor print quality, 159	rendering color, 172
previewing prints, 107	resize handle, 61
sampler sheets, 112	resolution
single pages of books, 95	imported Photo CD/Picture CD images, 16
standard print sizes, 113	low-resolution warning icons, 72, 86
tips for, 115	pixels and dots, 170–171
troubleshooting, 159	pixel-to-inches conversion, 124
prints	recommended ranges for print sizes, 124
don't appear on page correctly, 159	Retouch wand, 60, 74
errors during ordering, 164	retouching photos, 74
not all received from Apple, 163	reusing CD-RW discs, 25
order damaged or not received, 164	reversing sort order of photos, 48
ordering 125	Revert to Original command

dimmed, 160	exporting to Web pages, 142-143
undoing changes with, 75, 76	full-page photos, 109
revising Hot Plug Action, 7	greeting cards, 110
Rotate buttons, 66	with HomePage, 129–131
rotating photos	with .Mac account, 129
on book pages, 84	.Mac Slides, 132, 133
exporting after, 141	as movies, 119, 144–145
setting rotation direction, 66	on networked Macs, 26, 147–149
running slideshows, 117	ordering books, 126
	ordering prints, 125
S	paper types for printing, 115
Sampler print style, 112	preparing to order prints, 124
Screen Saver tab (Desktop & Screen Saver	previewing prints, 107
preference pane), 133	printing photos, 106–115
screen savers	receiving iPhoto disc, 139
configuring, 133, 135	running slideshows, 117
	sampler sheets, 112
creating, 135	screen savers, 133, 135
using, 133	setting up Apple ID, 122
Scripts menu, 151 scrolling, 35	setting up .Mac account, 128
	setting up slideshows, 116
searching	sign in with Apple ID, 123
by rating, 40	slideshow tools, 118
finding duplicate copies, 65 for text in smart albums, 41	standard print sizes, 113
via keyword, 54	tips for slideshows, 118
	tools for, 104-105
selecting	turning on photo sharing, 26, 148
before zooming, 64	with users on your Mac, 146, 147
multiple albums, 45	Sharing tab (Preferences window), 26
multiple pictures, 45	sharing tools, 104–105
parts of photo, 70	shipping information
photos, 45	charges for books and prints, 125
selection rectangle, 60	shipping address, 123
Sepia button, 60, 68	shipping costs, 126
sepia-toned photos, 68 Set Title To commands, 45	Show Colors command, 91
Set Title To Commands, 45 Set Title To Date/Time dialog, 45	Show Image File AppleScript script, 19
	showing all photos, 51, 54
Set Up Account dialog, 122 Settings tab (Slideshow dialog), 116	showing slideshow controls, 117
shared volumes, 147	size slider
sharing photos, 103–151. See also ordering	illustrated, 9, 60
books and prints; slideshows	moving and adjusting settings for, 32
about ordered books, 127	in organize mode, 31
accessing, 149	Slideshow button, 105
among users of shared volumes, 147	Slideshow dialog, 116
AppleScript scripts for iPhoto, 150–151	slideshows
burning photo disc, 25, 26, 138	arranging photos, 48
contact sheets, 108	deleting photos from, 20
custom layouts, 114	DVD, 136–137
	exporting to QuickTime movies, 144
displaying on Desktop, 134 as DVD slideshows, 136–137	iMovie, 119
emailing photos, 120–121	music for, 116, 118, 137
exporting files, 140, 141	running, 117
exporting mes, 140, 141 exporting to QuickTime movies, 144	setting up, 116
exporting to Quick Time movies, 177	tips for, 118, 137

tools for, 118	accessories for cameras, 179
troubleshooting, 158	artistic vs. documentary photos, 176
smart albums	child and pet photos, 183
creating and editing, 40	choosing cameras, 177
deleting photos from, 20	finding reviews of cameras, 178
removing photos from, 41, 47	general tips for, 180–181
searching, 41	landscape photos, 184
SmartSound Movie Maestro, 118	portrait photos, 182
software	travel photos, 185
Art Explosion Greeting Card Factory, 110	testing printer output, 107
BetterHTMLExport, 143	text
compatible email, 120	changing color of, 91
Easy Card Creator, 110	checking spelling as you type, 93
GarageBand, 118	deleting when switching themes, 87
GraphicConverter, 77, 140	editing HomePage, 131
iLife, 3, 4	entering or editing, 87
Image Rodeo, 143	fonts, 89, 90
ImageBuddy, 108, 114	printing photos and, 106
iTunes, 116, 118	searching for, 41
iView Media Pro, 118	styles, 89, 90
myPhoto, 143	typing punctuation and, 88
photos don't open in external program, 160	text warning icons, 86
Photoshop Elements, 78	Theme pop-up menu, 81, 83
PixelNhance, 77	themes
Portraits & Prints, 114	Catalog book, 96
Print Explosion, 110	choosing book, 83
QuickTime Player Pro, 145	Classic book, 97
SmartSound Movie Maestro, 118	Collage book, 83, 98
Still Life, 118	creating new, 82
software requirements, 2	Picture book, 99
Software Update pane, 5	Portfolio book, 100
Speech menu, 93	Story Book, 101
spelling check, 92–93	text deleted when switched, 87
Spelling palette, 92	Year Book, 102
Standard Prints print style, 113	thumbnails
Start Speaking command, 93	arranging photos as, 81, 85
Still Life, 118	crashes viewing, 161
stopping photo importing, 15	display during image downloading, 13
Story Book theme, 101	don't reflect editing changes, 161
strong passwords, 122	organizing film roll as, 12
styles	Thumbs folders, 19
changing text, 89, 90	TidBITS, 165
print, 108–113	titles
subscribing to .Mac Slides, 133	adding to books, 83
Subscriptions dialog (.Mac), 133	arranging by, 49
switching	assigning, 49
to import mode, 12	changing film roll, 36
in/out of book mode, 80	illustrated, 31
between iPhoto Library folders, 23	printing for contact sheets, 108
between portrait and landscape views, 71	showing or hiding, 32
	toolbar
T	customizing, 62
taking better photos, 175–185	displaying tools on, 63
5 - 5 - 5 - 5 - 5 - 5 - 5 - 5 - 5 - 5 -	using, 63

tools book mode, 81 display pane, 60 displaying on toolbar, 63 editing, 60-61 organize mode, 31, 104 for sharing photos, 104-105 for slideshows, 118 Web export, 143 tracking imports as separate film rolls, 12 Trash dragging photo to, 20 dragging photo to Trash album, 47 removing photos from, 21 travel photos, 185 troubleshooting, 153-166 camera or card reader not recognized, 156 can't enable 1-Click ordering, 164 crashes viewing thumbnail, 161 damaged photo warnings, 157 disappearing photos, 154 duplicate images after import, 158 excessive editing, 161 files don't appear after import, 156-157 flaky behavior and crashes, 155 font and style changes, 90 help for, 165 importing problems, 156–158 iPhoto crashes when photos double-clicked, 160 launch problems after upgrading, 7 memory card problems, 156 miscellaneous problems, 155 order damaged or not received, 164 performance problems, 154 photos don't open in external program, 160 printing, 159 problems with prints and books, 162–163 Revert to Original command dimmed, 160 slideshows, 158 thumbnails don't reflect changes, 161 unable to edit photos, 160 warning icons, 166 turning on photo sharing, 26, 148 typing punctuation and text, 88 U underlined text, 90 undoing

USB ports, 2 user interface, 9

V

versions
comparison of features, 6
numbering of iPhoto, 3
viewing
crashes during thumbnail, 161
last set of imported photos, 12
PDF file of book, 94
photo information, 56
volumes, disconnecting camera, 13

W

warning icons low-resolution, 72, 86 in Print dialog, 108 text, 86 troubleshooting, 166 Web Page tab (Export Photos dialog), 142 Web sites. See also .Mac account Apple .Mac Signup page, 128 camera review, 178 checking for iPhoto updates, 5 exporting photos to, 142–143 publishing photos using HomePage, 130 windows. See also Preferences window; and specific windows dragging photos to outgoing email, 121 tools for editing in separate, 61 zooming photos in image-editing, 64 writing AppleScript scripts, 150

Y

Year Book theme, 102

Z

Zoom buttons, 61, 64 zooming photos, 64

changes, 75, 76

keyword assignments, 53 updating iPhoto, 5–6 USB card/PC Card reader, 179